IN CAMERA
FRANCIS BACON
PHOTOGRAPHY, FILM AND
THE PRACTICE OF PAINTING

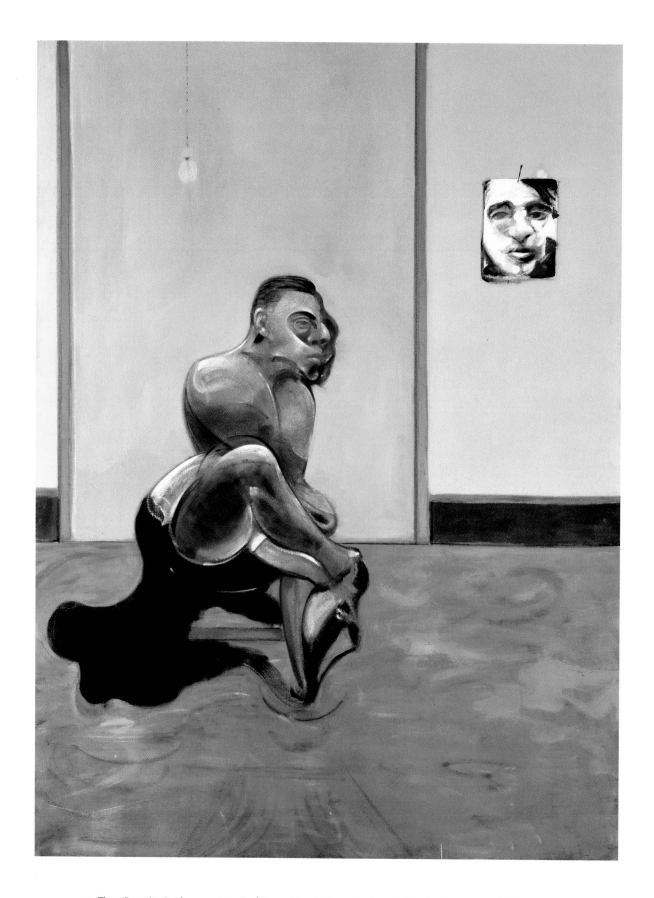

1 *Three Portraits: Posthumous Portrait of George Dyer, Self-portrait, Portrait of Lucian Freud* (1973), left-hand panel

Martin Harrison

IN CAMERA
FRANCIS BACON
PHOTOGRAPHY, FILM AND
THE PRACTICE OF PAINTING

With 275 illustrations, 200 in color

Thames & Hudson

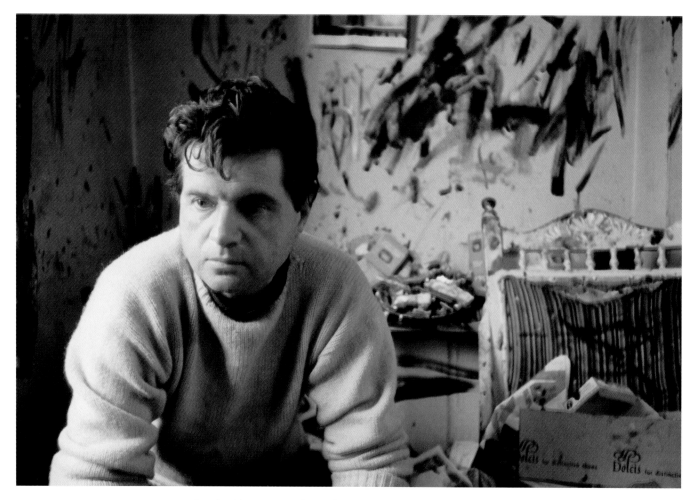

2 Douglas Glass: Bacon in his studio, Overstrand Mansions, Battersea, 1957

This publication is supported by the Estates of
Francis Bacon and John Edwards

First published in 2005 in hardcover in the United States of America by
Thames & Hudson Inc., 500 Fifth Avenue, New York, New York 10110

thamesandhudsonusa.com

Library of Congress Catalog Card Number 2004112479

ISBN-13: 978-0-500-23820-2
ISBN-10: 0-500-23820-0

Design: Martin Harrison and Tony Waddingham
Printed and bound in Germany by Steidl

CONTENTS

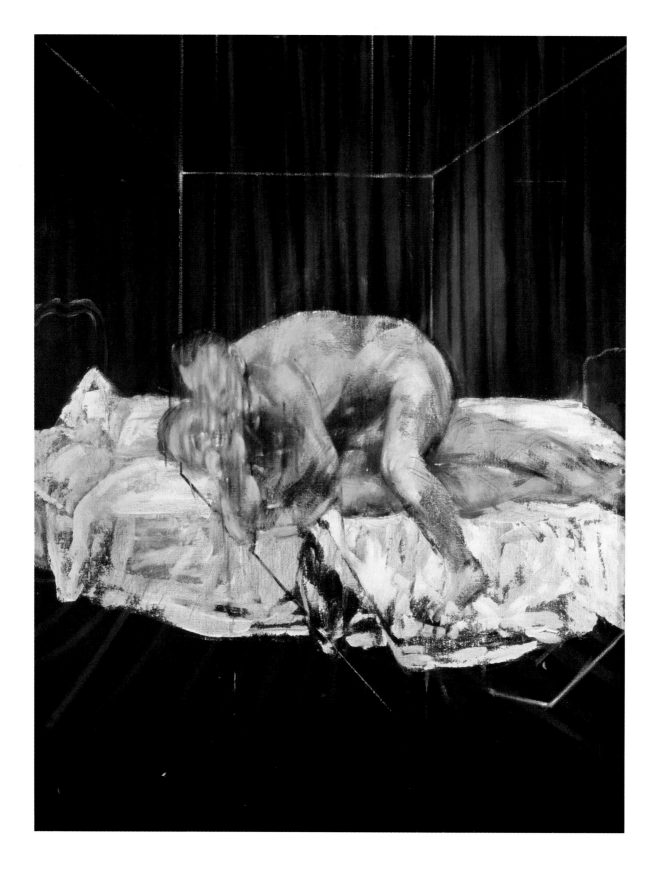

3 *Two Figures* (1953)

INTRODUCTION

When Francis Bacon declared his intention to paint 'the history of Europe in my lifetime'[1] he meant to distil a world in which traditional certitudes no longer applied. The history of his own family mirrored the decline of Britain's empire: if he yearned for grandeur in both life and art, as a sceptic he acknowledged the futility of such pretensions. The painting he considered as marking his debut, *Three Studies for Figures at the Base of a Crucifixion* (1944), was received as a shocking threnody on war but was fundamentally an expression of his isolation and despair. A year later a snapshot triggered the equally ferocious *Figure in a Landscape*. He went on to appropriate masterpieces of art history and to co-opt photographs as agents for dismantling them into modern high tragedy. In half-tone reproduction a seminal Baroque painting by Velázquez was no more or less potent, or open to manipulation, than an image torn from a medical reference book or a close-up film still. Bacon explored the tensions between intelligence and sensation, abstraction and illustration, stasis and motion, order and chaos, to generate some of the most compellingly raw paintings of the century.

Bacon has been described as 'internationally recognized as one of the outstanding postwar artists',[2] yet he attained this status with no formal training and a repertory of unorthodox techniques. He was inspired to become a painter by the example of Picasso and was driven by the necessity, as he saw it, of challenging Picasso's domination of art in the first half of the twentieth century. The contingency and fragmentation of photographs were crucial tools in Bacon's arsenal. His paintings – among the most distinctive and idiosyncratic of the twentieth century – were the response to the complex cultural contexts

of a kind of Nietzschean superman, who on the one hand was indifferent to his reputation, but on the other was determined to impose his highly individual vision on the world.

While the main focus of this book is on Bacon's use of mechanical reproductions of paintings, photographs and films in a shifting dialectic between art and photography, it also aims to elucidate the evolution of his modern figural style by incorporating elements of biography and by analyzing paintings made at pivotal moments in his career.

Three biographies appeared within four years of Bacon's death in 1992, all containing information he had suppressed, but significant gaps in our knowledge remain – a testament to the censorship he wielded in his lifetime.[3] John Russell's critical biography is established as a standard text, and all future research will be indebted to David Sylvester's interviews with the artist, the catalogue raisonné by Sir John Rothenstein and Ronald Alley, and the perceptive critiques of Hugh M. Davies.[4] Bacon willingly colluded in the alignment of his work with Velázquez or Ingres, and many recent writers have perpetuated these elevated conjunctions.[5] Andrew Brighton's foregrounding of the less fashionable Roy de Maistre, whose effect on Bacon was arguably more decisive than Michelangelo's, is a welcome corrective to this bias.[6] The layers of obfuscation surrounding a great artist are only just beginning to be penetrated.

Bacon's consumption of imagery was, in a sense, non-hierarchical. Irrespective of an image's original state as a photograph or painting it was homogenized – democratized – by its reproduction through a mechanical screen. It may be helpful to bear in mind the following general principles governing his appropriation of images:

1. Before 1962 Bacon seldom employed photographs other than in the form of reproductions he took from books, magazines or newspapers. The earliest records of these 'working documents' are two photographs taken in 1950 by Sam Hunter in Bacon's Cromwell Place studio. The material Hunter selected was rearranged to compress the optimum visual information into the frame. There were no original photographic prints in this selection.[7]

2. After 1962 Bacon not only used photographic prints as source material but actually commissioned photographs of models to conform with preconceived ideas for a painting.

3. From the publication date of a printed source or the release date of a film it does not follow that Bacon necessarily acquired, used or saw it at that time. There were, in any case, usually multiple sources at play in his reworkings of images.

4. A nucleus of photographically illustrated books accumulated early in Bacon's career remained fertile image sources throughout his life. Amédée Ozenfant's *Foundations of Modern*

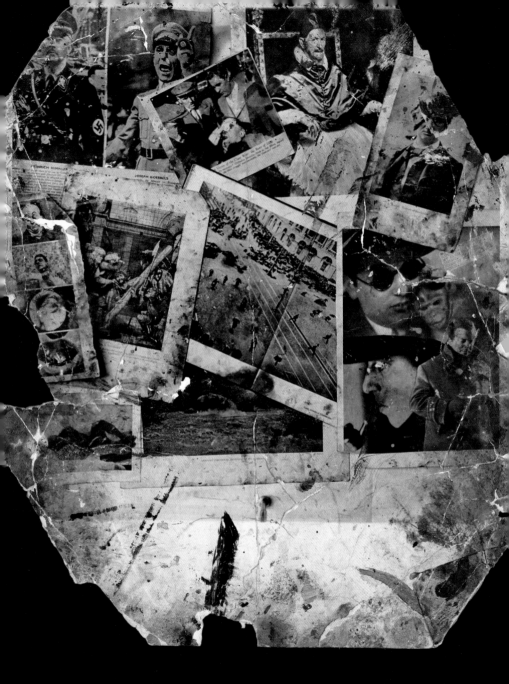

4 Working document: photograph by Sam Hunter
of Bacon's printed source imagery 1950, mounted on card

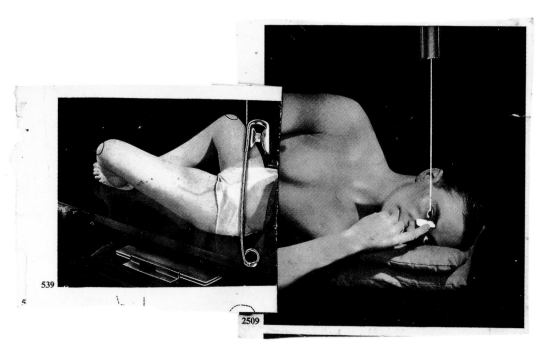

5 Working document: two plates from K. C. Clark, *Positioning in Radiography*, 1939, attached with a large safety-pin

Art was published first in Paris, where Bacon may have acquired it, in 1928 and in England in 1931. Many of its illustrations occur with greater or lesser modification in his paintings, among which the photograph of a model Egyptian army (pl. 8), the source for the troop of soldiers in *Untitled (Marching Figures), c.* 1950 (pl. 9), was a typically idiosyncratic borrowing. Bacon bought another important volume, of diseases of the mouth, from a Paris bookstall in the 1930s: doubtless its hand-tinted illustrations, as well as Picasso's drawings, informed the grimacing mouths with bared teeth he painted at that time. Baron Albert von Schrenck Notzing's *Phenomena of Materialisation* was published in German in 1913 and in English in 1920. Again it is uncertain when Bacon obtained a copy, but the earliest quotation traced by the present author is in *Three Studies for Figures at the Base of a Crucifixion* (1944). When K. C. Clark's *Positioning in Radiography* was published, in 1939, Bacon was doing little or no painting. Its over 2,500 illustrations of patients correctly positioned for X-rays were of considerable generic significance for his paintings, but specific borrowings are rare: an exception is the figure with a bandaged leg in a splint in *Three Studies from the Human Body* (1967).

5. Although Bacon had seen Eadweard Muybridge's photographs previously, it was not until 1949, when his friend Dennis Wirth-Miller introduced him to the complete eleven-volume set of *Animal Locomotion* (1887), comprising 781 gravure plates, that they became his most fecund resource. An abridged version was published as *The Human Figure in Motion* in 1955,

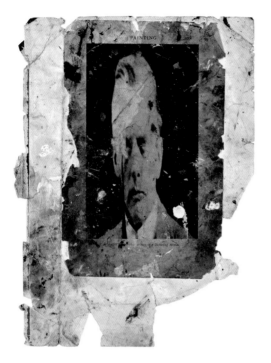

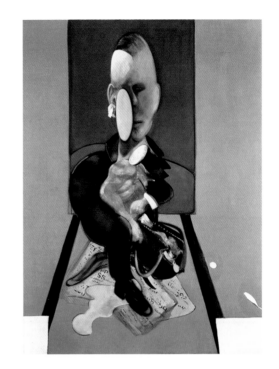

6 Working document: 'Sir Austen Chamberlain',
Foundations of Modern Art, 1931, mounted on card

7 *Triptych* (1976),
left-hand panel

four different copies of which were found in Bacon's Reece Mews studio after his death, along with more than one hundred loose leaves. The amassing of multiple copies of the most suggestive photographs was paralleled by his acquisitiveness in respect of reproductions of certain paintings, such as Velázquez's *Pope Innocent X* (and indeed works by Velázquez which he did not directly reference). The extent of this hoarding was a Baconian phenomenon, and implies that he saw nuances of scale, definition and colour as potentially revelatory of fresh means of employing images in his iconoclastic recombinations.

6. In the 1970s there was a significant change in Bacon's deployment of photographs. As his paintings quoted increasingly from themes in his own *œuvre*, so the incorporation of pictorial elements derived from photographs became self-referential, even parodic. The prototype for the images in the outer panels of *Triptych* (1976) was a photograph of the distorted reflection of Sir Austen Chamberlain, reproduced in Ozenfant's *Foundations of Modern Art*. But by 1976, photographic stimuli were not subsumed into an overall conception, but 'wound up', as Bacon put it, isolated and placed on display. Bacon was referring to *the fact of having used photographs in the past*: the use of photographs had become ironic, postmodern. His eliding of Old Masters, literature and photography had always been, in part, ironic. Working from coarse reproductions he re-scaled and reinvented them in exhilarated paint, while conscious that the dissemination of his own paintings would depend on mechanical reproductions.

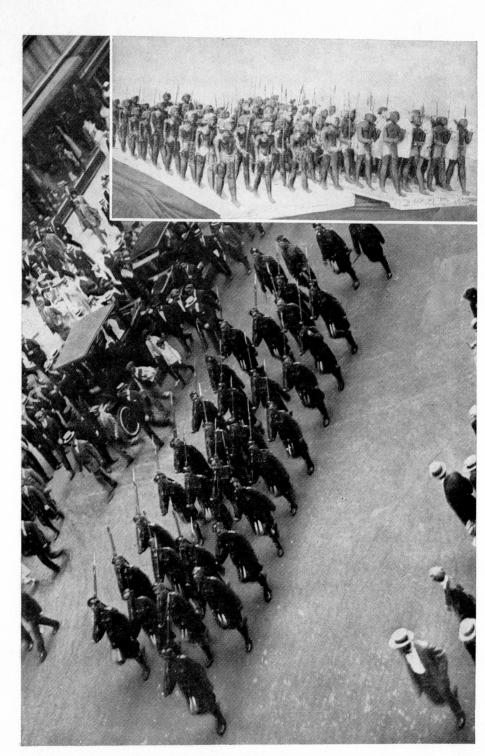

Egyptian and British Armies.

14

8 'Egyptian and British Armies', a plate from Amédée Ozenfant, *Foundations of Modern Art*, 1931

9 *Untitled (Marching Figures)*, c. 1950

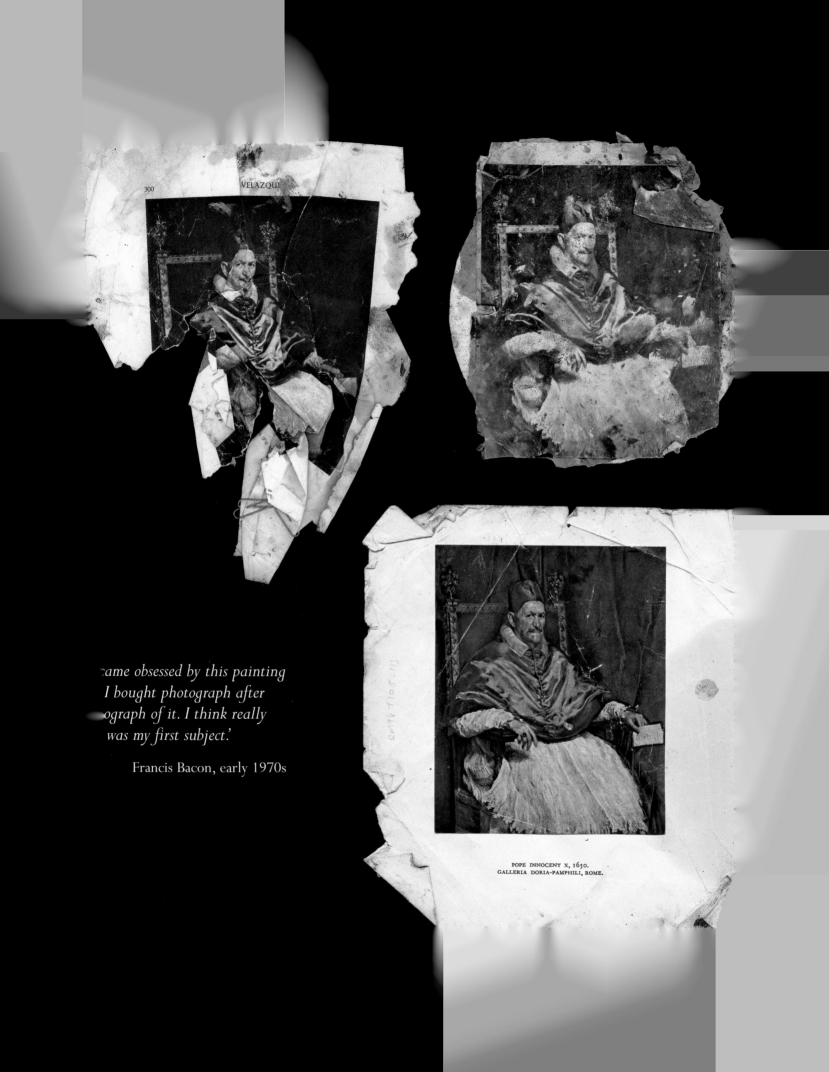

300 VELAZQU

...ame obsessed by this painting
...I bought photograph after
...ograph of it. I think really
...was my first subject.'

Francis Bacon, early 1970s

POPE INNOCENT X, 1650.
GALLERIA DORIA-PAMPHILI, ROME.

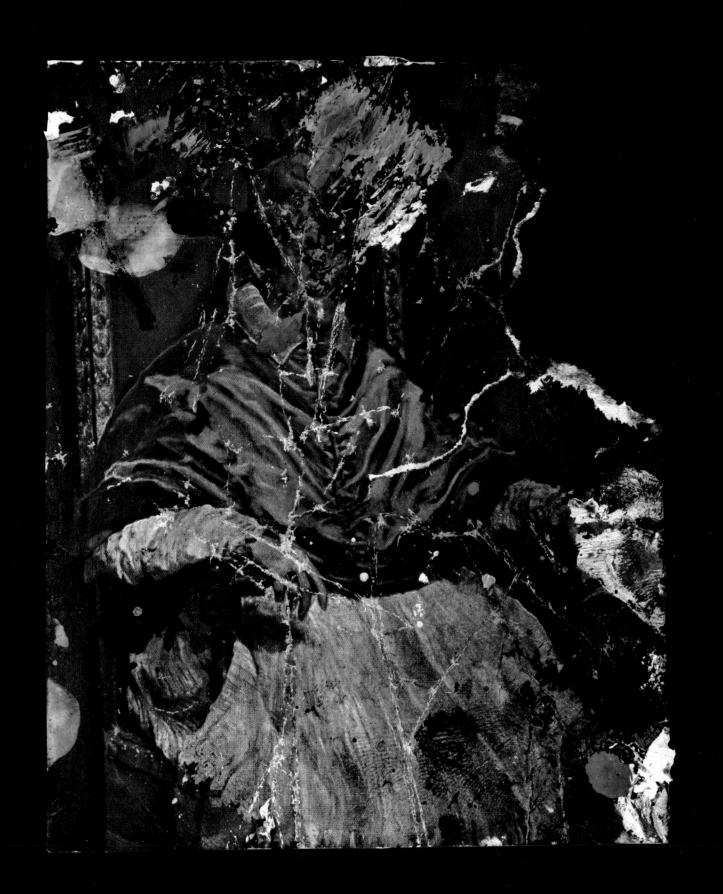

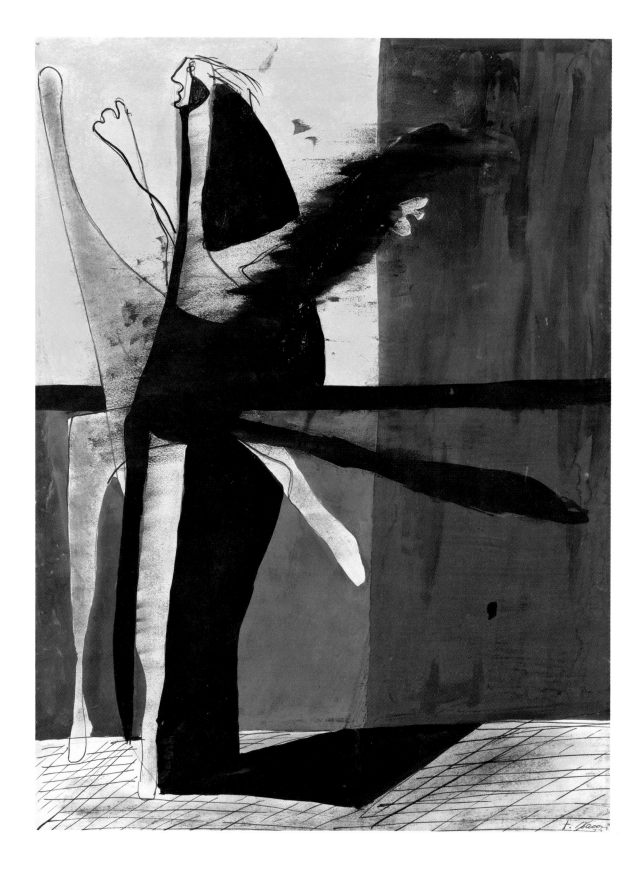

14 *Composition (Figure)*, 1933

AFTER PICASSO

Francis Bacon was born in a nursing home in Dublin on 28 October 1909, the second son of English Protestants, Anthony Edward Mortimer Bacon and Christina Winifred Loxley Bacon (née Firth). They lived at Cannycourt House, Co. Kildare, where his father, a retired army captain, trained racehorses. Francis was baptised in the nearby church of St Patrick, Carnalway, notable – apart from the hamlet's curiously prophetic appellation – as the site of the mausoleum of the la Touche family: Rose la Touche had been the object of John Ruskin's affection since she was ten years of age and her death in 1875 tipped him towards insanity. The Bacons frequently changed houses, and it was from Straffan Lodge, near Celbridge, that Francis was ejected at the age of sixteen when his father found him dressed in his mother's underwear. He drifted around London for several months, taking various odd jobs to supplement a three-pounds-a-week allowance from his mother, until in 1927 it was arranged for him to travel to Berlin accompanied by a young male relative whom his father hoped would cure him of his homosexuality but who instead seduced him.

After two months Francis travelled to Paris and saw a Picasso exhibition at the Galerie Paul Rosenberg which, he maintained, inspired him to take up painting; yet the exhibition consisted almost entirely of neoclassical drawings and not the Picassos Bacon revered, the surrealistic, biomorphic bathers begun at Cannes in the summer of 1927, resumed at Dinard the following year and continued until 1932. It was these metamorphic figures that were the departure point for Bacon's repertory of forms and concepts. The psychological connotations of the confined spaces of Picasso's beach huts (*cabañas*) and the monumentality of the figures,

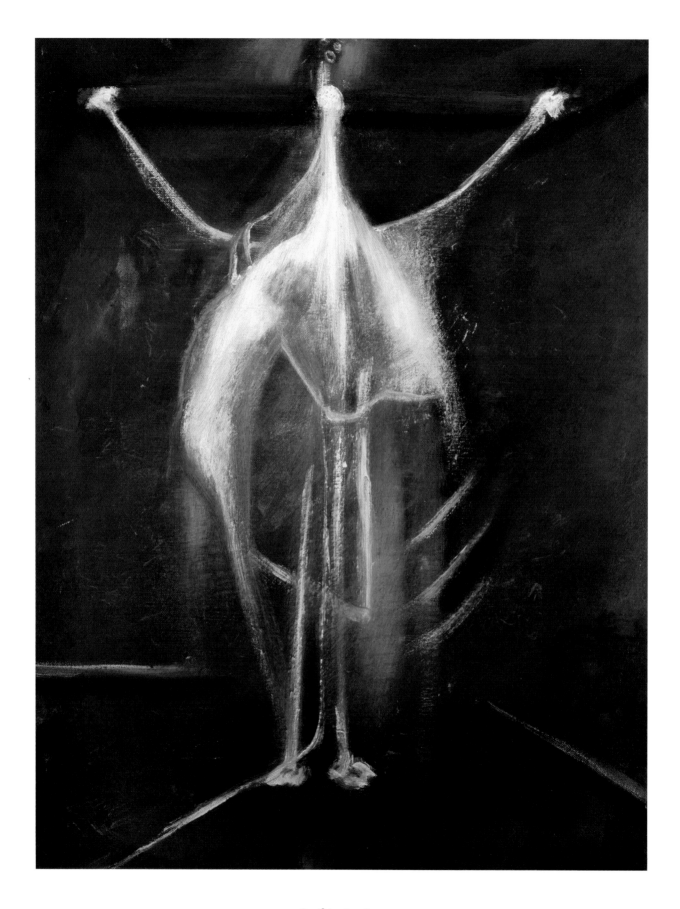

15 *Crucifixion* (1933)

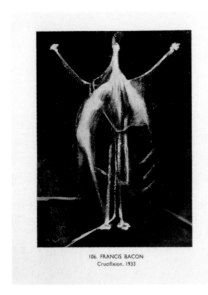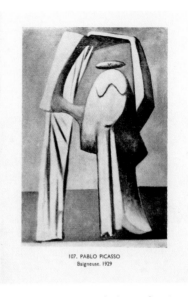

106. FRANCIS BACON
Crucifixion. 1933

107. PABLO PICASSO
Baigneuse. 1929

16 Double-page spread from Herbert Read, *Art Now*, 1933 (revised edition of 1948, which transposed the Picasso and Bacon images)

many of them conceived as sketches for possible sculptures, held a lasting potency for Bacon. In 1962 he argued that Picasso's organic forms, which related to the human image but were 'a complete distortion of it',[1] remained under-explored, and he revisited their Freudian motifs, such as the coded references to Picasso's mistress Marie-Thérèse Walter expressed in the ritualistically repeated images of a key unlocking a cabin door, into the late 1970s.

But if Bacon's grasp of chronology was reliable and the Picasso epiphany did occur in Paris in 1927, it is unclear how its impact was manifested. For rather than becoming an artist Bacon returned to London and in 1929 established an interior design studio, only painting desultorily. Evidently the absorption of Picasso was more gradual, less dramatic. The classical columns on a tripartite decorative screen Bacon designed about 1929 derive from Giorgio de Chirico, and the 'pinheads' and mutated anatomies were probably transmitted through Picasso imitators. Bacon destroyed most of his early paintings and drawings, and the eleven surviving works from the 1930s are an insufficient basis from which to draw broad conclusions. Until 1933, however, they showed no trace of Picasso's biomorphs. A few of these were exhibited in London in June 1931 and in 1933 Picasso's *Une Anatomie* designs and drawings of the Crucifixion after Grünewald were reproduced in *Minotaure* no. 1. He then became a constant presence for Bacon, but by 1933 his bone figures reverberated in the work of many British artists, including Eileen Agar, Stanley William Hayter, John Melville, Ceri Richards and Julian Trevelyan. Though it was not an isolated phenomenon, Bacon's response to Picasso's reaction to Surrealism was not simple plagiarism: rather, it took as a departure point Picasso's privileging of intuition over intellect in the recoding of appearances.

Reproduced in Herbert Read's 1933 survey *Art Now* opposite Picasso's *Baigneuse aux Bras Levés* (1929), Bacon's *Crucifixion* (1933) was his first painting to attract public attention. It was a considerable achievement for a young, semi-trained artist. Read's juxtaposition explicitly linked the attenuated, etiolated Christ and his wraith-like 'attendant' with Picasso,

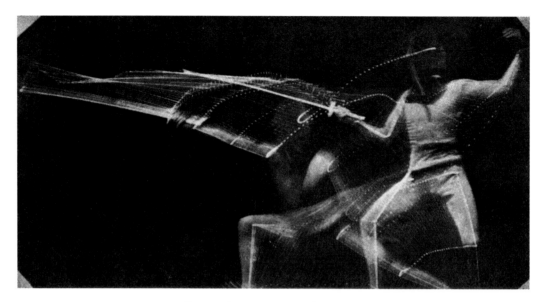

17 Etienne-Jules Marey, *Le coup d'épée* (c. 1890),
plate from *Minotaure* no. 1, 1933

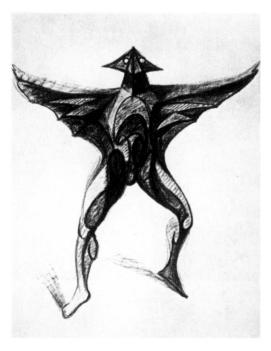

18 André Masson, *Le Sort* (design for *Les Présages*, 1933),
plate from *Minotaure* no. 1, 1933

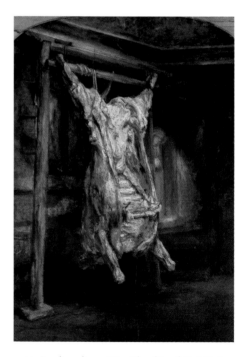

19 Rembrandt van Rijn, *Slaughtered Ox* (1655)

but the sombre tonal range and interior frame structure of Bacon's painting appear to have been informed, rather, by Rembrandt's *Slaughtered Ox* (1655). This was, therefore, his first conjunction of slaughterhouse and sacrifice, which Dawn Ades has related to the theories of the Surrealist writer and polemicist Georges Bataille, and specifically to Eli Lotar's photographs of the slaughterhouses at La Villette, published in Bataille's *Documents* in 1929.[2] In contrast to *The Crucifixion* (1933; pl. 28), painted only months later, *Crucifixion* is rigorously monochromatic, indeed vaporously *photographic*. It recalls the soft focus of a vignetted camera obscura image and the haziness of the *fin-de-siècle* paintings of Eugène Carrière, themselves hard to distinguish in reproduction from the painterly or graphic textures of seccesionist photographs, such as the gum bichromates of Robert Demachy.

Evidently Bacon had near at hand, as well as a reproduction of the Rembrandt (probably in black and white), the first issue of *Minotaure*, a lavishly produced Surrealist art journal published in Paris by Albert Skira between 1933 and 1939. Bacon's informal mentor and most important artistic contact in the 1930s was the Australian painter Roy de Maistre, and it may have been he who informed Bacon of the journal (that de Maistre had access to it is confirmed by the sexual coupling in his 1934 pastel *Interior with Figures +3*, an almost exact copy of a Matisse design of a faun – an illustration for Mallarmé's *Poésies* – reproduced in *Minotaure* no. 1).[3] Lawrence Gowing compared Bacon's atrophied forms with a bat-like figure of *Le Sort* (Destiny), designed by André Masson for a Ballets Russes production, *Les Présages*, in 1933 and illustrated in *Minotaure* no. 1, as are nine of Picasso's designs after Grünewald's *Crucifixion*. But on the page facing the Masson is a chronophotograph of a fencer, taken by Etienne-Jules Marey (*c.* 1890). The blur and flicker of transitional movement – the spectral trace of the figure lunging with his foil in front of a black backcloth – is precisely what Bacon sought to translate into paint in *Crucifixion*. The trigger for its most original aspect was the time-lapse aura of Marey's penumbral lighting, the result of extended exposure of the plate.

The inference that Herbert Read intended with his opposition of Picasso and Bacon has seldom been questioned, but *Crucifixion* is as remarkable in its deviation from Picasso as in its reliance on him. In fact its resemblance to a Picasso is relatively superficial, and is restricted to the stick-like figures, which are desculptured in Bacon's rendition. If Cubism was partly a response to Henri Bergson's concept of the duration of time then Bacon, seeking a way through and beyond Picasso, represented time not in the staccato, multiple-viewpoint rhythms of Analytical Cubism but in the kind of continuous, flowing movement accessible only through the blurred motion of the photographic (and cinematographic) image. Bacon understood the futility of replicating Picasso; to challenge him was a daunting task, and the struggle was to consume – and at times overwhelm – him until 1945, but he announced with *Crucifixion* that he was intuitively alert to the transformative potential of photography.

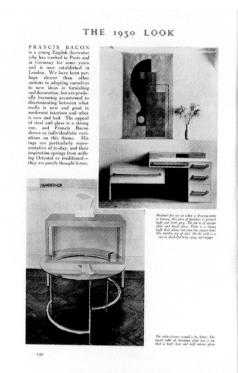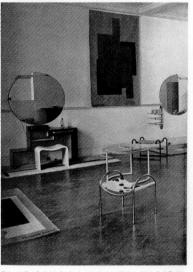

THE 1930 LOOK IN BRITISH DECORATION

FRANCIS BACON is a young English decorator who has worked in Paris and in Germany for some years and is now established in London. We have been perhaps slower than other nations in adapting ourselves to new ideas in furnishing and decoration, but are gradually becoming accustomed to discriminating between what really is new and good in modernist interiors and what is new and bad. The appeal of steel and glass is a strong one, and Francis Bacon shows us individualistic variations on this theme. His rugs are particularly representative of to-day, and their inspiration springs from nothing Oriental or traditional—they are purely thought forms.

140

141

20 'The 1930 Look in British Decoration', *The Studio*, August 1930, pp. 140–41. These pages show three views of Bacon's first studio at Queensberry Mews West, South Kensington, London

21 Eric Megaw: Thérèse Veder in Bacon's living room at Carlyle Studios, Chelsea, London, *c*. 1932.
Bacon's rug, table and sofa are to his design

By Design

In common with most aspects of Bacon's life before 1950 his brief career as a designer of furniture, fabrics and interiors is inadequately documented. He opened a design studio in a two-storey premises at 17 Queensberry Mews West, South Kensington, in 1929. In characterizing himself as a habitually late starter, he was, therefore, overlooking this ambitious project, launched when he was either nineteen or twenty. The mews building, a former garage previously in use as a dance school, was transformed by Bacon into a stark modernist interior, with rugs, wall hangings and furniture of his own design. The only substantial coverage accorded the venture was an article in *The Studio*, August 1930, entitled 'The 1930 Look in British Decoration', in which it was reported that Bacon had 'worked in Paris and Germany for some years' (he claimed later that he did some design work in Paris, but no evidence of this has been found and 'worked' may have been a euphemism). He later dismissed his interior designs as unoriginal, influenced mainly by his French peers, but if derivative they were *au courant* and of considerable sophistication. In his own studio the white surgical rubber drapes were the most innovative (and erotically perverse) flourish. Bacon staged two exhibitions at Queensberry Mews West, one in 1929 that included paintings but was dominated by his decorative work, and another in November 1930 in which he showed five of his paintings (and four rugs) alongside seven paintings by Roy de Maistre and thirty-one pastels and drawings by the actress and portrait artist Jean Shepeard.

The rugs, wall hangings and painted screens Bacon designed between about 1929 and 1931 evince regular contact with Paris, and as close a familiarity with the work of Fernard Léger, Jean Lurçat and Jean Souverbie as with that of Picasso. The stylized figures he painted on the screens are indebted to Souverbie's Cubist Neo-Classicism; one of his first oils, *Painting* (*c.* 1929–30), has affinities with Lurçat's *Arcachon* (1930); and the leaves in his painting *Watercolour* (1929) correspond to those in Léger's *Composition* (1928). His non-figurative designs in this period, mostly for rugs, are comparable with the decorative work of the British artists Paul Nash and Edward Wadsworth. Bacon's experience in the realm of interior design, although he sought to minimize its significance, informed both the pared-down modernist spaces in his paintings and the armatures on which he displayed their figures. The offset circles of his chromium-plated tubular steel coffee table, *c.* 1929, were, as he admitted, prototypes of the metal railing in *Figure in a Landscape* (1945; pl. 43) and the dais in *Painting 1946* (pl. 47), and many of the rostrum devices in his paintings can be traced to his early furniture. They disclose that as a painter he remained an extremely resourceful designer. In photographs of his studios one often finds one or two T-squares, drawing equipment more readily associated with a designer than a painter, and further evidence of Bacon's unorthodox techniques, a legacy of his unconventional art education.

22 Roy de Maistre, *Untitled (Figure on a Sofa)*, *c.* early 1930s

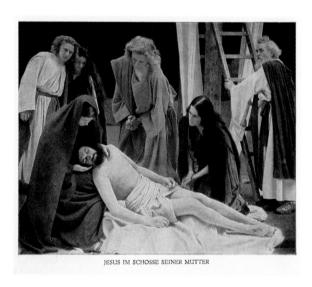

JESUS IM SCHOSSE SEINER MUTTER

23 'Lamentation over the Dead Christ',
plate from the handbook of the Oberammergau Passion Play, 1930

Bacon elected not to divulge more than a skeleton account of his early life, and the anecdotes that have been preserved seldom prove to be accurate. His vaunted excursion to Berlin and Paris in 1927 (assuming that date is verified) was not an isolated visit, for he returned to Germany in 1929 and 1930, for example, and on the latter occasion attended the Passion Play at Oberammergau. The dramatically lit portrait of Bacon by former film cameraman Helmar Lerski has been dated 1927–28, but Lerski did not open his studio until 1929. Although Bacon is known to have occupied a studio at Queensberry Mews West, South Kensington, from about 1929 until 1931, his movements during the next six years remain uncertain. In 1932–33 he probably shared a space at Carlyle Studios, Chelsea, with Roy de Maistre. It contained a rug, mirror, sofa and other furnishings designed by Bacon, and de Maistre kept the sofa for the rest of his life.

24 Rug designed by Bacon, woven by the Royal
Wilton Carpet Factory, c.1929–30

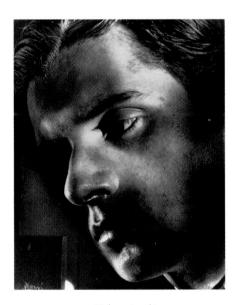

25 Helmar Lerski:
Francis Bacon, Berlin, c.1929–30

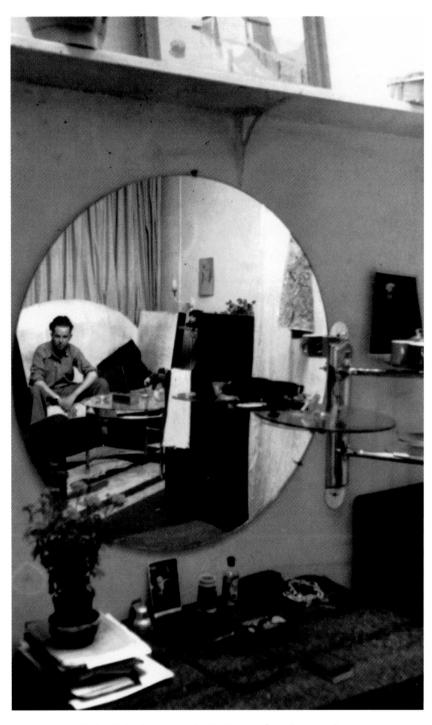

26 Thérèse Veder (later Megaw): Eric Megaw reflected in a circular mirror
designed by Bacon, at Carlyle Studios, London, c.1932

Moving Pictures

'Oh, yes, cinema is great art!' Bacon declared. 'I've often said to myself that I would have liked to have been a film director if I hadn't been a painter.'[4] Assessing the impact that cinema had on Bacon's painting, however, is problematical, due mainly to the lack of information concerning the films he saw. But in his formative years of the late 1920s and early 1930s film made a powerful impression on him. Although he expressed admiration for the 'New Wave' directors Alain Resnais and Jean-Luc Godard, and also for Luis Buñuel's *Belle de Jour* (1966), he referred with much greater frequency to pioneering masterpieces of the European avant-garde, such as Buñuel's *L'Age d'or* and *Un Chien Andalou*, and remained most strongly attached to the early films of Sergei Eisenstein (though he never mentioned those of Dziga Vertov or Vsevelod Pudovkin). Such 'arthouse' fare was, like his taste in literature, reasonably elevated but not exceptional. Film was perhaps, like music, a medium capable of inspiring him but about which he felt inadequately informed.

The establishment of the Film Society in London in 1925 marked the entry of film culture into critical discourse in Britain. Among the Society's influential founders, Ivor Montagu was already reviewing films for *The Observer*, as was Iris Barry in the *Daily Mail*, and the interest of intellectuals from other disciplines, such as Roger Fry and Julian Huxley, contributed to the legitimization of film-making as a serious creative endeavour. The sculptor Frank Dobson was a founder as well as a council member of the Film Society, whose 'significance…for numerous artists in the late 1920s can hardly be overestimated'.[5] Dobson was also, along with Jean Shepeard and the poet and writer Edward Ashcroft, a member of the Emotionist Group, formed in 1928 by R.O. Dunlop, and either Ashcroft or Shepeard could have effected an introduction between Dobson and Bacon. Jean Shepeard shared a London flat with the actress Peggy Ashcroft, whose brother Edward became a friend of Bacon's (characterizing his limited conversational skills at that time, Bacon recalled Ashcroft's salutary remark to him: 'Whatever is clearly thought can be clearly said').[6] Since mainstream cinemas would have provided Bacon with limited opportunities to watch the innovatory European films he later cited as inspirational, it is to be hoped that more evidence will resurface concerning the extent of his engagement with this group's activities. The assumption that he saw Eisenstein's *The Battleship Potemkin* (1925) while travelling in Europe in the late 1920s is not supported by any of his vague assertions, although he did, apparently, see Abel Gance's *Napoléon* (1927) at that time. An ideal opportunity to see the film, however, presented itself when he was back in London working as an interior decorator, for in 1929 both Pudovkin and Eisenstein accompanied their films to London and delivered lectures to the Film Society. With the director present, therefore, Bacon could have seen *The Battleship Potemkin* at its first London screening, in November 1929.

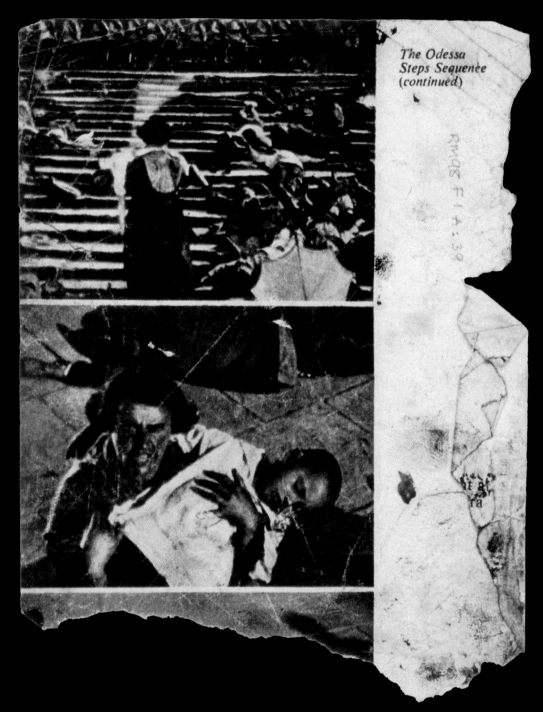

The Odessa
Steps Sequence
(continued)

27 Working document: torn leaf from Roger Manvell, *Film*, 1944, showing
stills of 'The Odessa Steps Sequence', from *The Battleship Potemkin* (Eisenstein, 1925)

Neither of these images can be tied to a Bacon painting, but the sequential layout of film stills was significant for his practice. Manvell's book reproduced fifteen images from *The Battleship Potemkin*, arranged three-per-page, and cumulatively they may have acted as a stimulus for Bacon's memory of experiencing the film's most dramatic and poignant sequence. From 1927 to 1933, Eisenstein was a frequent contributor to *Close Up* (the first British journal devoted to film as an art form), with which Bacon was probably familiar.

Absorption

It is possible that Bacon and Roy de Maistre first met in France since, according to Sir John Rothenstein, they became acquainted in 1929 and de Maistre did not move to London until 1930, shortly before the joint exhibition in Bacon's studio. In 1934 de Maistre set up The School of Contemporary Painting and Drawing in Ebury Street, London, with Martin Bloch, who had recently emigrated to Britain, a refugee from Nazi oppression. Bloch and de Maistre had met in London the previous year, when Bloch stayed with his brother-in-law, the National Gallery's picture restorer Helmut Ruhemann. Bloch had opened a successful art school in Berlin in 1923, which he ran jointly with Anton Kerschbaumer and later with Karl Schmidt-Rottluf. His London venture with de Maistre was short-lived, but their teaching methods, which valued self-expression above formal discipline, may explain how the technical advice de Maistre is known to have imparted to Bacon was sympathetically as well as helpfully conveyed. Although there is no proof that Bacon was aware of it, Bloch had painted from photographs in Berlin in the late 1920s,[7] while de Maistre, who was obsessed by his supposed royal ancestry, frequently painted members of the Royal Family from newspaper photographs. His painting *The Procession*, for example, was squared-up from a photograph of the Duke and Duchess of Kent leaving their home in Belgrave Square, published in *The Star* in 1937.[8] De Maistre was also trying to find finance for a film at this time, in which he planned to combine a ballet he had written and designed with his experiments in colour and sound. Nothing came of the project, but it can be imagined that he would have discussed his ideas with Bacon.

There is a tendency to regard photographs, convenient substitutes for preliminary drawings, as having been fundamental to Bacon's working process throughout his career, but their relevance to his art in the 1930s has not been substantiated; it is possible he used photographs only twice before 1945, and one of these occasions he did not instigate. Sir Michael Sadler had purchased Bacon's *Crucifixion* (1933) by telegram on the strength of the reproduction in *Art Now*, and followed up by commissioning Bacon to paint his portrait, sending an X-ray of his skull as the model. Despite the somewhat perfunctory integration of the skull, *The Crucifixion* (1933) that resulted is a compelling painting. Vivid in colour and the most *malerisch* of his surviving work from this period, it appears to have been an early essay in painting *alla prima*. The Golgotha allusion of the skull is an intriguing one for an avowed atheist, and if Bacon combined it with a pre-existing Crucifixion it was plausibly at the suggestion of Roy de Maistre. The palette of *The Crucifixion* may reflect the softened Fauvist range of de Maistre's colour and music combinations, or to the 'Colour-Wheel' he invented in Australia and attempted to re-patent in England in 1930.[9] In London, de Maistre was associated with Dmitrije Mitrinovic, who as a student in Munich in 1913 had been close to

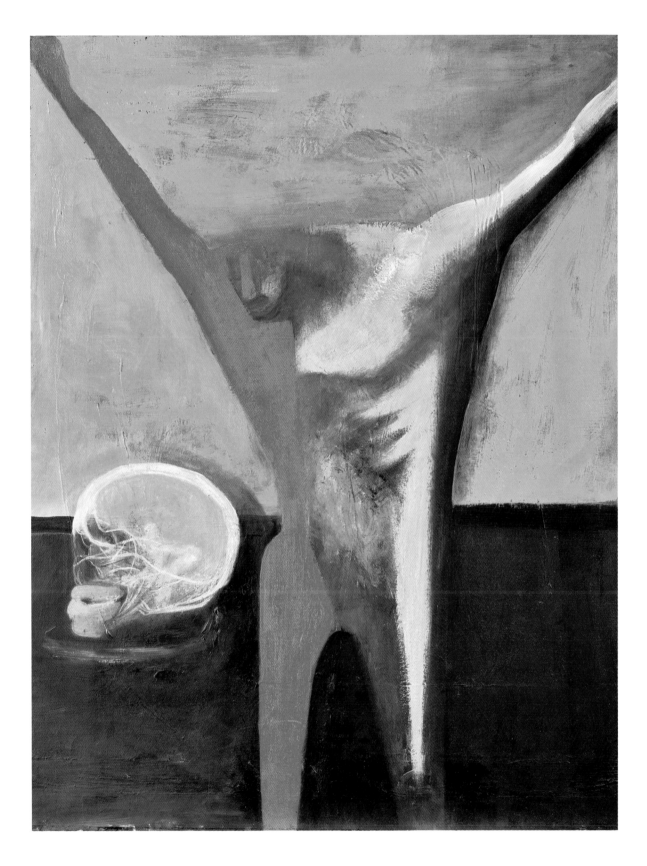

28 *The Crucifixion* (1933)

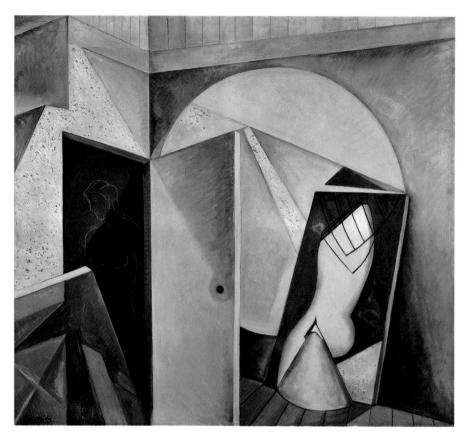

29 Roy de Maistre, *New Atlantis* (*c.*1933)

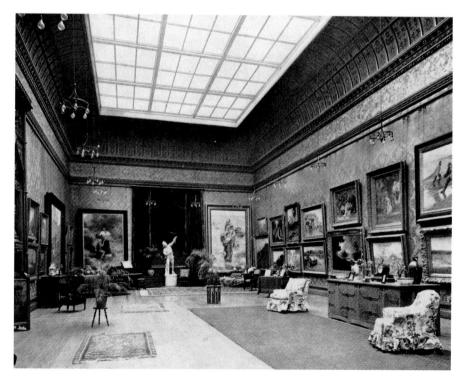

30 The Mitchells' Picture Gallery, Jesmond Towers, Northumberland, *c.*1900

Kandinsky and Klee in a grouping dedicated to connecting art with both the spiritual and a new social order. Mitrinovic was responsible for several 'New Age' journals in the 1930s, in two of which, *New Atlantis* and *New Britain*, he reproduced a painting by de Maistre of a corner of Bacon's studio that shows several (since destroyed) semi-abstract paintings.

An important factor in the friendship between Bacon and de Maistre was clearly their shared ardent Francophilia. Furthermore, Bacon, in addition to his relish for France's social and epicurean pleasures, positioned himself in relation to Degas, Seurat, Bonnard and Cézanne as much as, if not more than, the painters of the Renaissance or Grand Manner – and though neither Van Gogh, Soutine nor Picasso was a native of France, their groundbreaking paintings were made there. Even late in life Bacon remained 'almost the only important artist of his generation anywhere who behaved as if Paris were still the centre of the art world'.[10] His affiliations with Continental European art have been discussed extensively in recent literature but, while this follows the orientation Bacon himself promoted, it fails to take into account the British context from which he emerged, which was equally significant in moulding his outlook, not only in his formative years but throughout his career.

Bacon was born in the last months of the reign of King Edward VII. His ancestry was aristocratic and military on his father's side and industrial wealth on his mother's – old and new money. While he partly reinvented himself as a bohemian, he retained many of the attitudes as well as the demeanour of an Edwardian aristocrat: even in his eighties it was difficult to predict whether he would attend a function wearing a leather coat or a hand-tailored Savile Row suit. He played down his familial cultural background, but at Jesmond Towers, Northumberland, where he stayed with his great-aunt Eliza Mitchell during and after World War I, he was exposed to a panoply of nineteenth-century English and French art in the large top-lit picture gallery the Mitchells had added to their Gothic mansion in the 1880s. There were paintings by his late great-uncle, Charles W. Mitchell, whose *Hypatia* (1885), based on Charles Kingsley's novel, caused a minor sensation with its nude depiction of the eponymous heroine at bay from a Christian mob,[11] and if not of uniformly high merit the collection included works by Etty and Leighton. It may have reflected an outmoded taste, but the image of opulently gilt-framed and glazed paintings stacked on tall brocaded walls was likely to have imprinted itself on Bacon's memory. It was reflected in the stately presentation of his own paintings, an astute strategy – in contrast to the unglazed framings of most contemporary art, in simple, unprofiled, painted wood mouldings – that located them in a continuum with the Old Masters, a tradition Bacon simultaneously subverted.

In the 1930s the property developer and interior designer Arundell Clarke was active in the Mayfair district of London, where he specialized in the refurbishment and modernization of Victorian and Edwardian dwellings. In the period of Bacon's transition

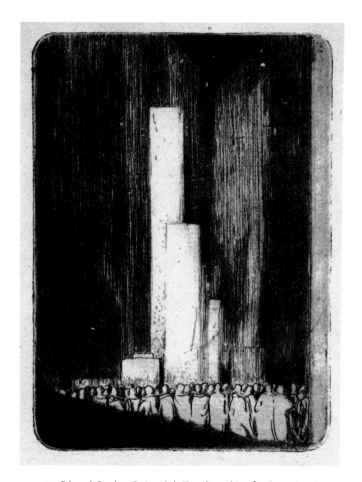

31 Arundell Clarke furniture catalogue, *c*.1935, front cover

32 Edward Gordon Craig, *Little Temple*, etching for *Scene* (1911)

Sparse, dramatically lit spaces were popular in interior and set design among Bacon's friends and contemporaries, including Clarke and Craig, at the time of Bacon's transition from design to painting. In his paintings of the late 1940s and onwards, the geometry of Bacon's settings for his figures, though seldom as taut or as monumental, continued to carry echoes of this modernist vogue.

from designer to painter, his friendship with Clarke was probably of greater significance than is at present understood. It was Clarke, for example, who owned Sunderland House on Curzon Street, the basement of which Bacon temporarily transformed into the Transition Gallery to stage an exhibition of his paintings in 1934. Less innovative than his sometime associates Denham Maclaren and Gerald Lacoste, Arundell Clarke was vying with Ronald Fleming and Syrie Maugham for the patronage of the cocktail party set, stripping their apartments of Victorian detailing and simplifying their lines. Their sparsely decorated all-white interiors incorporated chic soft furnishings and diffused lighting through tall windows.

The hybrid of thirties' Neo-Classicism with imperialist undertones and 'International Modern' in these lofty elevations recalls the epic, Piranesi-inflected paintings of James Pryde and the soaring Edwardian theatre sets of Edward Gordon Craig. Pryde and Craig were friends and, like Walter Richard Sickert, had been on the stage. The theatrical element in their work foreshadows Bacon's stagings of bodies on podiums, his artificially isolated domains of human interaction. In Pryde's *magnum opus*, *The Human Comedy*, a suite of twelve paintings begun in 1909, an allegory of life and death is played out on a vast fourposter bed. The series has been compared with Bacon's 'traumatic spaces' and 'bed iconography',[12] but where Pryde's vertiginous perspectives induce awe, from his less dramatic viewpoint Bacon directs our gaze onto an enclosed and – irrespective of the psychological distance – more intimate space. In the harrowing depiction of existential isolation, however, Pryde, as David Mellor observed, anticipated one of Bacon's central themes.[13]

In the 1890s Pryde followed Whistler, Sargent and Lavery in the vanguard of a renewed popularity in Britain of Spanish painting, marked by Robert A. M. Stevenson's perceptive study *Velázquez* (1895) and by the exhibition of Spanish art at the New Gallery in 1896. Bacon's alignment with Picasso could be said to have converged with an inherited Edwardian taste for Velázquez. Sam Hunter referred to Bacon's 'neo-Edwardian sense of luxury'[14] and Bryan Robertson commented that 'he touches a special nerve in modern sensibility but essentially he is a late Edwardian'.[15] John Rothenstein attended an exhibition opening in 1957 at which another neo-Edwardian taste of Bacon's was manifested, by 'the teddy-boys with exotic haircuts and leather jackets (many of them very drunk), who mysteriously arrive at…any quasi-public function of which Francis is the occasion'.[16] In life as in art, he deftly crossed cultural as well as temporal boundaries.

Iconography
Bacon said the discouraging reaction to his 1934 exhibition at the Transition Gallery was instrumental in his virtual abandonment of painting in 1937, but the dilemma posed by Picasso, whose example he knew he had to transcend, probably exacerbated his crisis of

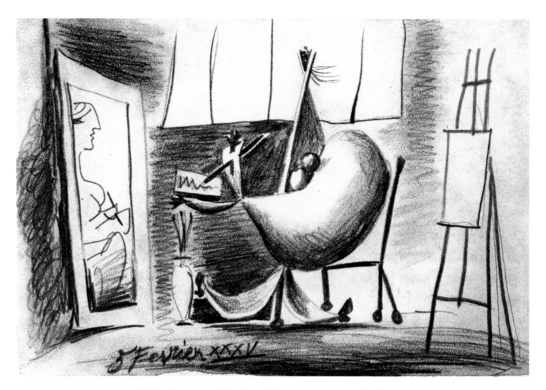

33 Pablo Picasso, study for *Jeune fille dessinant dans un intérieur* (1935)

confidence. The success with which he rose to the challenge fluctuated. He seemed to have established a certain distance between himself and Picasso with *Crucifixion* (1933), but the principal compositional elements of *Studio Interior* – the easel, pedestal and 'web-footed' biomorph – all lean on Picasso's studies for *Jeune fille dessinant dans un intérieur* (1935), published in a special edition of *Cahiers d'Art* in 1936, 'Pablo Picasso 1930–1935'.[17] Ronald Alley's date of *c.*1934 has been widely accepted for Bacon's small pastel, but since it can hardly have evolved independently of Picasso's drawings, an adjustment to *c.*1936 is proposed here. The positioning of a form on a pedestal foreshadows, as Alley noted, the displaying of the *Three Studies for Figures at the Base of a Crucifixion* (1944; pl. 36).[18] It is paradoxical, therefore, that the near contemporaneous *Figures in a Garden* (1936; pl. 35) demonstrates a considerable advance in the escape from Picasso's biomorphs.

 Figures in a Garden, which was bought by Bacon's second cousin Diana Watson from 'Young British Painters' at Thomas Agnew & Sons, London, in January 1937, was also known as *The Fox and the Grapes*, and was resold under this title at Sotheby's in 1952. It appears to have been a response to *The Fox* (*c.*1934–35), one of Roy de Maistre's most Matisse-like paintings, which represents, notwithstanding its imprecise title, Aesop's fable *The Fox and the Mask*.[19] Bacon conflated this and another fable, *The Fox and the Grapes*, turning the eponymous russet beast with its tentatively upraised paw through 90 degrees in relation to de Maistre's depiction. De Maistre's choice of subject probably stemmed from the amateur theatricals in

34 *Studio Interior* (c. 1936)

which he had taken part at Compiègne. Aesop's moral, that there is nothing to fear but fear itself, had a timely relevance for the young Bacon, while the unveiling of the 'sour' grapes and 'brainless' mask would no doubt have appealed to his sardonic streak.

When Ronald Alley and Sir John Rothenstein were compiling the entry for *Figures in a Garden* in the Bacon catalogue raisonné of 1964, Bacon evidently deemed it prudent to mention that he 'did not intend it to have an illustrative content',[20] thereby drawing attention to an overriding factor in the suppression of his early work. No doubt the indeterminacy of the central figure partly stemmed from the impulse to depart from the prescribed narrative. Bacon incorporated shadowy, approximately canine forms, in several of his later paintings, entering at the bottom of the frame. A dog situated at the base of the picture field is archetypal in medieval and later depictions of *The Annunciation to the Shepherds*, a precedent in religious art that is unlikely to have occurred to Bacon but may have to de Maistre, whose exploration of Christian subjects had begun by 1930. Clearly Bacon received more than just technical advice from de Maistre, for between 1931 and 1936 their subject matter was closely interdependent. 'Young British Painters' included three paintings by de Maistre and was the first occasion on which Bacon co-exhibited with Graham Sutherland, Ivon Hitchens, Robert Medley, Victor Pasmore, John Piper, Ceri Richards and Julian Trevelyan. In this context it is probably not insignificant that the pastoral palette and rich vegetation of *Figures in a Garden* was the closest Bacon came to nascent English Neo-Romanticism.

The exhibition was organized by Eric Hall, a friend of Jerry Agnew. Hall was Bacon's lover in the 1930s and 1940s and a major influence in his life. He was thirteen years Bacon's senior: if Bacon's avowed sexual desire for his father was subsumed into his complex feelings for Hall, their relationship completed the unconventional support system of parental surrogates he had initiated when his former nanny, Jessie Lightfoot, came to live with him in about 1929. Hall was wealthy, cultivated and a pillar of society, and although he tried to maintain a respectable front the affair harmed his marriage and social position. He supported and educated Bacon, who said 'he was an intelligent man and had a lot of sensibility. I mean he taught me the value of things'.[21] Together with Robert Wellington, Hall planned to launch a gallery for 'contemporary painters and sculptors' which they hoped would attract buyers for the work of young artists (and sponsors to guarantee them a minimum income), but in the event 'Young British Painters' was the only concrete outcome of their scheme.

In the context of the unstable distinctions between Surrealism and Neo-Romanticism in the late 1930s, *Figures in a Garden* could have been defined as Surrealist. If the painting Bacon submitted to the 1936 International Surrealist Exhibition was similar to *Figures in a Garden*, its refusal by Herbert Read and Roland Penrose as 'insufficiently surreal', given the latitude of their selection criteria, is puzzling. Although Bacon expressed interest in the writings of André Breton and his circle, and admitted that Surrealist painting had informed his earliest work, he understated his engagement with Surrealism as 'slightly complicated'.[22] His art remained in a dialogue with Surrealism, as it did with Analytical Cubism, Picasso's biomorphs or photography. His persistent invoking of 'chance' and 'involuntary marks', for example, was a legacy of Surrealist Automatism. While a problematical concept, Automatism was an article of faith for many artists in the 1930s. In his first book, *Picasso: Master of the Phantom*, published in 1939, Robert Melville (who ten years later wrote the first substantial article on Bacon) noted with approbation Herbert Read's suggestion that Picasso 'does not know in advance what he is going to put on the canvas', but 'allows his sensibilities a free rein, paints in a trance'.[23] Julian Trevelyan, one of many British artists to experiment briefly with Surrealism in the 1930s, testified to its 'enrichment of my visual world' and the 'poetic release of spirit' it had brought 'many English painters, not least Sutherland and Bacon'.[24] But if Bacon was inclined to pursue either Neo-Romanticism or Surrealism, it became irrelevant when, shortly after the Agnew exhibition, he virtually ceased to paint. Today a maximum of three works exist from the period between 1937 and 1943.[25] It is as though he withdrew to consider the implications of his rejections, lack of sales, and the challenge to Picasso. Having tentatively found his own voice with *Figures in a Garden* he had retreated. His public re-emergence in 1945 was to be both surprising and shocking.

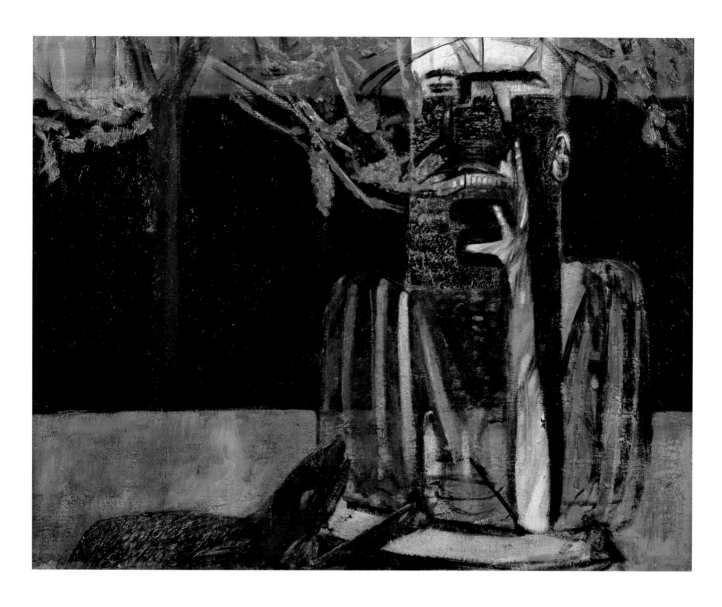

35 *Figures in a Garden* (1936)

36 *Three Studies for Figures at the Base of a Crucifixion* (1944)

Breakthrough

As Bacon's relationship with Eric Hall entered what was probably a relatively stable phase, they devoted the immediate pre-war years to travelling and to gambling. Instead of painting, Bacon remarked pointedly, 'I enjoyed myself.'[26] It coincided with a lessening of Bacon's intimacy with, and the end of his artistic reliance on, Roy de Maistre, although they kept in touch until de Maistre's death in 1968. Whether or not their relationship was ever physical, de Maistre was clearly enamoured of Bacon, who was fifteen years younger than him. He made several affectionate portraits of Bacon and at least ten paintings of his studios. In about 1937 Bacon left his studio in Royal Hospital Road (near to de Maistre's temporary studio in Ebury Street) and moved to a flat Hall had taken on the top floor of 1 Glebe Place, Chelsea. From 1941 he and Hall switched between London and a cottage, Bedales Lodge, Steep, near Petersfield, Sussex. The long hiatus, punctuated only intermittently by work, is represented now by just two unfinished paintings, usually assigned to '1941–42?'[27] This dating was predicated on the inscription 'F. Bacon/Petersfield' on the reverse of *Man in a Cap*, and the fact that both it and *Seated Man/Man Standing* (painted recto and verso) were executed in oils on composition board. But Bacon was still staying at Steep in 1943, which in certain

respects is a more convincing date for these works. Owing to his tendency at this point in his career, though not subsequently, to leave canvases unfinished and return to them later, precise dating is, on the basis of current knowledge, impracticable.

Among the few paintings that Bacon allowed to leave his studio in the 1930s, a few were sold to private collectors. He was anxious whenever they resurfaced, and sought to have them destroyed. He was adamant that *Three Studies for Figures at the Base of a Crucifixion* (1944) should be considered his first painting, and remained steadfastly attached to it, and to *Painting 1946*. *Three Studies for Figures at the Base of a Crucifixion* reprised several themes Bacon had begun, and then abandoned, in 1936. Considering the faltering start to his career, it was a work of surpassing confidence and authority. But when this masterpiece of dissonance was first exhibited at the Lefevre Gallery, London, in April 1945, viewers were overwhelmed and uncomprehending, and dismissed it as 'virulent' and 'gloomily phallic'.[28] John Russell recalled the 'total consternation' caused by these 'freaks, monsters'.[29] In the month of the painting's public debut Lee Miller entered the concentration camp at Dachau, and the shattering photographs she sent back of Holocaust victims reinforced the association of Bacon's images with an event of real human degradation, as though he had foretold an

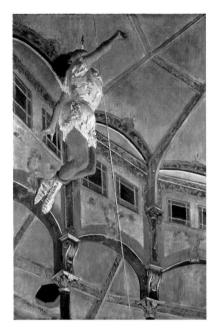

37 Edgar Degas,
Miss La La at the Cirque Fernando (1879)

38 ?Edgar Degas: partly solarized gelatin dry plate
negative of a dancer, *c.*1895–96

FIG. 64. AUTHOR'S FIRST FLASHLIGHT PHOTOGRAPH, 7 JANUARY, 1912.

39 'Author's first flashlight photograph, 7 January, 1912', Eva Carrière,
Fig. 64 from Baron von Schrenck Notzing, *Phenomena of Materialisation*, 1920

atrocity. But Bacon's painting was neither prophecy nor protest. It depicted the Eumenides, 'wingless, black, utterly loathsome'. He had acquired a copy of W. B. Stanford's *Aeschylus in his Style* soon after its publication in 1942, and Aeschylus's *The Oresteian Trilogy* suggested more pictures to him than any other text. Like most Greek tragedy, Aeschylus's play devolves around family conflicts, a thematic with which Bacon, who demonized his parents, strongly identified. But art was not, for him, a vehicle for sublimation. He painted the Eumenides in *Three Studies for Figures at the Base of a Crucifixion* as synonyms for vengeance.

The *Three Studies* are painted in oils and pastels on Sundeala fibre board. It was not until 1948 that Bacon started to use the reverse, unprimed side of the canvas, which facilitated the evolution from mixed media to a more fluid and vigorous painterliness. Although the paint surface is quite dry, and at first sight or in reproduction appears rather even in texture, on closer scrutiny it is applied with skill, intensity and conviction (the greenish-brown modulations visible today probably result from show-through of a vermilion underlayer).[30] The cadmium orange ground is a lyrical counterpoint to the deathly greys of the tautly writhing Eumenides, and in the left-hand panel is subtly disharmonious with the pinks and mauves of the lower parts of the enervated Fury. Bacon's palette in this panel reveals one of the triptych's inspirations – the narrowed colour range of Degas's *La Coiffure* (*c*.1896; pl. 40), which had been purchased by the National Gallery, London, in 1937. Latterly Degas's main subject was people in rooms, and this in turn became Bacon's subject. The charcoal black contours of Degas's figures may also have suggested Bacon's black perspective lines, which on the right-hand panel follow a reserve of 'raw' fibre board. Parts of the unresolved legs of the 'tripod' in the centre panel are also delineated on an area of uncovered support, anticipating the passages of unpainted canvas in his later paintings.

Degas had employed an orange-dominated palette before, notably in another painting in the National Gallery, *Miss La La at the Cirque Fernando* (1879), but *La Coiffure* dates from a period when Degas was taking his own photographs. Three gelatin negatives of semi-solarized images of ballet dancers remained in Degas's studio at his death, and have become the subject of controversy concerning his authorship; but irrespective of whether he was the photographer, *La Coiffure* closely replicates the vivid orange-red hues of the partly solarized glass plates. Thus Bacon's 'first' painting appears to have been informed, albeit circuitously, by the great Impressionist's experiencing of photography. The head of Bacon's Eumenides in the left-hand panel was definitely based on a photograph. It is a direct quotation from Fig. 66 in *Phenomena of Materialisation*, a blown-up segment of a photograph taken in 1912 by Baron von Schrenck Notzing at a séance in Paris, during which the celebrated medium Eva Carrière manifested the ectoplasmic 'La Petite Estelle' on her shoulder. Carrière was hypnotized by

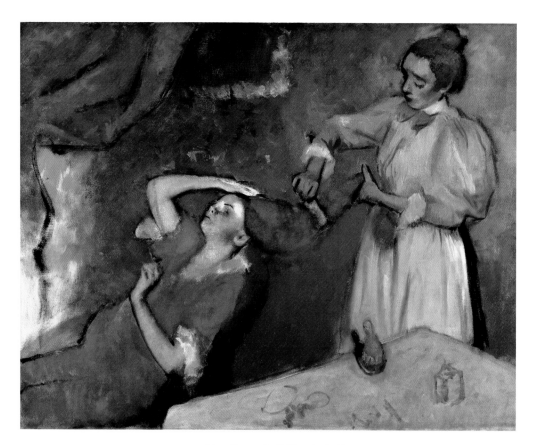

40 Edgar Degas, *La Coiffure* (*c.*1896)

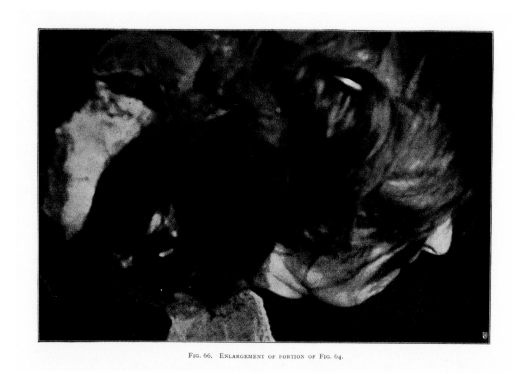

FIG. 66. ENLARGEMENT OF PORTION OF FIG. 64.

41 'Enlargement of portion of Fig. 64', Eva Carrière, Fig. 66 from Baron von Schrenck Notzing,
Phenomena of Materialisation, 1920

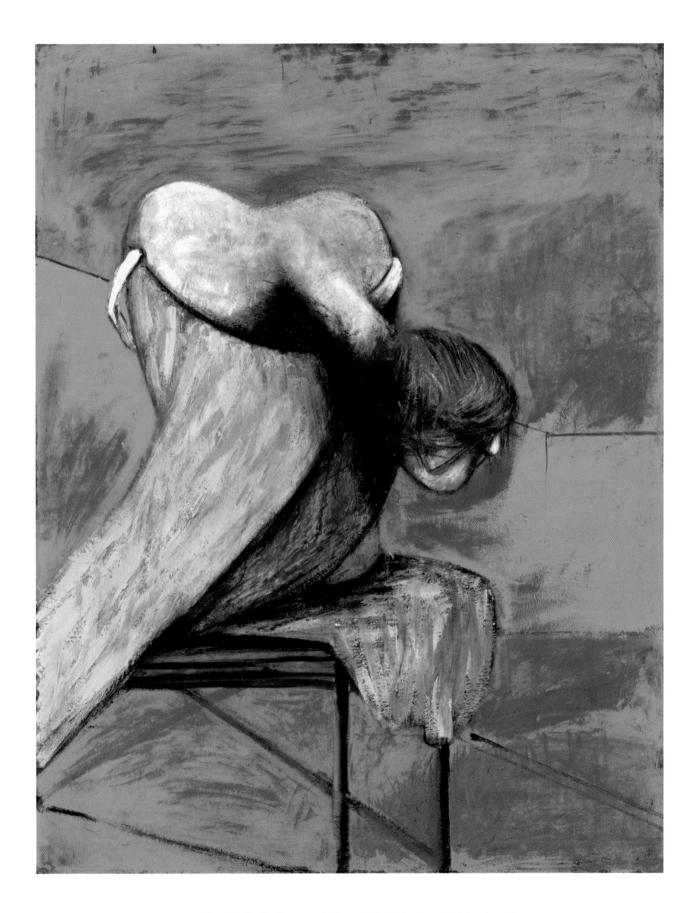

42 *Three Studies for Figures at the Base of a Crucifixion* (1944), left-hand panel

Juliette Bisson, whose house she had shared since 1910 in a relationship which Notzing likened to 'that of a faithful dog to its master'[!][31] Six years earlier, under her real name of Marthe Bertaud, Carrière had been exposed as a fraud in Algiers. Carrière's unkempt hairstyle, faithfully transposed by Bacon, reminded one commentator of 'a female jailbird'.[32]

As well as a rebirth, *Three Studies for Figures at the Base of a Crucifixion* signalled Bacon's valediction – although they re-emerged, altered, in the 1960s – to Picasso's biomorphs, of which there is no trace in Bacon's next major painting, *Figure in a Landscape* (1945). The snapshot of Eric Hall dozing in a chair in Hyde Park that instigated the seated and menacingly obscured man in *Figure in a Landscape* was possibly only the third occasion on which a photograph was a decisive factor in the genesis of a Bacon painting. Whether the photograph functioned as a serviceable likeness of Hall (unfortunately it is not known to survive), it may have embodied a characteristic – under-exposure for example – that was a catalyst for the disquieting direction the painting took. Hall is partly erased, stripped of his identity and subsumed into a complex composition that is in sharp contrast to the formal simplicity of *Three Studies for Figures at the Base of a Crucifixion*. The idyllic pale blue sky, studded with lyrical if perfunctory white clouds, is in startling disjunction with the desolate park landscape, the bloodied mouth and the ominous machine gun. Hall was metaphorically decapitated under the shadow of the umbrella. Over the next twelve months Bacon made at least four further paintings in which a cipher – a hat or an umbrella – supplanted the human head. But he destroyed most of his work at this time, including three paintings he had begun in Monte Carlo in 1946 after Velázquez's portrait of *Pope Innocent X*, and only four paintings survive from the period between *Three Studies for Figures at the Base of a Crucifixion* (1944) and *Head I* (1948). His work pattern steadied, however, and the rate of destruction lessened, after he returned from Monte Carlo in 1948 to prepare for his first one-man show at the Hanover Gallery, London.[33] He had found his 'real subject'[34] – the human body projected through his nervous system – and advanced rapidly both in the realization of his ideas and the handling of paint.

Synapse

Bacon was an atheist, and stoutly resisted all attempts to identify religious meanings in his work. Yet, as we have seen, his first substantial public recognition hinged on the publication in Herbert Read's *Art Now* of *Crucifixion* (1933). Although Roy de Maistre did not convert to Roman Catholicism until 1951, he was painting devotional subjects when he was close to Bacon in the 1930s: he began a series of Stations of the Cross in 1930 and painted a Crucifixion in 1932, a year before Bacon's first painting of the subject. But if de Maistre gave the lead, the chasm in intention can be clearly demonstrated by comparing his devout *Crucifixion* (1961) for the Roman Catholic church at Hayes, Middlesex, with Bacon's *Three*

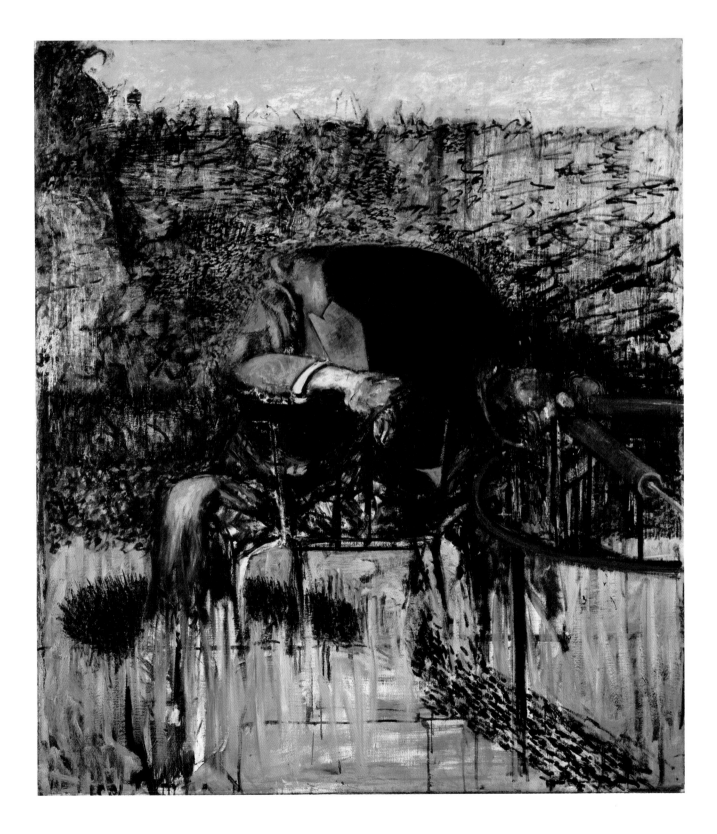

43 *Figure in a Landscape* (1945)

Studies for a Crucifixion (1962; pl. 167).[35] The appropriation of Christian archetypes is not, then, inconsistent with Bacon's atheism. His interventions into conventional formats and iconographies acknowledge the power of art-historical precedent but are equally tenable as provocations – 'laughter at the apocalypse'.[36] His high regard for a work already sanctioned for reinterpretation by Picasso, Matthias Grünewald's Isenheim altarpiece (1515), was predicated on Christ's graphically depicted wounds, but he sidestepped the biblical relevance of the wounds, registering them instead as a metaphor for eternal human suffering.

Although Bacon was generally uninterested in Northern Renaissance art, he based the bandaged head of the Eumenides in the central panel of *Three Studies for Figures at the Base of a Crucifixion* on Christ's blindfold in Grünewald's *Mocking of Christ* (1503), and there are Baconian parallels in the enclosed space and flame-orange dossal of Rogier van der Weyden's *Crucifixion* diptych (*c.* 1465); the catalogue of a Munich exhibition, *Albrecht Altdorfer und Sein Kreis* (1938), a copy of which Bacon owned, includes an illustration of the *Mocking of Christ* by Jorg Breu the Elder, a scene enacted in a room with three blind windows in the rear wall.[37] Bacon's Popes on their golden thrones are analogous, in formal terms, to altarpieces of the enthroned Madonna and Child, placed at the focal point of churches and cathedrals. The deep, curved space of the eastwards apse is reflected in the 'apsidal' room setting of *Painting 1946*, in which the umbrella shading the menacing 'prelate' translates into a secular paraphrase of a baldacchino.

The indefinite article in the title *Three Studies for Figures at the Base of a Crucifixion* is another indication of Bacon's unbelief, which was further clarified in the substitution of Roman centurions, or Mary and John, by the Eumenides. In the Bible, after the Crucifixion the soldiers at the foot of the cross cast lots for Christ's clothes (their dice are Instruments of the Passion), a posthumous humiliation that introduces an emphatically Baconian activity, gambling, into the Crucifixion scene. But although he recognized 'how very potent some of the images of Christianity have been',[38] Bacon's secularization of sacred themes was not a tacit affirmation of the enduring relevance of their moral or ethical precepts but a means of tapping into and twisting their emotional charge. A crucifixion was, in his words, 'a magnificent armature on which you can hang all types of feeling and sensation'.[39] His antipathy to religious convention was manifested frequently: at dinner with W. H. Auden and Robert Medley in 1953 he suddenly leapt from the table in a fury and turned on the 'monster' Auden, declaring, 'Never before have I had to submit to such a disgusting display of hypocritical *Christian* morality!'[40] While he was capable of dissembling and obfuscation, there is no reason to doubt the sincerity of Bacon's atheism. Yet there is a tendency to skew his statements, to create an anodyne. His admiration for Buñuel and Dalí's *L'Age d'or* (1930), for example, is habitually understood in the context of the film's shocking, Surrealist visuals

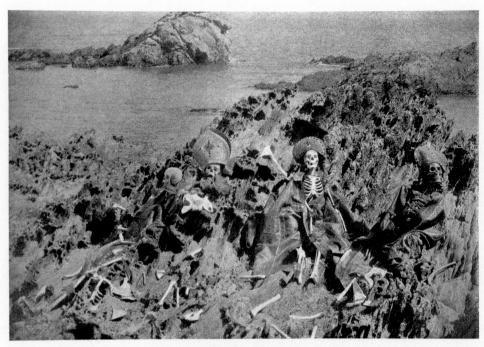

259. L'AGE D'OR. BUNUEL. 1930.

44 Still from *L'Age d'or* (Buñuel and Dalí, 1930), plate from Nicole Vedrès, *Images du cinéma français*, 1945. Bacon owned a copy of this book, and plates torn out from it were found in his studio after his death

but Buñuel was also an atheist: Bacon was raised under Church of Ireland conventions and had to attend regular services, Buñuel was educated by Jesuits. Bacon seldom found images compelling solely for their aesthetic qualities. He did not quote from *L'Age d'or* in his paintings, but its violent anti-clericalism, conveyed in astringent images such as the skeletal bishops cast upon the rocks, would have resonated with him at a philosophical level.

Graham Sutherland was also a formative influence on Bacon, albeit with his secular works rather than his religious paintings. His *Red Tree* (1936) and Bacon's *Figures in a Garden* (1936) were exhibited together in 'Young British Painters' in 1937, and both the morphology and the colour of *Red Tree* are residually present in Bacon's work up to 1946. The graphic shorthand Bacon employed in *Figure in a Landscape* (1945) to delineate the vegetation is similar to the hatched, flicked and scribbled pen lines in Sutherland's Welsh landscapes. Bacon would have seen the letter from Sutherland to his patron Colin Anderson, published as 'Welsh Sketch Book' in *Horizon*, April 1942, which described his emotional and intellectual response to the 'exultant strangeness' of the wild Pembrokeshire landscape, its earth's 'enveloping quality', that created 'a mysterious space-limit – a womb-like enclosure – which gives the human form an extraordinary focus and significance'.[41] Between 1943 and 1946, when there was an important and reciprocal interaction between the artists, it is difficult to assign precedence in their work. Bacon claimed to dislike Sutherland's spiky plant forms, although he borrowed his distinctive palm leaves, and he probably responded to the semi-

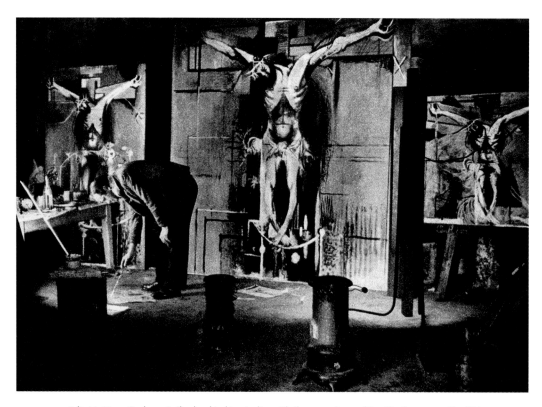

45 Felix H. Man: Graham Sutherland in his studio, with three versions of the Northampton *Crucifixion*, published in *Picture Post*, 21 December 1946

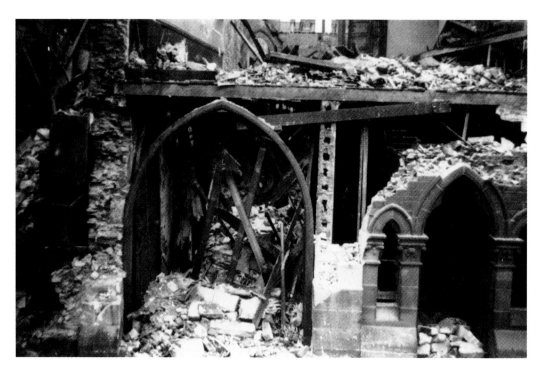

46 Graham Sutherland: bombed Masonic Hall, Swansea (*c.* 1940). Sutherland almost certainly took this photograph himself (it does not have the usual Ministry of Information stamp on the reverse). The devastation of Swansea in the Blitz of 1940–41 gave Sutherland his 'first sight of the possibilities of destruction as a subject'

human allusions in works such as *Green Tree Form* (1939). The stooping form of Bacon's wittily sinister disembodied coat in *Figure Study I* may have been indebted to Sutherland's *Woman Picking Vegetables* (1945), although the sculptural solidity of the leaning torso of *Figure Study II* (1945–46) has been convincingly compared by Grey Gowrie with 'the poise of a Giotto figure'[42] (it specifically resembles those in the *Lamentation over the Dead Christ*, *c*.1305, in the Arena Chapel, Padua).

Bacon's *Painting 1946* (pl. 47) was contemporaneous with Sutherland's first important work of religious art, the large *Crucifixion* commissioned by the Revd. Walter Hussey for St Matthew's Church, Northampton, England. The two paintings have several common elements – the raising of the figure on a dais, the geometrical subdivision of the background – and Bacon's sides of meat mimic a 'crucifixion' posture. But Bacon did not see Sutherland's painting until after it was reproduced in *Picture Post* in December 1946, and it would in any case have been uncharacteristic of him to remain for long in a subordinate position to anyone. Sutherland was the sole British artist whom Bacon had respected, and he had absorbed from his dry surfaces, unorthodox colour range and lexicon of organic forms. *Painting 1946* signalled the end of his residual Neo-Romanticism – and a reversal of the artists' roles. Bacon symbolically underlined this when, from Monte Carlo, he wrote to Sutherland asking him to apply fixative to patches of unstable pastel colour on *Painting 1946* before it was shipped to New York (it had been bought in 1948 by Alfred Barr of the Museum of Modern Art, New York – the first museum purchase of a Bacon painting). Sutherland could be forgiven if he found this call on their friendship impertinent. Yet Sutherland's drawing, *Reclining Figure* (1946), was essentially a copy of the left-hand Eumenides in *Three Studies for Figures at the Base of a Crucifixion*. It seems to acknowledge the younger artist's dominance, and this perception became widespread. The artist and critic Patrick Heron complained that Sutherland's 'silvery greys and dead olives…do not vibrate – as Bacon's vibrate – with the resonance, depth and harmony of good colour',[43] and while more cautious about Bacon's influence Douglas Cooper, collector, critic and author of a Sutherland monograph, thought 'it is at any rate probable that Sutherland was receptive to some of his ideas'.[44]

In 1940 Sutherland was appointed an official war artist by the War Artists Advisory Committee, chaired by Sir Kenneth Clark, and the drawings he produced under the aegis of the committee were those Bacon said he most admired. Sutherland augmented rapid *in situ* sketches of bomb-damaged buildings with photographs, taken both by himself and by the Ministry of Information. While Sutherland may not have wished to advertise this practice, Bacon is likely to have been aware of it and to have noted it as a further example of an artist using photographs as preliminary studies. The photojournalist Felix H. Man became acquainted with Sutherland on the *Picture Post* sitting in 1946, and subsequently took

photographs as guides for several of his portraits. But it may have been Bacon's example that persuaded Sutherland to base the atypical *Laughing Woman* (1946) on a newspaper photograph. Like Bacon he was only gradually evolving into a painter of the human body, and was probably receptive to experimenting with unusual models. Sutherland must have been impressed by Bacon's transition from a linear to a painterly style, and by the distance Bacon had put between himself and Picasso. It was ironic, therefore, that a factor in the monumental scale of *Painting 1946* (at two metres high it was easily Bacon's largest painting up to that date) may have been the *Picasso-Matisse* exhibition at the Victoria & Albert Museum, London, in December 1945, in which the epic proportions of Picasso's paintings astounded a British public unfamiliar with his work since the exhibiting of *Guernica* in 1938.

One of Bacon's more impenetrable works, *Painting 1946* has defied all attempts at interpretation. It resembles an unholy *Trinity*, in which the son usurps the father. Bacon called it his 'butcher's shop picture', which connects it with the slaughterhouse reference in *Crucifixion* (1933). Within its confined spatial matrix the umbrella, the haunting figure, carcasses, swags and microphones had evolved, according to Bacon, from a painting of a chimpanzee in long grass that mutated into a bird of prey landing in a field. He said its ultimate form emerged completely by chance, and more than forty years later he continued to cite this painting to exemplify the crucial rôle that accident played in his work. Yet he had employed the umbrella motif – a staple of Surrealist phallic symbolism – twice within the previous year, in *Figure in a Landscape* (1945) and in *Figure Study II* (1945–46); *Study for Man with Microphones* (1946), a painting he reworked about 1947–48 (and later partly destroyed), was probably a rehearsal for – rather than a recapitulation of – both the man and the umbrella.[45] Nevertheless the notion of the accidental was the most persistent of Bacon's precepts and, despite having resurrected the umbrella in *Second Version of 'Painting 1946'* in 1971, he maintained he had not foreseen it in painting *Triptych 1974–77*. The open umbrella in *Painting 1946* could have originated less fortuitously at the painting's second evolutionary stage by referencing the umbrella bird. Bacon was fascinated by exotic avifauna and collected books and reproductions of bird life, and the umbrella birds of Central America are named for their black, umbrella-like crests, raised during courtship display.

The only photographic sources for *Painting 1946* identified so far relate to specific details. The swags were suggested by the decoration on a canopy above Hitler speaking at a rally and the head may have been based on a photograph of Mussolini – although the overall conception also has affinities with numerous photographs of Hollywood film crews of the 1920s, in which an umbrella to shield the camera was a standard item of equipment. Yet before 1949, it is probable that Bacon made only intermittent use of photographs. With his reintroduction to Muybridge that was about to change.

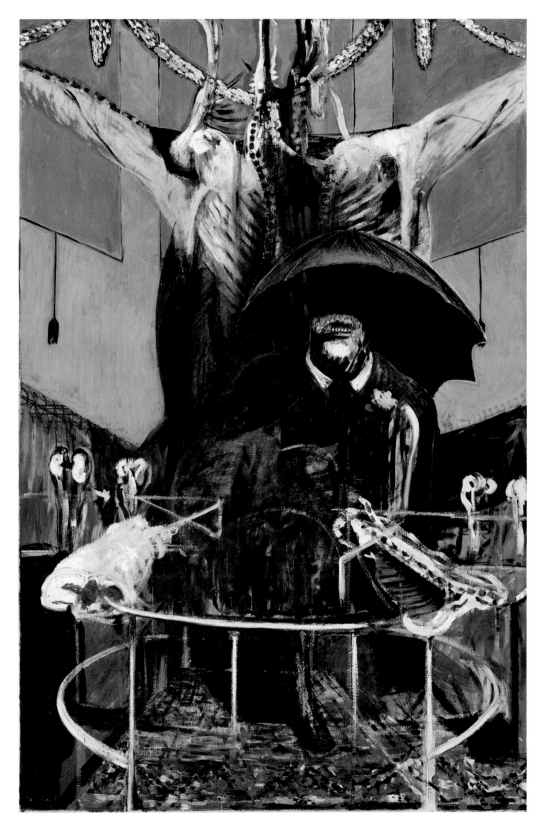

47 *Painting 1946*
The spatial disposition and low viewpoint of *Painting 1946* have affinities with Masaccio's fresco of the
Trinity (*c.*1424–28, Santa Maria Novella, Florence), a masterpiece by a Renaissance artist Bacon greatly admired

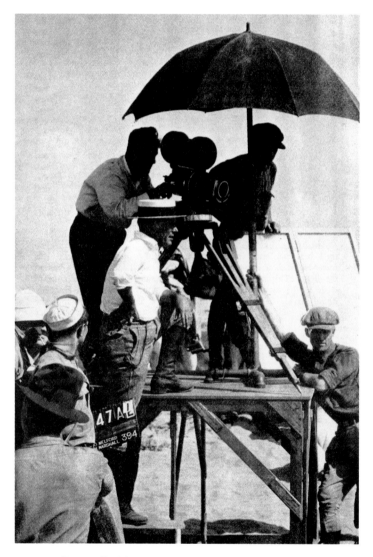

48 William Melford directing *The Sheik*, 1921 (photographer unknown)

Umbrellas were a common sight on film sets in the 1920s, used to shield the camera from sunlight (*above*). Bacon used the umbrella motif in *Painting 1946* (pl. 47) in combination with the device of a raised figure on a podium (see opposite for a later example found in Bacon's studio).

SOME PHASES IN A WRESTLING MATCH.
See Series 40.

MICHELANGELO AND MUYBRIDGE

Painting and photography have coexisted in an uneasy symbiosis since Niépce fixed an image from nature in 1825. By then the physics and mechanics of photography had been exploited as a drawing aid for two centuries in the form of the portable *camera obscura*, a circumstance that framed the agenda for photography's reception as a means of recording correct perspective. Niépce's photo-chemistry was perfected by Daguerre, who went public with the invention in 1839, causing the painter Paul Delaroche to declare, 'From today painting is dead.'[1] Photography's grip on realism, and consequently its challenge to painting, had been initiated. Delaroche embraced the daguerreotype as the ultimate in optical exactitude, and its impact was evident in the tonal values of his paintings. In Britain, Turner demurred, 'This is the end of Art. I am glad I have had my day.'[2] His prophecy of art's demise proved unfounded, however, and artists from Ruskin and Degas to Picasso, Warhol and beyond went on to enter into a dialogue with photography. Yet its status remained a fiercely debated topic until the postmodern era, when it became widely accepted that no art form had an independent, autonomous existence, and photography was adopted as a medium by artists who had never held a paintbrush. But Bacon's version of realism depended on live, fluid pigment. He did not paint simulacra of photographs, but he appropriated their transformative charge to disrupt European cultural traditions, to dissolve past into present.

Although he fell in with the backhanded compliment to photography that it had released art from illustration, Bacon did not consider it had parity with painting. Yet in his

consumption of images he was quintessentially an artist in the age of the photomechanical reproduction and the mass media. In a society 'assaulted all the time by photography and by film'[3] he absorbed the full scope of the imagery he encountered, 'from an advertisement to a Greek tragedy'.[4] In his distortion and reassembling of art-historical icons he systematically engaged photography's fragmented instantaneity, enmeshing Michelangelo and Muybridge, Eisenstein and Velázquez. At the same time Modernism's reluctance to embrace mass culture was being challenged in the USA by Marshall McLuhan, whose ideas were taken up by the Independent Group in Britain. The non-hierarchical deconstruction of popular culture was not part of Bacon's agenda, but a by-product of his proto-Pop sweep of disparate imagery was its contribution to subverting orthodox 'high art/low art' distinctions.

The 'convulsive beauty' of his paintings of the human body was driven as much by his response to Muybridge's photographs – he painted the motion, as well as the emotional charge they lacked – as by the grandeur of Velázquez's paintings and the voluptuousness of Michelangelo's drawings and sculptures. But Bacon insisted he had used the Muybridge and Eisenstein images as records, not as models. His equivocation is understandable: it should be stressed, in view of the recent shift in perceptions of photographic practice, that for an artist to admit a serious interest in the pariah, photography, was, until the 1970s, to invite deep suspicion. Peter Blake was obliged to hide his mass-media stimuli from tutors at the Royal College of Art in the mid-1950s, and ten years later Robert Rauschenberg and Andy Warhol continued to provoke dissent in the art establishment. On the other hand, Bacon was probably referring to some of the Pop artists when he attacked the 'mixed-media jackdaws' who insufficiently 'digested and transformed' their sources.[5] His rejection of the literal transcription of pictorial data as 'simple illustration' echoes Turner's deprecation of 'merely pictures of bits',[6] and his recombinations of heterogeneous constituents are comparable with Turner's imaginative syntheses. Bacon did not want his paintings reduced to their sources. His use of photographs has been public knowledge for more than fifty years, but as he refused to interpret his paintings so he resisted, outside a limited corpus over which he maintained strict control, the identification of their specific pictorial models. Significantly, he admired Marcel Duchamp's *The Large Glass* not only because it 'takes to the limit this problem of abstraction and realism' but also on the grounds that it was 'so impervious to interpretation'[7] (in fact Arturo Schwarz has analyzed *The Large Glass* in terms of hermaphroditism and the operation of chance[8]). No doubt Bacon was sincere when he reminded interviewers he had been influenced by everything he had seen, but it was also an evasion tactic. And although he claimed his dependence on photography had been misapprehended, he also issued an emphatic self-contradiction: '99 per cent of the time I find that photographs are very much more interesting than abstract or figurative painting. I have always been haunted by them.'[9]

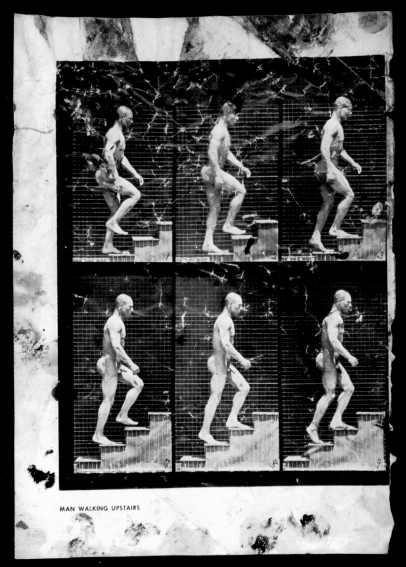

'*Actually, Michelangelo and Muybridge
are mixed up in my mind together.*'

Francis Bacon, April 1974

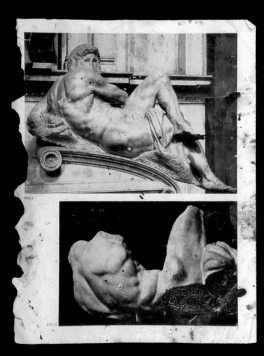

51 Working document: Eadweard Muybridge, 'Man Walking Upstairs',
plate 14 from *The Human Figure in Motion*, 1955 edition

52 Working document: leaf torn from an unidentified
Michelangelo catalogue, showing *Day*, from the tomb of
Giuliano de' Medici, San Lorenzo, Florence (1526–33)
and, below, a clay model for the same figure

'*I want to isolate the image much further…to take it very much
further away from the photograph… I only use photographs
as I would use a dictionary in a foreign language.*'

Francis Bacon, 1974

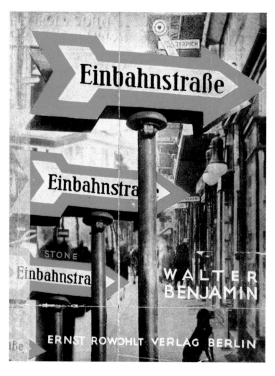

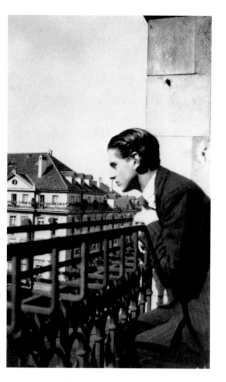

53 Sascha Stone: front cover dust jacket of
Walter Benjamin, *Einbahnstraße*, 1928

54 Bacon in Berlin, *c.*1929
(photographer unknown)

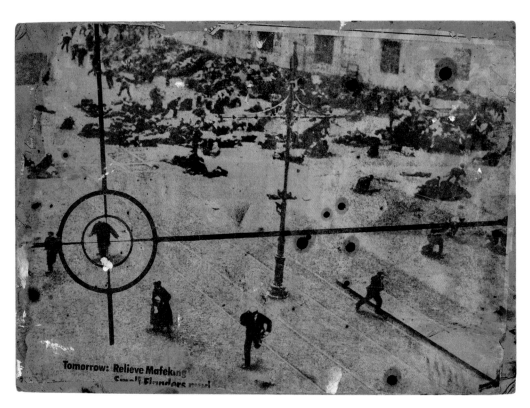

55 Working document: leaf from an unidentified broadsheet newspaper, mounted on card, showing street-fighting
in Petrograd, 17 July 1917. Another version of this image is visible in Sam Hunter's photograph (pl. 4)

Unconscious Optics

Seeking a succinct phrase to explain the evolution of his ideas for paintings, Bacon often had recourse to photographic analogies. He described his reconfigurations of human bodies as putting them 'slightly out of focus to bring in their memory traces',[10] and his transposition and interpolation of images is evoked in the remark, 'I can daydream for hours and pictures fall in just like slides.'[11] The merging and superimposition of images connects with the 'multilayering' theories of Walter Benjamin, who reasoned that modern equipment and reproduction techniques, and the cine-camera's penetrative, multi-fragmented view of the world, created new conditions for the artist. In *The Work of Art in the Age of Mechanical Reproduction* (1936), which has become, since its translation into English in 1968, an ur text of photo-theory, Benjamin observed that, unlike paintings, photographs do not encapsulate a complete picture but 'consist of multiple fragments…which are assembled under a new law'.[12] Benjamin's *Einbahnstraße* (1928) was itself a montage of urban aphorisms, an exploration of the social layering of cities, their streets, warehouses and lighting, and the underbellies of prostitution and gambling. Bacon probably did not read any of Benjamin's texts until the 1980s, but they were, by coincidence, synchronous travellers in Berlin and Paris in 1927, Baudelairian *flâneurs* at home in Europe's great cities in a time of social flux. Bacon, however, saw his slouching through metropolitan underworlds as a release from inhibitions. In furious revolt against a privileged but psychologically disastrous childhood he crashed through the subcultural basements of Berlin in the last days of Weimar Germany's sexual freedoms. But when John Deakin was stalking the territory of urban London for his first book of photographs, *London Today* (1949), he found 'no tradition of café society' in a city where 'real life goes on behind doors and lace-curtained windows'.[13] Bacon was, like the subjects of most of his paintings, essentially solitary. He painted figures in rooms to describe his inner life. And although – when not sequestered in his studio – sporadically gregarious, he remained for the most part private, furtive, even as a nocturnal frequenter of the clubs, bars and restaurants of Soho, Paris or Tangier, and the casinos of the French Riviera.

Although Bacon was antipathetic to Dada or Surrealist montages, there is reciprocity between his non-linear colliding of images and Benjamin's readings of painting and photography. Benjamin compared the painter with a magician who maintains a distance from reality, while the cameraman 'penetrates deeply into its web'.[14] Bacon combined their functions in a way Benjamin could not be expected to have foreseen: if, in its unmediated state, much of Bacon's base material was trivia, he recombined these 'multiple fragments' into a *gestalt*, an exalted rhopography-with-figures. In fact Bacon's astutely selected 'working documents' suggest he did not consider them trivial: his favourite images, pasted or taped onto card, resemble touchingly poignant collages – talismans rather than simple references.

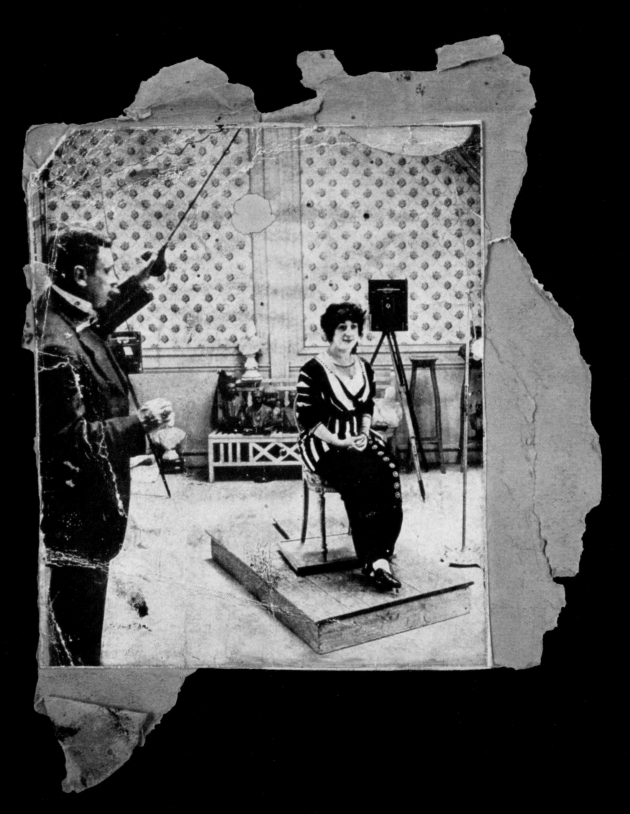

56 Working document: page 55 from Amédée Ozenfant, *Foundations of Modern Art*, 1931, mounted on card.
Ozenfant used this image to support his theory that photography had helped to demonstrate
that exact imitation cannot reproduce nature

Although Bacon's radical transformations stood outside the tradition of artists learning by imitating masters, he was not the first to paraphrase Old Master paintings. In February 1939 several artists of his acquaintance participated in 'An Exhibition of Paraphrases (Free Copies)' at the Storran Gallery, 5 Albany Court Yard, London. The gallery, which opened in 1935, showed paintings by Soutine, Picasso and Matisse in 1938, but did not survive the outbreak of World War II; it was run by Eardley Knollys and Frank Coombs, whose secretary, Erica Brausen, became Bacon's gallerist in 1948. A Tiepolo after Veronese and Cezanne's re-working of Delacroix's *La Barque de Dante* provided an historical context for 'Paraphrases', but the exhibition was dominated by Bloomsbury and Euston Road School painters – the Storran was among the first galleries to exhibit the latter.[15] Working from a photograph (the original was in the Louvre), Victor Pasmore painted an effectively smudgy version of Vermeer's *The Lace Maker* (1669–70); Claude Rogers interpreted a Corot, Graham Bell a Watteau, Rodrigo Moynihan a Titian and Lawrence Gowing a Goya: other contributors included Vanessa Bell, Mark Gertler and Duncan Grant. Sickert, who had painted the first of his English 'Echoes' in 1927, sent an echo of a nineteenth-century illustration by Georgina Bowers, but probably of more significance for Bacon was Graham Sutherland's painting based on El Greco's *Agony in the Garden*: if Bacon missed the exhibition, he had many opportunities to see the Sutherland.

Camera-Shock

The connection between Bacon's paintings and the cinema was first published in 1949 by Robert Melville. He noticed – or Bacon informed him of – the quotation in *Head VI* (1949; pl. 86) from the Odessa steps sequence in Eisenstein's *The Battleship Potemkin*, and added that only Bacon had disclosed the human condition with the 'visual force and lucidity' of the Buñuel–Dalí film *Un Chien Andalou*.[16] Two years later Neville Wallis, art critic of *The Observer*, described Bacon's *Pope III* (1951) as having 'a fugitive expression seemingly caught unawares by a press photographer' and suggested that *Portrait of Lucian Freud* (1951) owed 'more to the flickering silent screen than to flashlight photography'.[17] In a BBC radio talk in December 1951 David Sylvester suggested Bacon had learned his 'candid camera' technique not from photographs but from the later paintings of Rembrandt, which 'had shown him how to use an extremely restricted range of colour, how to dissolve forms into space and how to destroy the picture-plane'.[18] The remark might have provoked (though it did not) a debate over what Bacon absorbed from paintings, but among alternative stimuli that bore on the 'photographic' appearance of Bacon's paintings at this time Rembrandt's sombre monochromes were probably a contributory factor and deserve closer attention than they have been paid.

Bacon's practice was announced in the non-specialist press in 1953, when a review in *The Times* of his exhibition at the Beaux-Arts Gallery, London, was subheaded 'Extraordinary

use of Photographs'. The (anonymous) critic was disturbed by the 'unbearably unpleasant' disintegration and the 'disagreeable colour and texture of a photographic enlargement' in *Three Studies of the Human Head* (1953).[19] Subsequently the topic aroused less comment, which, unless it reflected Bacon's less overt referencing of photographs, is hard to explain. In 1964 Sir John Rothenstein and Ronald Alley's catalogue raisonné included five illustrations of Bacon's photographic sources – the first time they had been reproduced in Britain. By then the photographic community was assiduously cataloguing its medium's effect on the fine arts, although the researches of photography historians such as Aaron Scharf and Van Deren Coke failed to reverberate with British art historians until much later. Both Coke in *The Painter and the Photograph* (1964) and Scharf in *Art and Photography* (1968) discussed Bacon and Muybridge, their research drawn largely from Rothenstein and Alley. But source images were absent from the catalogues of the major Bacon retrospective at the Grand Palais, Paris, 1971, and the exhibition at the Metropolitan Museum of Art, New York, 1975, and it was not until 'Web of Images', the exemplary essay by Dawn Ades in the publication

57 *Three Studies of the Human Head* (1953)

accompanying Bacon's second Tate Gallery retrospective in 1985, that the investigation was reopened on a scholarly footing.[20] Following the revelation of 'new' material since the artist's death in 1992 there has been an exponential increase in this area of Bacon studies.[21]

Eyes and Lens

Bacon was indifferent to photography's struggle for recognition as an independent art form. 'Some photographers are artists,' he allowed, but 'I'm not particularly interested in that aspect of photography.'[22] The photographs he found compelling were not the result of painstaking craft but grab-shots, intuitive, instantaneous images. He contrasted the photographer, whose highest aspiration he believed was a 'diverted illustration',[23] to the painter, who aimed 'to trap this living fact alive',[24] and the texture of a photograph which 'seems to go through an illustrational process' to that of a painting which 'seems to come immediately onto the nervous system'.[25] Artists manipulate the physicality of their pigments to invest life into a painting, whereas in a photograph the image is sealed inside the coating

of chemical emulsion. There is only a fine distinction between this and Walter Benjamin's theory that even the most perfect reproduction lacks the uniqueness, the 'presence in time and space', of the 'authentic' work of art, whose basis in ritual, 'however remote, is still recognizable as secularized ritual even in the most profane forms of the cult of beauty'.[26] But Benjamin, who described this presence as an artwork's 'aura', had been prepared to assign it to early photographs, since he believed the *image*, in the Proustian sense of a memory trigger, transcended its formal attributes. Thus Bacon's profane rituals may be said to have been accomplished at the intersection of Benjamin's conflicting views of photography and painting.

Baudelaire, too, believed photography to be not a medium of the imagination but useful only for recording nature with exactitude. He posited Courbet's painted 'realism' against photography's low illusionism, and the expressive materiality of paint against the mechanical imitation of the daguerreotype. Nevertheless, Corot, Courbet and Delacroix all employed photographs as studies for paintings, often having them taken specifically for this purpose. Uncertainty over the status of photography compounded the problem of defining realism in art, which has continued to prove as elusive to art critics as has defining gravity to scientists. Bacon operated at what he called 'the extreme points of realism', documenting life in a manner he considered 'factual' and his supporters regarded as 'authentic' realism, free from the ethical or political affiliations they considered extrinsic to the purpose of painting. In a different context photography's perceived veracity ensured it was swiftly adopted as the ideal medium for portraying the clandestine, the forbidden and the pornographic – sordid connotations to which Bacon enthusiastically responded. And such vulgarities were not the only 'low' subjects – that is, outside high art's traditional iconography – that photography uncovered for artists. The camera's democratic fascination with the banal, the quotidian, and its revelatory action shots of urban life, gripped the young exponents of Social Realism in Britain as much as they did Bacon. When Irena Fullard married the sculptor George Fullard in 1946 they shared a house in Earl's Court full of Social Realists: 'Wednesday was *Picture Post* day,' she commented, 'and every week we couldn't wait to *devour* its photographs.'[27]

Several of the painters in Bacon's pantheon, notably Bonnard and Vuillard, were keen amateur photographers whose hand-held Kodak snapshots often served as preliminary 'sketches' for their paintings. But a direct photograph-painting correlation was antithetical, before 1962, to Bacon's deployment of 'found' photographs as points of departure. Neither was his frontal assault significantly indebted to camera-vision asymmetry, the haphazard framing and 'unbalanced' off-centre compositions that artists such as Degas derived, in part, from the instantaneous street photographs which began to appear in Paris in the 1860s.[28] The pre-Fauvist near-monochromes of Picasso have been linked by Anne Baldassari to his interest in photography, and she has identified photographic studies for some of the beach scenes he

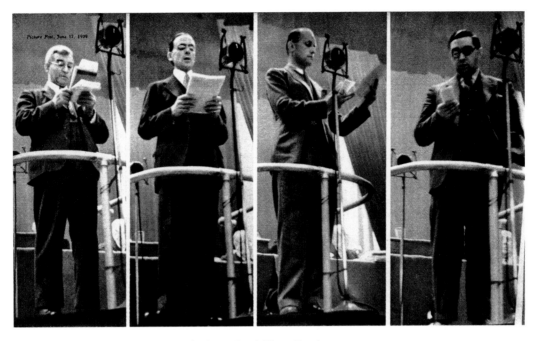

58 'The Cripps Case', *Picture Post*, June 17, 1939
Bacon was an avid consumer of this weekly publication. He was no doubt indifferent to the policies of the Labour Party,
but the rostrums, the microphones and the polyptych format all figured in the iconography and layout of his paintings

painted at Dinard in 1928 and 1929, the works that inspired Bacon to take up painting.[29] But Picasso's photo-portraits of Dora Maar, combining cliché-verre and photogram, required darkroom work, a hands-on engagement with the craft that was in distinct contrast to Bacon's arm's-length accumulation of photographic images.[30] Ultimately of greater significance for Bacon (and for the study of art history) was photography's rôle in recording works of art, and their dissemination through mechanical reproductions. Indeed the claims now being made for photography's centrality to twentieth-century art practice carry the risk, in Bacon's case, of overdetermining the relationship between his paintings and their sources. On the other hand, although, as Rosalind Krauss has argued in relation to Picasso, photography's significance may have been exaggerated (since photo-optics are tied to single-point perspective and this was inimical to Cubism's dismantling of perspectival space[31]), Bacon's revision of Analytical Cubism depended on the revelations of machine vision – on the multiple viewpoints of sequential photographic and cinematographic imagery.

Photography and Modern Art in Britain
Although membership of a putative School of London was bestowed on Bacon by R. B. Kitaj in 1976, he is not considered to have belonged to any artistic grouping in the 1930s. He was, however, less isolated from the British art scene than might be inferred from his selective accounts of the period. Owing to the dearth of information about these activities during this formative decade, some of the following remarks are necessarily speculative, but close scrutiny of events in London and Paris was consistent with Bacon's intelligence and cultural

59–60 *Picture Post*, April 26, 1947, pages 7–8

61 ?Working document: torn leaf from *Picture Post*, April 26, 1947
Although this fragment is spattered with paint, the images of figures on rostrums on the remainder of the page from which
Bacon tore it may have been of greater interest to him than this surviving portion (see the complete page, and its reverse, *above*)

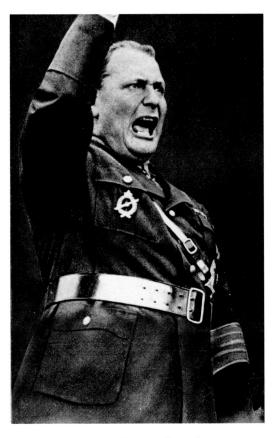

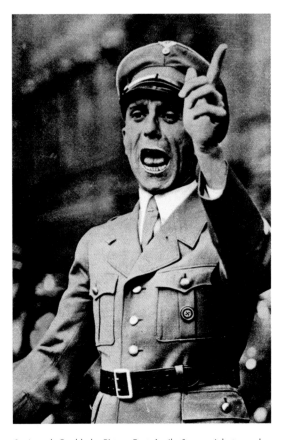

62 Hermann Goering, *Picture Post*,
April 26, 1947 (photographer unknown)

63 Joseph Goebbels, *Picture Post*, April 26, 1947 (photographer
unknown). This image was in Bacon's studio in 1950

"The only law governing the selection is a mysterious topical and psychological
pertinence. Violence is the common denominator." (Photographs by the author)

12 MAGAZINE OF ART

64 'Anatomy of Horror', a selection of Bacon's working documents (including the image of Goebbels, *above*, pl. 63)
photographed by Sam Hunter in 1950, as reproduced in the *Magazine of Art*, January 1952

65 Sketch in thinned oils of a seated figure, *c.*1960–62

alertness, and in both capitals modernist photography and avant-garde film, as well as nascent photojournalism and 'candid camera' imagery, were making a decisive impact on artistic sensibilities. Bacon presented himself as an autodidact. Redacting his own myth he claimed to have had little formal education and parents who were 'horrified at the thought that I might want to be an artist'.[32] Yet he was privately tutored by a Church of Ireland curate and attended Dean Close School, Cheltenham, from 1924 to 1926. A tennis-playing companion, Doreen Mills, remembered the 'many drawings' he made as a teenager in Ireland, which his sister Ianthe described as 'brightly coloured, of flappers with cloche hats, very long cigarette holders, high rouged cheekbones and bright red lips'.[33] He made 'Cubist-inspired' drawings while staying in France in 1927–28,[34] and his second cousin, Diana Watson, suggested that he 'may have had a few drawing lessons at the age of seventeen at St Martin's School of Art',[35] the specificity of which information warrants its serious consideration. But it does not follow from these youthful activities that as a mature artist Bacon covertly indulged in making preliminary drawings in a draughtsmanly style. It was integral to his method that no drawing stage that bore significantly on the final outcome preceded the spontaneous application of paint. He cited Soutine as an artist who similarly eschewed intermediate drawings, but there were other precedents: Tintoretto, for example, by staging wax and clay figurines in strongly lit boxes, had 'removed the need for compositional sketches altogether'.[36] Although Bacon experimented briefly by making three-dimensional 'figurines', he 'removed the need' by substituting photographs for compositional drawings.

Nevertheless, his working processes remain in dispute. In addition to a few 'working documents' now in private ownership, three substantial archives have emerged during the last decade to encourage revisionist theories concerning Bacon's claims that he did not draw. Two collections of 'works on paper' with secure provenances (they were acquired from Bacon's friends Peter Pollock and Paul Danquah, and from the estate of Stephen Spender) were purchased by the Tate in 1997 and 1998. These have been meticulously analyzed and published by Matthew Gale, who has dated the works to c. 1957–61.[37] The vast body of material disinterred from the studio at Reece Mews is now housed at Dublin City Gallery The Hugh Lane: it provides further reliable evidence of Bacon's working procedures and is a uniquely important resource. Lastly there is the archive presented to the Tate by the collector Barry Joule in 2004, some of which had been exhibited at the Irish Museum of Modern Art, Dublin, in 2000, and at the Barbican Centre, London, in 2001.[38] The Joule archive, a portion of which was retained by its owner in 2004 and another group donated to the Musée Picasso, Paris, comprises more than a thousand items – the majority of them worked-over magazine or book pages – together with the so-called 'X Album', which contains sixty-eight leaves of mainly oil sketches.

The forty-two rapid, vigorous sketches on paper already in the Tate collection were executed in oils, pencil and ballpoint pen. As Matthew Gale has argued, they are directly related to paintings made between 1957 and 1961, and they help to elucidate a period in which Bacon was reassessing his configurations of human bodies and the spaces they occupied. By 1962 he had largely resolved these problems – and photographs had again become central to his mode of working. No doubt Bacon always made idle sketches (doodles) in one form or another, and the works on paper probably occupied him for no longer than the associated lists of ideas for paintings: they were equivalents, perhaps, of the personal form of speedwriting he invented when working as a secretary in his 'drifting years'. Moreover, it is quite plausible that what appears to represent a more concentrated phase of 'preliminary drawing' was limited to this transitional period. And it is debatable whether these works on paper constitute a refutation of his denial that he made (by any accepted definition of the term) preliminary drawings. There is no substantial evidence of his 'drawing' outside this period, although there are countless examples of other intermediate objects – reproductions, lists, photographs of his own work. In one of his last interviews Bacon insisted, 'If you asked me to draw something, I don't think I would be able to.'[39] Although the veracity of this remark has also been disputed, Bacon may have considered that falling below the standard of Michelangelo's draughtsmanship was commensurate with the inability to draw an object. In fact the rough outlining of forms onto the canvas (done at one time in chalks) was not a procedure he consistently repudiated, for in an interview in 1966 he described how, especially when painting portraits, he sketched the outlines in oils thinned with turpentine.[40] Yet the persistent clamour that there was collusion, knowingly or not, in the suppression of his 'secret vice', appears to confirm Bacon's fears that dwelling on the preliminaries would distract from the finished product.

While extravagant and highly speculative claims have been made for the significance of the Barry Joule archive, its authenticity and legitimacy have also been questioned. Until the objects have been rigorously analyzed and forensically and art-historically tested, judgment must be reserved. Irrefutably the interventions on the 'working documents' bear little resemblance to related material of which Bacon's authorship is beyond dispute, and the X Album, which even its first curator allowed may have been due partly to other hands, is similarly inconsistent in style and technique with securely documented works. Considering the limited amount of comparative material, it is of course possible that the X Album sketches are in an idiom not hitherto recognized as Bacon's. The 'working documents' are more problematical. The base material consists primarily of French boxing and soccer magazines of the late 1940s, and British Sunday newspaper colour magazines of the 1970s and 1980s. Irrespective of their date of origin, the markings on these documents tend to be

CARPENTIER—BOGEYMAN
TO

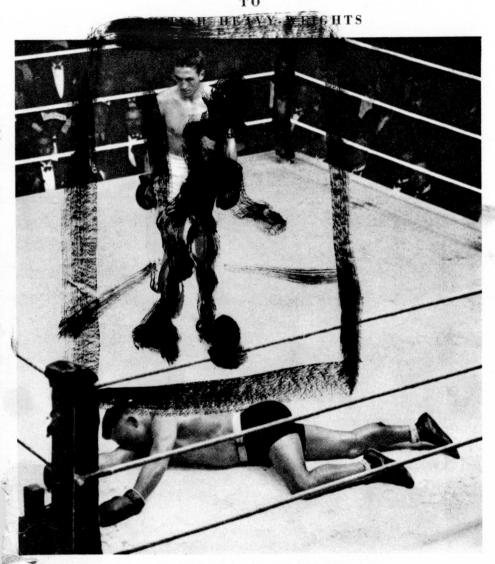

JOE BECKETT v. GEORGES CARPENTIER

Joe Beckett, British heavy-weight champion, was twice a one-round victim to Georges Carpentier, a great light-heavy-weight, who caused havoc among the heavy-weights of Europe. Their first fight (above) took place at Holborn Stadium, London, on December 4, 1919, the second at Olympia, London, on October 1, 1923—both with the same result. One or two sporting writers started up a controversy in which it was alleged François Descamps, Carpentier's manager, put an hypnotic eye on Beckett. All that really happened was that Georges each time put an hypnotic right on Joe's chin.

176

made, somewhat haphazardly, in pink or magenta watercolour. They are in a homogeneous style that presumably should be assigned to the 1980s. Whether some, or all, of the marks were due to Bacon, the documents seem likely to have come from his premises at Reece Mews. They are scheduled to become available for public consultation in 2007, and meanwhile await cataloguing and the empirical sifting of evidence.

As for Bacon's formal training, it can readily be imagined that for someone of his temperament the stultifying discipline of a conventional art school curriculum *circa* 1926–27 would have acted as a deterrent. His rejection of the English academic tradition that privileged drawing as the basis of fine art was not publicly articulated by him until much later, when it became inextricable from his contempt for 'illustration', but the lengthy course of instruction he had bypassed was adumbrated by his contemporary (and later friend) Rodrigo Moynihan, who entered the Slade School of Fine Art in 1928. The Slade Professor of Art until his retirement in 1930 was Henry Tonks, who had joined the staff in 1893. Under Tonks's régime students spent two years drawing from casts and the live figure before being 'allowed to touch a brush'.[41] Moynihan recalled that when he embarked on his first paintings and was 'faced with the problems of colour and tone' they appeared as 'puzzling novelties of which he had been told little'.[42] Colour – available to Bacon from the outset – was applied as the final flourish onto a layer of monochrome tonal painting over a linear structural base. In rebelling against the primacy of drawing, Moynihan and his Slade colleagues William Coldstream and Geoffrey Tibble realigned themselves with French Impressionism, especially late Monet but also as filtered into Britain through Sickert and the Camden Town Group. Their enthusiasm, therefore, predated Bacon's, although he 'used to swank that he had talked about late Monet at a time when most people said it was like ice creams'.[43]

In 1933 Moynihan became leader of the Objective Abstraction Group, painting anti-formalist compositions of swirling light-toned paint inflected by both Monet and Turner. At the same time William Coldstream was undergoing a crisis during which he was unable to paint. Instead 'I have been amusing myself with a camera,' he wrote, 'taking anything I fancied in the studio – & I think it is good for me & clears up some of the muddle... And it only takes a second!'[44] Of photography's challenge to painting he said 'it is true that the logical development of the mainstream of European painting has led to photography. After Degas the camera.'[45] Briefly abandoning painting almost entirely, he joined John Grierson's GPO Films Department: this placed him at the centre of British documentary film-making, which under Grierson's enlightened leadership embraced realism and experimentation, fact and fictionalization. Moynihan returned to subject painting when he became associated with the Euston Road School of Drawing and Painting in 1937, founded by Coldstream, Victor Pasmore and Claude Rogers, and devoted to an objective realism derived ultimately from

PAINTER'S
OBJECT

Picasso
ozenfant
Kandinsky
max ernst
Paul Nash
Julian Trevelyan
F. léger
John Piper
Calder
Henry Moore
Graham Sutherland
Hélion
L. Moholy = Nagy
G. de Chirico

Edited and with an Introduction by
MYFANWY EVANS

GERALD HOWE LTD 50 GERRARD STREET LONDON W.I

68 Myfanwy Evans (ed.), *The Painter's Object*, 1937, front cover dust jacket
The book includes Paul Nash's essay, 'Swanage, or Seaside Surrealism', and John Piper's 'England's Early Sculptors', illustrated with his own photographs. The emergence of photography into art practice is symbolized by the painter's palette framing a photograph

Cézanne (among the school's first pupils was Lawrence Gowing, who as an artist and friend, and especially as a perceptive critic, came to occupy an important position in Bacon's life). Here, and as Slade Professor from 1949 until 1975, Coldstream perhaps contributed more than anyone to sustaining the tradition of life drawing in England's art teaching.

Although German 'New Photography' was diffused into commercial photography in Britain in the 1930s, interest in camera-vision was restricted to the fringes of avant-garde art practice, and none of the British artists produced the extensive corpuses of photographs assigned to their American counterparts Charles Sheeler and Ben Shahn: indeed Sheeler's photographs are now held in higher regard than his paintings. Paul Nash used a simple Kodak camera as an investigative recording tool, often in relation to projected paintings, from 1929 until his death in 1946, and John Piper followed in 1932. Though never as committed to Surrealism as Nash, there was a Surrealist aspect to some of Piper's early topography. He continued taking photographs throughout his three-year experiment with constructivist abstraction, and photography, a persistent link with the 'valuable object', was, like his coastal collages, a factor in his return to figuration after 1937. Among other leading British artists, Keith Vaughan joined the Lintas advertising agency as a trainee layout artist in 1931 and was persuaded by the art director Roy Jenkins to buy a Leica camera, which he found useful in his advertising work and for photographing young men as references for his paintings.[46] Edward Burra's painting *Two Sisters* (1929) was freely based on a postcard of the Dolly Sisters sent to him by his close friend the photographer Barbara Ker-Seymer. It coincided with the brief period in which Burra made collages, inspired by Dada photomontage, but he continued throughout his life to use photographs and postcards as models for paintings. John Rothenstein visited Burra in Rye in 1942 and was disturbed by his fascination (conspicuously shared by Bacon) with decay: at the entrance to Burra's apartment was an enlarged photograph of a leper, 'far gone in his fearful affliction', which the easily flustered Rothenstein found 'bizarre in the extreme'.[47] Henry Moore, too, began to photograph his sculpture with a plate camera in 1937, fascinated as an artist working mainly in three dimensions with factual, monocular vision and the camera's control over scale and spatial recession.[48]

In the context of Bacon's by no means unprecedented interest in photography, his most significant precursor in Britain was W. R. Sickert. Sickert's absorption of the photographic effects of blur and differential focus was evident from the inception of his 'Camden Town' period about 1906, and in the last fifteen years of his life a majority of his most important paintings drew directly upon photographs. Bacon was aware of Sickert's fascination with the *demi-monde* and of his tabloid press sources. Both artists identified claustrophobic rooms as sites for sexual tension, but it was Sickert who had exposed these transgressive themes to a prudish Edwardian public, redefining a realism that would deal

'joyously with gross material facts' and convey the sensation of pages 'torn from the book of life.'[49] He preceded, too, Bacon's 'lifelong interest in spectacular crimes'[50] in his controversial paintings of 1908–09, inspired by the notorious 'Camden Town Murder', which dwelt on social mores the respectable middle classes would have preferred to remain uncovered. Condemned as sordid, odious and pornographic, they anticipated by two decades press photography's luridly flash-lit documents of criminals and their victims, a base genre that held a powerful attraction for Bacon, a great admirer of one of its classic books, Weegee's *Naked City* (1945). The right-hand panel of Bacon's 1967 *Triptych (inspired by T. S. Eliot's poem 'Sweeney Agonistes')*, cited by John Russell as evoking a crime scene, again emulates Sickert in its mood of suppressed threat and in the sexualized power relationship, although the man speaking on the telephone is given an Eliotic twist, to appear neurasthenic as much as voyeuristic. Voyeurism, narcissism and the theatricalized staging of bodies in secluded spaces were all Sickertian tropes extended by Bacon, for example in *Portrait of George Dyer in a Mirror* (1967–68) and *Study for a Nude With Figure in a Mirror* (1969). In the latter painting the 'attendant', as Bacon termed these oddly lurking voyeurs – who recall the watchman in Aeschylus's *Oresteian Trilogy* – is indelibly associated with Sickert's bedroom scenes.

There were also fundamental divergences in Bacon's intentions and strategies. Sickert translated black and white photographs into oil colours on an epic scale. While he exercised editorial discretion by eliminating superfluous detail, the photograph tended to dictate both the content and composition of his paintings, though not, of course, the movement of paint. He valued the propensity of candid press photographs (first employed in a British newspaper by the *Daily Mirror* in 1903) to capture celebrities in off-skew, informal moments as expanding art's traditional vocabulary of poses – as a source of unusual atttitudes that remained, nonetheless, rooted in realism and narrative. But Bacon was unconcerned with Sickert's *contre-jour* lighting effects and sought to bypass the narrative connotations inherent in reportorial photographs. Indeed his recontextualizations completely altered their original meaning. In the elimination of elaborate paraphernalia and the intensification of essentials, however, both artists veered towards the British caricaturist tradition of Hogarth, Gilray and Rowlandson. Bacon, whose regard for Daumier is also relevant in this context, is said to have admired Sickert's wilfully eschatological paintings of the Old Bedford Music Hall.[51] Their shared aversion to earnestness and the over-wrought had been demonstrated by Sickert in such paintings as *The Servant of Abraham: Self-Portrait* (1929), *Hugh Walpole* (1929) and *Claude Phillip Martin* (1935), in which he audaciously transposed the tonal suppression of their snapshot sources. These photo-based Sickerts presaged the morphology of Bacon's 1960s portraits as well as his predilection for dry paint textures, and in *Claude Phillip Martin* the monstrously sci-fi vegetation encroaching on the young boy is similar to the plant forms

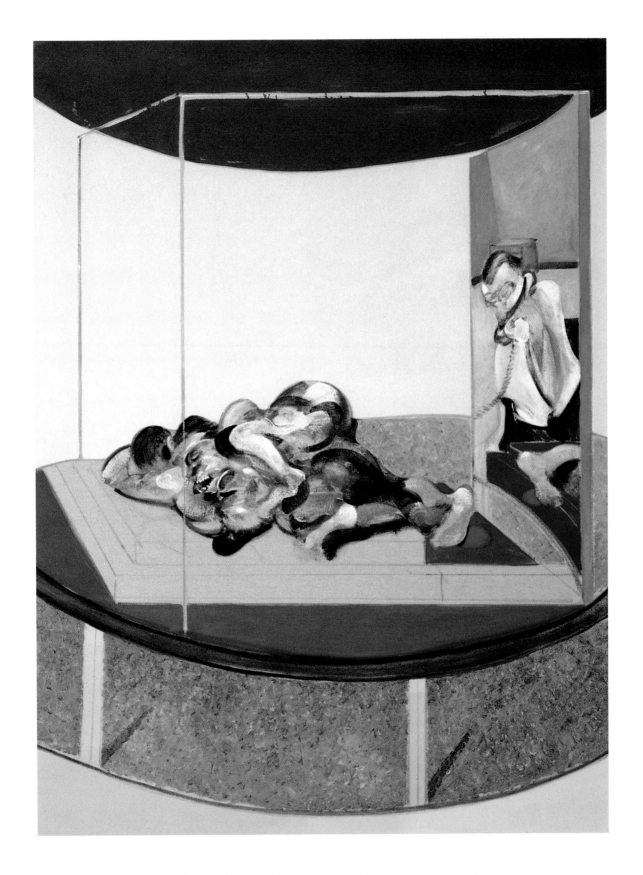

69 *Triptych (inspired by T. S. Eliot's poem 'Sweeney Agonistes')*, 1967, right-hand panel

70 W. R. Sickert, *Claude Phillip Martin* (1935)

71 W. R. Sickert, *Granby Street* (1912–13)

that briefly entered Bacon's lexicon in the mid-1940s. Bacon may have borrowed more directly from Sickert. David Sylvester suggested he may have seen Sickert's *The Miner* (1935–36) at the Lefevre Gallery, London, in 1944, where Bacon's *Figure in a Landscape* was exhibited in the following year. Sylvester proposed a link between the palettes of these paintings and the spatterings of paint, as well as their newsprint sources and the treatment of the hand and creasing of the sleeves of Bacon's figure.[52]

Bacon, who only occasionally acquired paintings by other artists, bought Sickert's *Granby Street* (1912–13) in 1971. Sickert frequently recycled his work in different forms, and made both an etching and an engraving of this image. The etching was entitled *My Awful Dad*, a reference to Charles Mathews's comedy play first performed in 1877, when Sickert was still working as an actor. The pejorative paternal reference in the title would not have escaped Bacon, although it is only proposed here as an intriguing coincidence. Continuing this circumstantial connection, Sickert gave the related engraving, which reversed the position of the man and woman, yet another title, *Et delator es*: the Martial epigram he reproduced on the third state of the engraving included the line 'Et fellator es, et lanista' (And you are a cocksucker, and an agitator). Further evidence for Bacon's knowledge of Sickert is slender, although it is feasible the artists could have met one another. Sir Michael Sadler, who bought three Bacons in 1933, was a friend as well as a patron of Sickert, and may have introduced them. Sickert was obsessed with Peggy Ashcroft and painted her at least fifteen times in the

72 Sickert, with his wife Thérèse, in his Broadstairs studio, 1938, *The Sketch*, 2 March 1938 (photographer unknown).
According to the caption, Sickert refused to have the floor tidied before the photograph was taken

1930s, mainly using snapshots taken by a photographer who accompanied him to her performances. Ashcroft, as we have seen, shared a London flat with the actress and artist Jean Shepeard, who exhibited with Bacon in his Queensberry Mews West studio in 1930. Since her brother, Edward Ashcroft, was a friend of Bacon's, this opened up another possible channel of communication between Sickert and Bacon.

Most of Sickert's late paintings were based either on snapshots or what Rebecca Daniels has aptly termed 'Press Art'.[53] Yet despite his friendship with and veneration of Degas, for whose paintings camera-vision was a decisive factor, Sickert had been an anti-photography dissenter in an 1893 survey published in *The Studio*, 'Is the Camera the Friend or Foe of Art?' (he was concerned at the threat posed to draughtsmanly skills should students be seduced by the facile option of copying photographs). But his reservations subsided and, having adopted tabloid newspaper imagery to stretch the parameters of his investigations of the urban *maelstrom*, he made no pretence at hiding his sources. His painting *King George V and his Racing Manager: A Conversation Piece at Aintree* (c. 1929–30) acknowledged its origins in boldly painted script at the top of the canvas – 'By courtesy of Topical Press Agency, Red Lion Court, E.C.4', and his portrait *Miss Gwen Frangçon-Davies* (1932) replicates the photographer's credit – 'Bertram Park: phot.' Sickert also took a perverse pride in the clutter of source material that lay on his studio floor. But Bacon was more voracious in his acquisition of images, more chaotic, and would draw from a wider range of imagery.

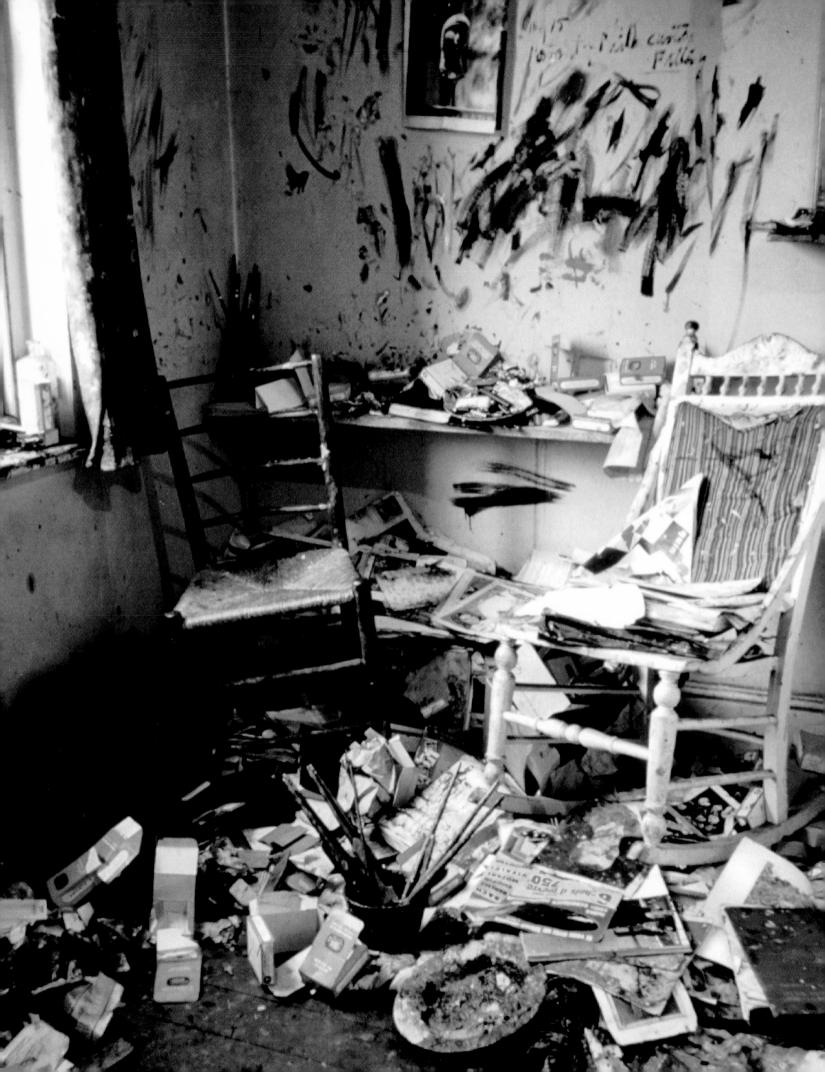

RAW MATERIAL

The debris of images strewn over Bacon's studio floor intrigued visitors. The earliest known photographs of his working environment were those taken in his Battersea studio by Douglas Glass in 1957, and the Reece Mews studio was documented from the 1960s onwards by countless others. In Glass's photographs the floor is covered with reproductions, but there are few images on the paint-spattered walls. Although walls and doors doubled as convenient surfaces for mixing paints, evidently Bacon's adoption of the wall-as-tackboard became integral to his practice only after the move to Reece Mews in 1961. And here, while the accretions on the floor grew denser, a wall was always reserved for reproductions of his own paintings – for it cannot be overstated that Bacon's principal pictorial references were to his own *œuvre* (see pl. 256): the reproductions pinned on the walls were equivalents of the lists he compiled of ideas for paintings.[1] Paradoxically, the increasing clarity of his paintings was in inverse ratio to the messiness of the studio. The images excavated from Reece Mews in 1998 were invariably creased, ripped and paint-spattered, which Bacon had passed off as a consequence of 'people walking over them and crumpling them and everything else'.[2] But who were these 'people'? He worked alone, and his cleaner was forbidden to touch the studio. He neglected the documents while retaining them, with the same ambivalence he held towards the portrait subjects he 'injured' yet immortalized. He described the 'whole world' as 'a vast lump of compost'.[3] Besides its obvious function, did he cultivate the mass of excremental waste as a metaphor of human mortality and, simultaneously, as a site for the phoenix-like rise of new images, of immortality?

73 (*opposite*) Douglas Glass:
Bacon's studio, Overstrand Mansions, Battersea, 1957

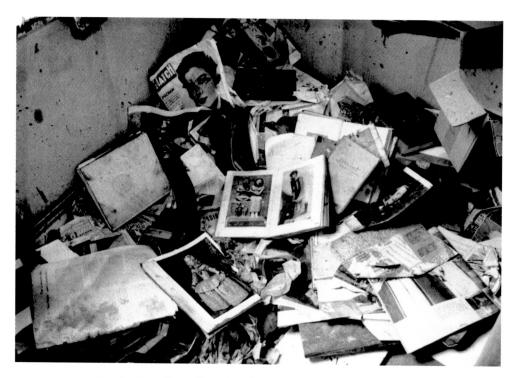

74 Douglas Glass: Floor of Bacon's studio, Overstrand Mansions, Battersea, 1960

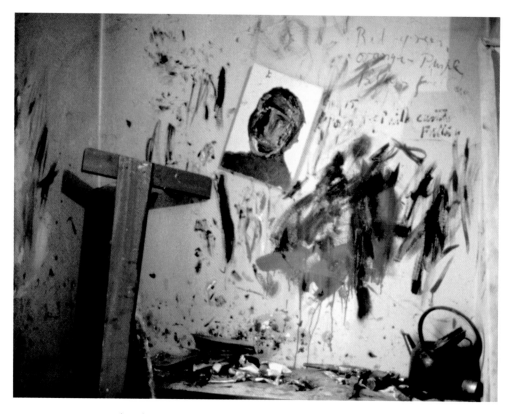

75 Douglas Glass: Wall of Bacon's studio, Overstrand Mansions, Battersea, 1957

Up to a point Bacon acknowledged his sources, admitting that images might 'breed' or 'trigger' new images. Occasionally they were adverted to in the titles he gave (or allowed his gallerists to append) to his paintings – *Study after Velázquez's Portrait of Pope Innocent X*, *Homage to Van Gogh*, and *After Muybridge: Woman Emptying Bowl of Water and Paralytic Child on All Fours*. His reluctance to divulge more about his image-bank was justified in the sense that it invited reductionism. Recycling a pre-existing image was less meaningful than the unexpected associations he made between it and other images, the transformative power of his interventions. He politely declined a request from John Russell (in regard to a revised edition of his 1971 monograph on Bacon) for access to previously unseen source images, saying that 'it would take a volume in itself – and in any case I do not think [it would be] very helpful'.[4] Towards the end of his life Bacon was asked by a researcher to bequeath his working documents to an archive, whereupon, according to Dennis Farr, he swept up 'all the photographs and press cuttings that littered his studio floor, bundled them into two plastic sacks, and made a bonfire of them'.[5] Consequently, many of his sources will, as Michael Peppiatt predicted in another context, 'no doubt elude his interpreters for ever'.[6] In fact these congeries had long been subject to periodic 'spring-cleans', yet hundreds of documents remained in the studio at the time of Bacon's death and, considering the survival of older items he could have discarded before moving to Reece Mews, the jettisoning of this material may have been more selective than Farr's anecdote implies. At the Cromwell Place studio in 1950 Sam Hunter found 'newspaper photographs and clippings, crime sheets like *Crapouillot* and photographs or reproductions of personalities who have passed across the public stage in recent years'.[7] They were not, however, cast at random over the floor, but kept on tables opposite Bacon's paintings in a space that Hunter described as having 'the character of a modern laboratory'[8] – an impression of clinical efficiency that is difficult to reconcile with the myriad photographs of disorder in his Overstrand Mansions and Reece Mews studios. It may be inferred that Bacon's archaeological stratification of documents evolved only gradually as a strategy for propagating images in a haphazard and more suggestive fashion.

Revisions

Apart from the Picassos he saw in Paris, Bacon never referred to having encountered any other avant-garde art in France and Germany in the late 1920s. But his visits coincided with the inception of photojournalism and the picture press, and he was the ineluctable consumer of images from this dynamic new communication medium, documenting Europe's social and political upheaval. A pioneering anthology of photojournalism, Erich Salomon's *Berühmte Zeitgenossen in unbewachten Augenblicken* (Famous Contemporaries in Unguarded Moments),[9] published in Stuttgart in 1931, formed a corpus of the kind of grab-shot, hand-held press

76 Double-page spread from *X marks the spot*, 1930

77 'Secret Snapshots of Current History',
from an article on Erich Salomon, *The New York Times Magazine*, June 19, 1932

He was booked for pouring kerosene on his wife . . . locking her in the bath-room, then setting her afire. . . .

Sixteen-year-old boy . . . who strangled a four-year-old child to death.

166

78 Double-page spread from Weegee, *Naked City*, 1945

Little of Bacon's earlier source imagery has survived, and most of the books from which he tore out illustrations were eventually discarded. The images on these pages did not come from Bacon's studio, but it is likely he was aware of them.

A harrowing document of the Chicago Beer Wars murders, *X marks the spot* was the first photographically illustrated book of crime scenes. It was reviewed in 1930 in *Documents 7* by Georges Bataille, and the spread shown here as pl. 76 was reproduced in the journal. Like the work of most of the celebrated pioneers of photojournalism, Erich Salomon's photographs of politicians were widely syndicated throughout the Western world, and Bacon would certainly have been familiar with them. Bacon is known to have admired Weegee's *Naked City*, and Weegee's American photographs were also syndicated in Britain, for example through the London Express News & Feature Service.

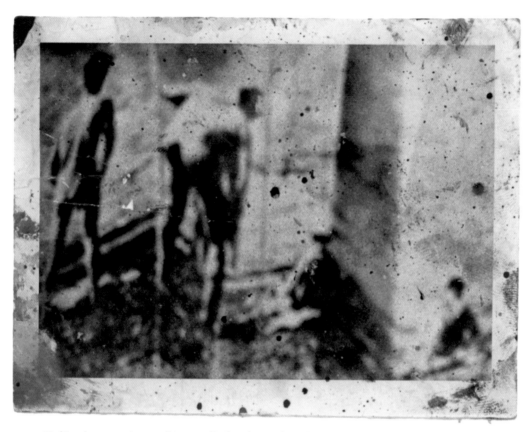

79 Working document: 'stressed' image of bathers by Nigel Henderson, based on a found lantern slide, *c.*1953

On the evidence of items found in Bacon's Reece Mews studio, he may have been more familiar with contemporary photography in the 1950s than has been supposed. He could be claimed as an aficionado of its avant-garde: Robert Frank's seminal *Les Américains* (*opposite*, pl. 80) was known to few, even in the photographic community at that time, and – outside the circle of the Institute of Contemporary Arts – the leading practitioners of British non-commercial photography, Nigel Henderson and Roger Mayne, did not achieve recognition until much later. Henderson's experiment in 'post-visualization' (*above*) may have appealed to Bacon both for its subject matter and for the screen-like 'pleating' of the image, which Henderson had subsequently re-photographed and re-printed. Bacon also admired Henderson's distorted photographs of boys on bicycles.

In 1970 Bacon was visiting John and Myfanwy Piper at Fawley Bottom in Oxfordshire when another visitor, the landscape gardener Sir Geoffrey Jellicoe, mentioned that his son-in-law was Roger Mayne. 'Oh, the man who takes those marvellous photographs of children,' commented Bacon, and plates from Mayne's extended portfolio published in *Uppercase* 5, 1961, mounted on card by Bacon, are also among his surviving working documents.

80 Working document: the cover of a first edition of
Robert Frank, *Les Américains*, 1958, splattered with paint

81 Working document: *Creative Camera*, July 1970,
with a cover photograph by Eugène Atget

*'One thing which has never been really worked out is how
photography has completely altered figurative painting.'*

Francis Bacon, October 1962

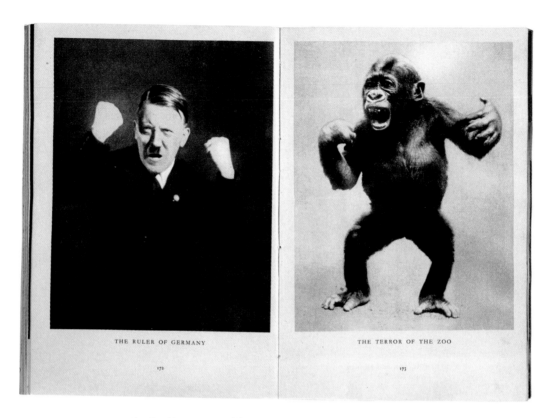

THE RULER OF GERMANY

THE TERROR OF THE ZOO

172

173

82 Double-page spread from *Chamberlain and the Beautiful Llama*
(an anthology of photographs from *Lilliput*, compiled by Stefan Lorant), 1940

photographs that featured prominently among the earliest images Bacon collected (the epithet 'candid camera' was in fact coined to describe Salomon's covert reportages). Miniature camera technology also facilitated the rise of sports photography, the instantaneous images of athletes in mid-motion that Bacon, albeit much later, exploited in his paintings. As the Nazis geared up for conflict they effectively condemned the liberal photojournalistic experiment, while appropriating its techniques in the dissemination of propaganda. The mass hysteria surrounding the rise to power of Hitler, Goebbels, Goering and Himmler coincided with the launching of the first British equivalents of the Continental illustrated magazines. Stefan Lorant, a refugee from the *Münchner Illustrierte Zeitung*, was involved in the inception of *Weekly Illustrated* in 1936 and founded *Lilliput* in 1937, selling the latter title to Edward Hulton in the following year. Many of the photographs in *Lilliput* were laid out opposite one another across a double-page spread, and were intended to be read as comic or ironic dualities: the gesticulating Hitler juxtaposed with an angry ape rehearsed distinctly Baconian postures, and the oddly raised arms, camp and ineptly haranguing, were a

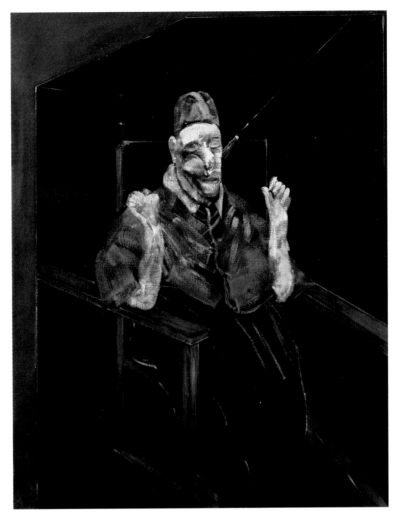

83 *Study for Portrait* (1957)

possible model for Bacon's *Study for Portrait* (1957).[10] *Picture Post,* founded by Hulton in 1938 under Lorant's editorship, was the most visually effective of the new magazines, the most political, and the most important as an image source for Bacon: its chief photographers, Felix H. Man and Kurt Hutton, had both been prominent photojournalists in Germany.

Bacon's twisting of art history's limpid religious or historical narratives is inconceivable without the impulse, facilitated by photographs, to mock as well as celebrate monumental pictorialism. In his favourite Velázquez painting, *Las Meninas* (1656), the candid realism of the royal household protagonists was achieved, not unlike Bacon's 'realism', by the painstakingly contrived unification of discrete components, allied to a handling of space that has been related to the use of a camera obscura.[11] But while the image of the King and Queen reflected in the mirror, as well as the artist's self-portrait at the easel, resonate in many of Bacon's paintings, he did not translate any of Velázquez's multi-figure compositions. Excluding the polyptychs, few of his paintings contain more than one figure, partly to obviate narrative implications. The already electric Velázquez portrait *Pope Innocent X* (c. 1650:

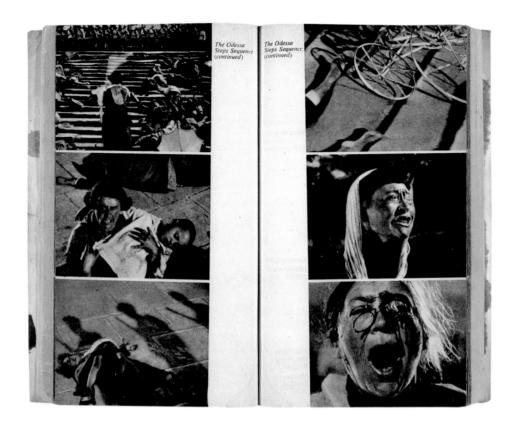

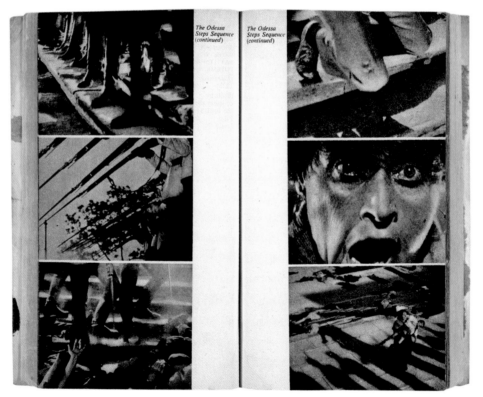

84–85 Two double-page spreads of stills from *The Battleship Potemkin* (Eisenstein, 1925), reproduced in Roger Manvell, *Film*, 1944

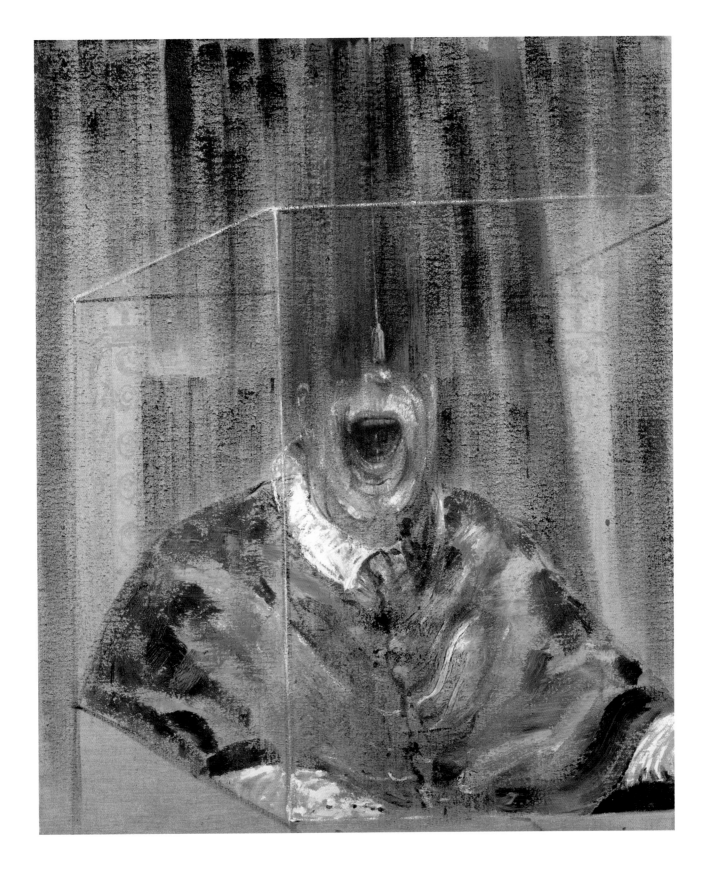

86 *Head VI* (1949)

see pp. 14–15) stands apart from Bacon's other borrowings and inspired more than thirty paintings between 1946 and 1971. If Bacon can be said to be represented by a 'signature image' it is the 'Screaming Pope', yet he came to regret his obsession with painting Popes as having been meretricious and unsuccessful interventions onto the Velázquez. In addition to their arguably absurd aspect – their Nietzschean fusion of comedy and tragedy – they are the only Bacon paintings whose Mannerist or Baroque origins are so readily apparent. However far he deviates from the original, there remains a recognizable reference to the portrait, either in general layout, Innocent's posture, or the positioning of his throne and attributes.

A comparison is afforded by the figure in the right-hand panel of *Triptych – Studies of the Human Body* (1970), in conceiving which Bacon distorted, undressed and regendered Caravaggio's *Narcissus* (1608–10). This is not an obvious quoting of Caravaggio – thirty years passed before it was spotted[12] – and indeed the figure's arched shoulder is closer to that of another Caravaggio, *Saint John the Baptist* (1605–06). These radical modifications are typical of Bacon's later recontextualization and re-presenting of Old Masters. No doubt relishing the art-historical game, he used old art as a legitimate point of departure. In fact *Triptych – Studies of the Human Body* reworks the Narcissus myth in a mode bleaker even than Caravaggio's. According to Alberti's treatise, *On Painting*, Narcissus was the inventor of painting, for as Alberti said, 'What is painting but the act of embracing, by means of art, the surface of the pool?'[13] Bacon shattered Narcissus's illusion and erotic gaze, suspending 'him' in oblivion, changing his sex and denying him altogether the reflection of his image.

Bacon began three Popes in Monte Carlo in 1946, but the earliest Pope to have survived is *Head VI* (1949). Since there are no records of the destroyed versions, *Head VI* must stand as the first occasion on which Bacon employed a photographic (or cinematographic) image to reinvent a famous Baroque painting. But Bacon did not see the original Velázquez until 1990 – the scream was based on still frames from *The Battleship Potemkin* in a paperback book. Thus *Head VI* was generated by quoting mass-produced mechanical reproductions. The sketchily delineated vaulting in the three Popes of 1951 was based on a press photograph of Pope Pius XII (elected 1939), visible in Sam Hunter's document of 1950 (pl. 4), which also inspired the 'fan' canopy of *Pope III* (1951). In a review of a mixed exhibition at the Lefevre Gallery in 1946, Roger Manvell praised the 'consummate' paint handling in Bacon's *Figure Study I* and *Figure Study II*, and, anticipating Wyndham Lewis, he compared it to that of Velázquez.[14] But most contemporary reaction was slanted towards the perception that Bacon's paintings were 'alarming', 'distorted' or 'sinister'. Three years later his first one-man show, which included *Head VI*, was greeted as 'repellent', 'violent' and 'nightmarish'. Incomprehensible as it may be today, these indiscriminate accusations of violence extended, for example, to the mysterious but tender *Study from the Human Body* (1949; pl. 263). Bacon's subsequent

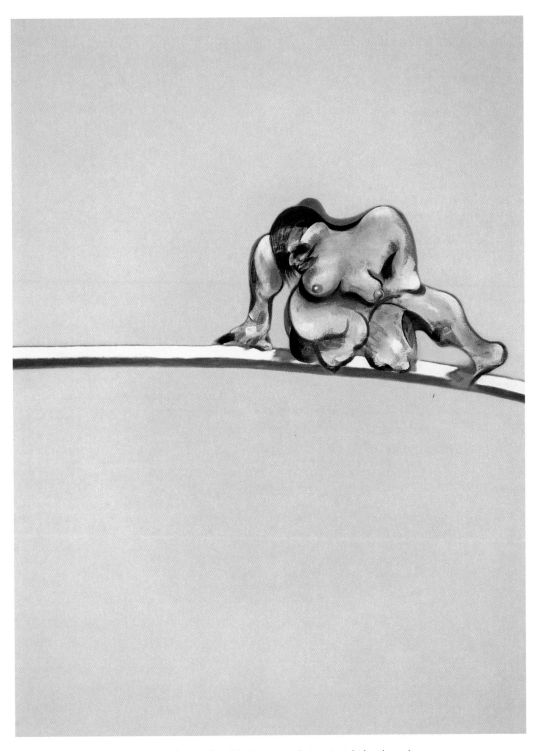

87 *Triptych – Studies of the Human Body* (1970), right-hand panel
The pinks and lavenders Bacon used increasingly from about 1970 were foreshadowed in the cosmetic colours
he applied to his early furniture designs – and perhaps, narcissistically, in the make-up he wore

32. LES DEUX TIMIDES. RENÉ CLAIR. 1928.

88 Still from *Les Deux Timides* (René Clair, 1928), reproduced in Nicole Vedrès, *Images du cinéma français*, 1945, which Bacon used as a source book

rejection of the Popes may have reflected his frustration at their disproportionate contribution to the sensationalist tenor of his art's reception. And the critical thrust fixed at that time – even Sam Hunter's sympathetic and perceptive article in the *Magazine of Art* was subtitled 'The Anatomy of Horror' and Bacon's first American exhibition (of eight Popes) was reported in *Time* magazine as 'Snapshots from Hell'[15] – has by no means entirely subsided.

Motion Stills

In 'The Cinema', a prescient essay published in 1926, Virginia Woolf strongly opposed the commercial imperative that drove the film industry's preoccupation with recycling the linear narratives of literary 'classics', which ignored cinema's potential to operate in another dimension, 'more real, or real with a different reality from that we perceive in daily life'. Bacon had taken lunch once with Woolf and Vita Sackville-West in the 1930s, but the occasion was not a success. Some of Woolf's remarks on film-making, however, were uncannily paradigmatic of Bacon's early paintings, and her description of a sequence in *The Cabinet of Dr Caligari* (1919) as an 'accidental shadow' that suddenly 'seemed to embody some monstrous diseased imagination of the lunatic's brain' anticipated the language of their critical reception.

89 'Vaudeville Films – "Facial" and Close-Ups', stills from (*above*) *Grandma's Reading Glass* (George Albert Smith, 1900) and (*below*) *A Big Swallow* (James Williamson, 1903), printed together on a page in Rachael Low and Roger Manvell, *The History of the British Film 1896–1906*, 1948 (detail)

Smith and Williamson were both members of the 'Brighton school' of cinematography: Smith pioneered the intercutting of long views with close-ups, and Williamson, whose acquisition of X-ray equipment in the 1890s was also influential, made a series of notable one-minute shorts. These close-up images, which relate to Bacon's portrait heads and screaming mouths, were among his early working documents (see pl. 4). Considering its avant-garde content, Bacon may well have been familiar with the first British journal of film theory (1927–33), aptly titled *Close Up*.

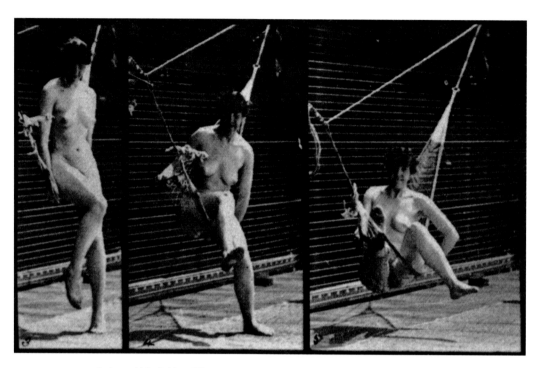

90 Eadweard Muybridge: 'Woman Lying Down in Hammock', reproduced as plate 174 in
The Human Figure in Motion, 1955 edition (detail)

While some instances of Bacon referencing film sequences no doubt await detection, his immediate source – the secondary one of printed reproductions of still-frames – has not been identified in any paintings prior to *Head VI* (1949). The prototype for the mouth in *Head VI* was the screaming nurse on the Odessa Steps in *The Battleship Potemkin*, an image he took from a still in Roger Manvell's *Film*, published in 1944 (pl. 84). Other Odessa Steps frames in Manvell's book are equally tenable as stimuli for the scream, and Bacon had access to innumerable alternative images of open mouths in different media, any of which could have been absorbed into his re-presentation of the motif in his paintings.

The most poignant ciphers for the nurse's distress, her dislodged and splintered *pince-nez*, do not appear in Bacon's paintings until *Pope III* (1951). Once the image had entered Bacon's lexicon he returned to it obsessively, and even reconfigured it as a full-length nude, *Study for the Nurse in the Film 'Battleship Potemkin'* (1957), in which the nurse is incongruously suspended in a bench or swing. Possibly based on Muybridge's 'Woman Lying Down in Hammock', another catalyst for this strange conceit may have been the swing in the swimming pool scene in Man Ray's film *Les Mystères du Château du Dé* (1929). Man Ray's theme was a response to the château's cubic shapes, which reminded him of Mallarmé's poem 'Un coup de dés jamais n'abolira le hasard': 'dice' and 'chance' would have been especially resonant for Bacon. The architect of the château, at Hyères, was Robert Mallet-Stevens (whose Paris office was the sort of establishment Bacon may have frequented in the

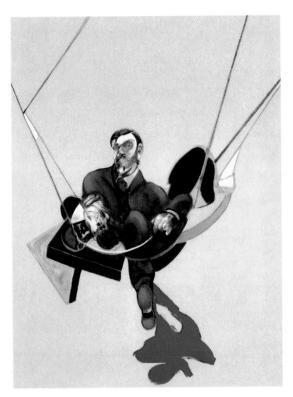

91 *Triptych* (1970), left-hand panel

92–93 Stills from *Les Mystères du Château du Dé* (Man Ray, 1929)

late 1920s) and its owner, the Vicomte de Noailles, financed Buñuel's *L'Age d'or*. The Surrealist photographer Jacques-André Boiffard, who assisted Man Ray and Buñuel on both films, was an important contributor to Georges Bataille's *Documents*, responsible for the close-up photographs of mouths and big toes that have been claimed as influential on Bacon.[16]

Motion Activated

The motion depicted in paintings is self-evidently illusory. Similarly, neither Muybridge's sequences nor the twenty-four-frames-per-second 'movement' of film are actual motion, except as translated by human perception. But Bacon was wedded to the idea of painting the trace, the flicker, the illusion of movement. Never seriously interested in taking photographs, he expressed more than once the desire to make films – a less controversial ambition to confess. Muybridge's celebrity owes more to his invention of the zoopraxiscope, an instrument for projecting moving images onto a screen embraced by film historians as a forerunner of cinematography, than to the stop-motion photographs he embarked on five years later. When Bacon applied himself with an unprecedented surge of energy to preparing his first one-man exhibitions in 1949 and 1950, he made use for the first time of a film still and the proto-filmic images of Muybridge. This phase of his engagement with photography began when he consulted Muybridge's original *Animal Locomotion* plates in the collection of the Victoria & Albert Museum, diagonally across the road from his Cromwell Place studio.

Given photography was a less decisive force in most of his early paintings than has been assumed, what caused Muybridge's serial sepia monochromes to resonate so powerfully with Bacon? As documents of bodies in motion they were of negative benefit, since paradoxically Muybridge's battery of twenty-four cameras arrested motion. Bacon worked around this contradiction and re-dynamized the freeze-frame forms, two-dimensional equivalents of the artists' lay figure, to paint the *implications* of movement. And if Muybridge's bleak and sometimes faintly sordid documents rendered their protagonists as raw scientific data, types stripped of their identity, they nevertheless provided an invaluable index of figures caught in the instant of mid-motion. Moreover, although Bacon may, like others before him, have found some of the images mildly homoerotic (and again pushed these *implications*), their prevailing emotional neutrality was congruent with his existential despair, his view of the human condition as hopeless and of humankind as carcasses of meat, as pools of flesh.

The revelation of *Animal Locomotion* coincided with Bacon's preparation for his first exhibition at the Hanover Gallery, London, in November 1949. As Helen Lessore remarked, 'It is in the heads and figures of 1949 that Bacon really begins to be a painter – to make the paint itself expressive.'[17] Bacon conceded that photographs might be triggers of ideas as well as points of reference, and now the body in motion became his core subject. He did not, however, seek to convey movement in extravagantly expressionist limb positions, but as energy oscillating on the picture surface. The painting of motion as though 'pinned to the body' was a quality Bacon respected in Géricault, whose 'incredible sense of movement' was not, Bacon stressed, the same as 'the representation of speed'.[18] Bacon's exhilarated reaction to Muybridge is almost palpable in the spontaneity of the painting of flesh in *Painting* (1950) and *Study for Nude Figures* (*c*.1950). Executed near-simultaneously, they were his most impressive improvisations up to that point on the theme of the elusive and photographic characteristic of the body dissolving in and out of focus. Circumstantial evidence points to their having been painted rapidly and under pressure: *Painting* was intended for Bacon's second Hanover Gallery exhibition in September 1950, but there are pentimenti 'which imply that there were changes of mind'[19] during execution, and in the event it was delivered late, missing inclusion in both the catalogue and the opening reviews.

The absence of contemporary reaction to *Painting* is regrettable, for while its mysterious aura and precise meaning are difficult to decrypt, it was, like *Study from the Human Body* (1949), a major work that eschewed violence. It would be interesting to know if it was received as an essentially British painting, and whether, in its intimations of sexual tension, it prompted comparisons with the work of, say, Keith Vaughan or Robert Colquhoun. For reasons unclear to the present writer, the nude figure is invariably interpreted as male. The enigmatically tilted shadow is indisputably male, which is a subtler

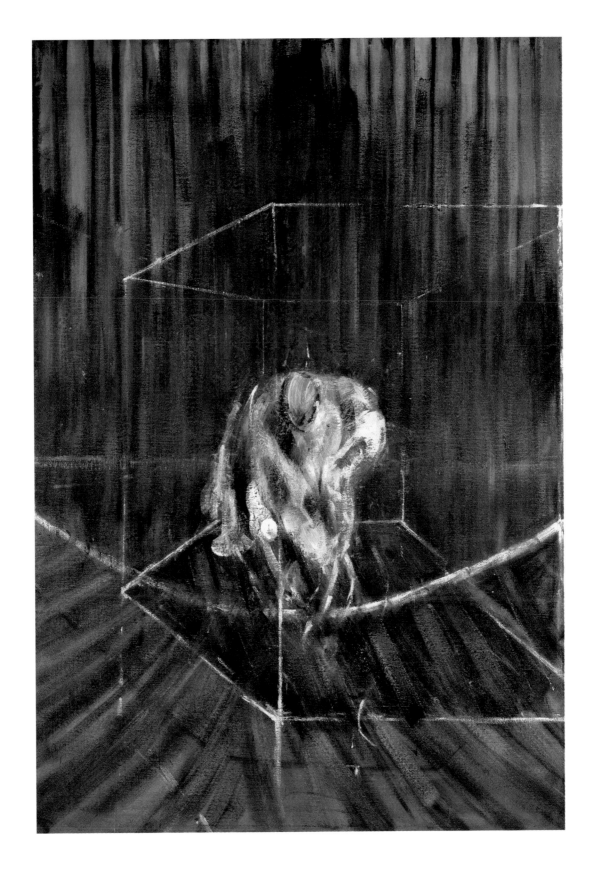

94 *Study for Nude Figures* (c.1950)

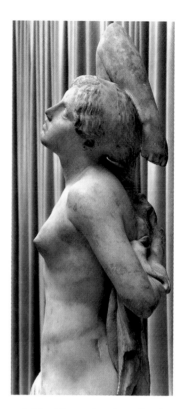

95 Nicolas Poussin, *Massacre of the Innocents* (c.1628–29)

96 Max Hirmer: *Daughter of Niobe* (c.440 BC), photographed in 1956

representation in terms of Bacon's psychology if the nude figure is a woman-androgyne. The vermilion and cobalt blue stripes of the curtain could have referenced any of Matisse's Nice-period tablecloths, but were probably based on the hanging fabric in *Odalisque with Grey Culottes* (1926–27). Bacon saw Matisse's *Bathers by the River* (1909–16) in Paris about 1930, when it was in the collection of Paul Guillaume. Guillaume also owned the *Odalisque*, and if Bacon did not see it then, he certainly did at the *Picasso-Matisse* exhibition at the Victoria & Albert Museum in 1945–46. Although, in Bacon's opinion, Matisse's paintings of the human body lacked Picasso's 'brutality of fact', Matisse seems to have been on Bacon's mind, for the formal geometrical structure of *Painting*, unique in his *œuvre*, appears indebted to Matisse, in particular to the vertical planes of his semi-abstract *French Window at Collioure* (1914).

The elements assimilated from Matisse, Michelangelo (musculature, androgyny) and Muybridge (the idea of movement) were fused with yet another, and in Bacon's procedure probably anterior, image. The raised arm pose of the nude figure is comparable with a statue of a *Daughter of Niobe* (c. 440 BC), in which the subject vainly attempts to remove a shaft from her back. The statue is in the collection of the Terme Museum, Rome, where such objects are photographed in front of a tightly folded fabric backdrop. A photograph of the dying Niobid taken by Max Hirmer in 1956 was widely published in books of Greek art,[20] and a similar, earlier image was the probable genesis of Bacon's curtain. Was a document of an antique sculpture of an adolescent girl the spur for one of Bacon's most spectacular transformations?

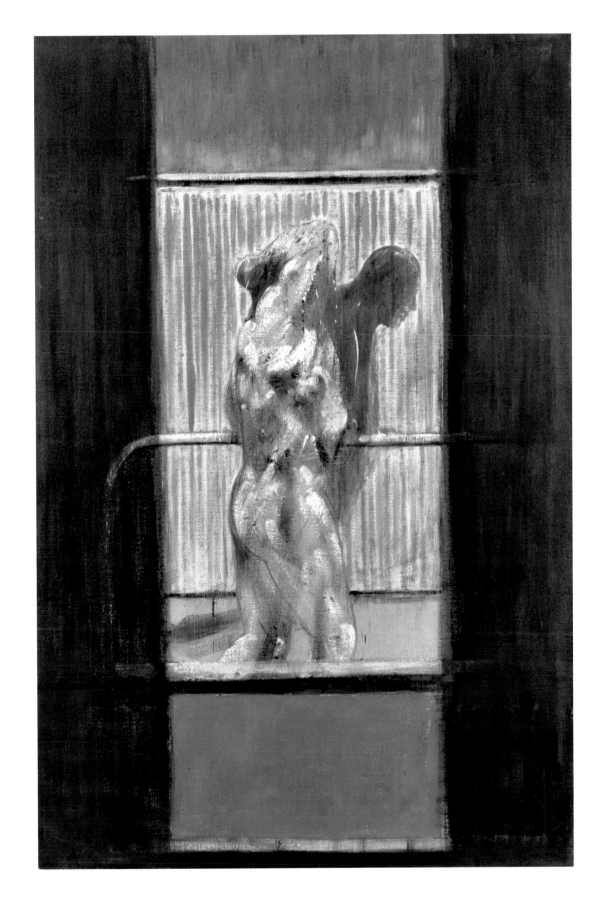

97 *Painting* (1950)

98 Titian, *Portrait of Cardinal Filippo Archinto*, (*c.*1551–62)

99 Working document: advertisement for Silk Cut cigarettes, 1989, from an unknown magazine

Or was Bacon manipulating all of these images, in one of his most eclectic fusions, into a reconstruction of the fleeing mother in Poussin's *Massacre of the Innocents*, a painting he had first seen in 1927? Poussin moved from Paris to Rome in 1624, and of all the great Baroque artists his dramatically staged compositions were the most solidly grounded in the pictorial disciplines of the antique. He made many drawings of the Massacre but before embarking on the final version he altered the original pose of the fleeing mother to conform with the classical Niobid now in the Terme Museum, a marble copy of a bronze statue moved to Rome in antiquity from the pediment of a Greek temple. The cry of the 'first' mother in *Massacre of the Innocents* was, said Bacon, 'the greatest human cry in art', but the ululating 'second' mother, carrying her dead child, may also have made an indelible impression on him.

The striated foreground in *Study for Nude Figures* was a device Bacon continued to explore up to the time of *Study for a Portrait* (1952). Like the diaphanous curtains in *Study from the Human Body* (1949), adapted from Titian's *Portrait of Cardinal Filippo Archinto* (*c.*1551–62) and those in *Study after Velázquez* (1950), it was a paradox, screening and 'shuttering' the figures from which Bacon, in repeated formulations, said he wanted to lift the veil and intensify their realism. It also raises a question of chronology regarding the extent to which Bacon's pictorial sources preceded an idea for a painting. Or did they coincide with an image he envisaged? Presumably he already owned a reproduction (or reproductions) of the Titian in 1949. These were his 'working documents', the equivalent of

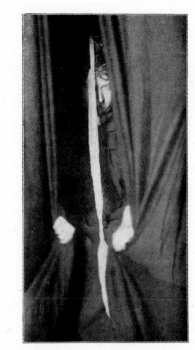

100 Juliette Bisson, Fig. 17 from *Les Phénomènes dits de Matérialisation*, 1921

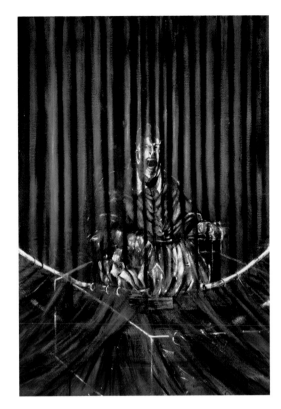

101 *Study after Velázquez* (1950)

drawings in conventional art practice. Did he, then, think of painting a filmy curtain, search for a suitable image, and recognize the aptness, in this instance, of Titian's veil? More than thirty years later he tore out from a magazine an advertisement for Silk Cut cigarettes. Its translucent purple curtain conformed with a by-then long discarded screening device, and it may simply have been an atavistic or nostalgic addition to the image-bank. Alternatively it may have resonated with a dream he wrote down in December 1984: 'I dreamed…a whole set of new pictures…on a blue satin curtain the images of everything done in a new shorthand of all the themes I have done in all my work before tonight.'[21]

The stripes in *Study for Nude Figures* and *Painting* (1950) are in vivid contrast to the prevailing sobriety of hue, and are augmented in the latter painting by large blocks of blue and scarlet reminiscent of Mark Rothko's shimmering fields of colour. Rothko's 'mature' style evolved in 1949, and since it is doubtful that it can have been transmitted to London in time to inform *Painting* the connection can only have been an uncanny parallelism, and Rothko's visit to England in August 1950, therefore, a tantalizing coincidence. On the other hand, the dark, evenly painted horizontal bands at the top and bottom respectively of *Sphinx I* (1953) and *Two Figures in the Grass* (1954) might feasibly be a response to Rothko. Bacon dismissed Rothko's 1961 Whitechapel Art Gallery retrospective as 'rather dismal variations on colour',[22] but both artists had a corner on solemnity and enclosed interior spaces and, though by different means, could be said to have sought similar ends. Rothko's exegesis of

Michelangelo's vestibule of the Biblioteca Laurenziana, Florence, for instance, was couched in terms equally applicable to Bacon: 'He achieved just the kind of feeling I'm after — he makes the viewers feel that they are trapped in a room where all the doors and windows are bricked up, so that all they can do is butt their heads forever against the wall.'[23]

Among Bacon's British contemporaries, Matthew Smith was one of the few artists he held in any esteem. Of the figurative painters only Smith, Frank Auerbach and the less well known (and underrated) Gerald Wilde could be said to have approached Bacon in emotional intensity and risk taking. Bacon was seldom prevailed upon to write about his own or anyone else's art, and it is a mark of his respect for Smith that he contributed to the catalogue of his 1953 retrospective at the Tate Gallery. But he was too much the individualist not to have been addressing his own ideals when he wrote that 'real painting is a mysterious and continuous struggle with chance', and in his litany of 'Smith's' aims, 'to make idea and technique inseparable...a complete interlocking of image and paint...the brushstroke creates the form and does not merely fill it in...'.[24] Bacon's thinking about paint, accident and motion is crystallized in *Painting* and *Study for Nude Figures*, their dialectic of impasto smears — the fluid dynamism of the slashes and flecks of white, grey and flesh-pink — outweighing any shortcomings in spatial articulation to command the picture-field. Although this vein of eloquent painterliness, which he pursued until *Study for a Pope* (1955), has affinities with gestural abstraction and the proto-Tachism of Wols or Fautrier, passages in *Painting 1946* (pl. 47) anticipated the free handling. Perhaps its main inspiration lay, after all, in Velázquez and Rembrandt. Bacon was perceived as having turned his flagrant disregard for conventional technique, in part a consequence of his lack of formal training, to his advantage: Robert Melville called him 'the greatest painter of flesh since Renoir' and Wyndham Lewis remarked: 'Of the younger painters none actually *paints* so beautifully as Francis Bacon.'[25] Melville's and Sylvester's Francophile aspirations were largely responsible for fixing the Continental European context of Bacon studies, their readings unfortunately overshadowing Sam Hunter's identification of Bacon's English antecedents. Hunter, from a non-European perspective, saw Bacon's Cassandra vision not only in terms of Goya or Sartre but also Blake, Turner, the Pre-Raphaelites, Aubrey Beardsley, Walter Sickert and Wyndham Lewis.

Spectrum

Bacon began painting on the unprimed side of his canvases about 1948, finding its coarser-toothed surface conducive to his painterly improvisations. His bravura painting techniques and unusual juxtapositions of colours distinctly enhanced his reputation among London's avant-garde. Hailing Bacon as 'one of the most powerful artists in Europe today', Wyndham Lewis referred to his fondness for blacks and his 'liquid whitish accents...delicately dropped

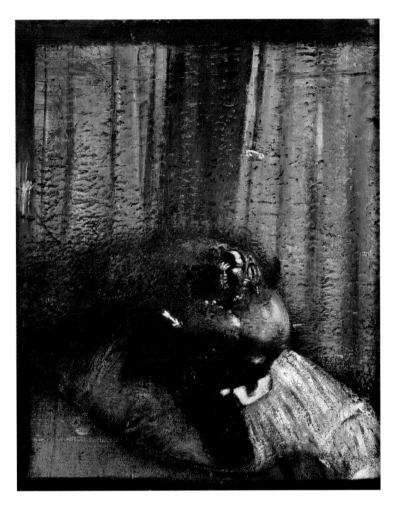

102 *Head II* (1949)

on sable ground, like blobs of mucus',[26] a description echoed in Bacon's desire to make his paintings 'look as if a human being had passed between them, like a snail...'.[27] Mucus here is convergent with ectoplasm, and liquid whites with the ejaculatory gestural marks that Bacon continued to employ in, for example, the bloody Eumenides in the left-hand panel of *Triptych Inspired by the Oresteia of Aeschylus* (1981). Counter to these liquid, sanguinary expressions was his aim to 'paint like Velázquez but with the texture of a hippopotamus skin',[28] which he achieved in the thickly impastoed and leathery greys of the achromatic *Head II* (1949), its palette redolent of the dull undertints of the *imprimatura*. The 'slightly furry quality'[29] of the flannel suit in *Figure in a Landscape* (1945; pl. 43) was obtained by mixing dust from the studio floor with a thin grey wash basecoat, and he added cotton wool to the white paint of the monstrous creatures in *Fragment of a Crucifixion* (1950; pl. 240). The layers of dust – a substance that 'seems to be eternal'[30] – also provided an apposite textural addition to his pigments in *Sand Dune* (1983). Evidently dust embodied symbolic significance for him – everything returns to dust. The thick paint of *Head II* is scumbled and distressed, as if

'pre-aged' to signify temporality; to the Interpreter in Bunyan's *The Pilgrim's Progress*, however, dust that chokes an unswept parlour is an analogue of 'Original Sin, and inward Corruptions'.

Bacon's juxtapositions of colours were innovative, risky and highly effective. The consistent monochromy of his paintings between 1950 and 1955 clearly reflects the tonal values of black and white photographs, and in addition the 'realism' of his human heads approximates the veiled and blurry realism of a fuzzy snapshot. The ghostly intangibility this implies, however, ran counter to his strategy of directly assaulting the viewer's nervous system, and this he accomplished in another dimension, painting the heads with an edgy, kinetic intensity. David Sylvester, as we have seen, compared Bacon's sombre palette with Rembrandt. Picasso's monochrome *Guernica* (1937) may also have been a spur, regardless of Bacon's professed aversion to the painting. Since arriving in London in 1946, Bacon's friend Louis le Brocquy had explored a similarly austere range, influenced by the muted tones of Spanish Baroque paintings as he was later by those of Nicolas Maes. By 1952 Michael Andrews and Victor Willing, ex-Slade School of Art students influenced by Bacon and by photography, were painting *en grisaille*. Bacon's response to the 'marvellous heads in thick paint' Frank Auerbach began to paint in 1953 was that in these densely accretive virtual monochromes 'something really new and exciting was happening'.[31] Despite his 'complicated and volatile'[32] opinions of Auerbach, he thought him 'a very remarkable painter' – high praise for a contemporary and in contrast to his equivocation over the work of Lucian Freud, with whom he maintained a closer and even more complicated friendship from 1944 until 1985.

Man in Blue I (1954), and the six extant variations on the theme, continued this sustained monochrome phase. The figures, painted from a man Bacon met at Henley-on-Thames, are isolated in the deep space of his internal framings, like museum specimens displayed in vitrines.[33] They were Bacon's most sardonic comments on the phenomenon of the tycoon in a sharp suit, white collar and tie, anticipating both the incipient Kennedy era in the USA, in which men in blue suits who played tennis wrested power from the men in grey who played golf, and the 'Executive' satirized in John Betjeman's poem.

The paintings' relentlessly cool, dark blue palette, the protagonists' awkward stabs at informality, and the clinical yet theatrical presentation, also recall the results of the long exposure torture to which sitters in early photographic portrait studios submitted, clamped in their chairs. Richard Beard and John Johnson opened Britain's first daguerreotype studio at the Royal Polytechnic Institution, Cavendish Square, London, in 1841. Smart society flocked to have their likenesses taken, among them the writer (and novelist of Ireland) Maria Edgeworth, whose report on the experience is uncannily evocative of Bacon's men in blue: 'It is a wonderful mysterious operation. You are taken from one room into another up stairs and down and you see various people whispering and hear them in neighbouring passages and

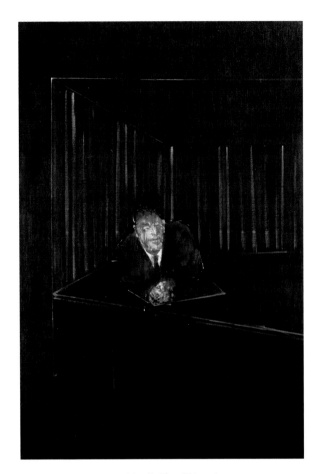

103 'The Daguerreotype in Great Britain', woodcut by
George Cruikshank of Richard Beard's portrait studio, 1842,
from *George Cruikshank's Omnibus*, 1842

104 *Man in Blue IV* (1954)

rooms unseen and the whole apparatus and stool on high platform under a glass dome casting a snapdragon blue light making all look like spectres and the men in black gliding about…'.[34]

In 1956, while conscious that by painting in bright, saturated colours he risked straying into a 'false fauve manner',[35] Bacon broke abruptly with cool greys and blues. Beginning with *Figures in a Landscape* (1956–57) he painted in arguably the most vivid hues and boldly gestural brushstrokes of his career, inspired by the vigour of Chaim Soutine and Vincent van Gogh. Although this phase lasted little more than six months, its legacy was evident in his brighter palette. David Sylvester suggested that Bacon's trips to Tangier affected his colour, and in 1960 Lawrence Alloway observed that 'Bacon's new paintings have the look not of black and white but of colour photography, as if he had moved with the times as magazines have gone over to colour'.[36] Such a direct causal link may well be valid. It should be noted, however, that Bacon had been using coloured reproductions of paintings for a considerable time, albeit the colours, owing to the limitations of reprographic techniques, were often falsified. The most prominent magazine in photographs of Bacon's studio in 1957, *Paris Match*, was printed predominantly in black and white. On the other hand Alloway's

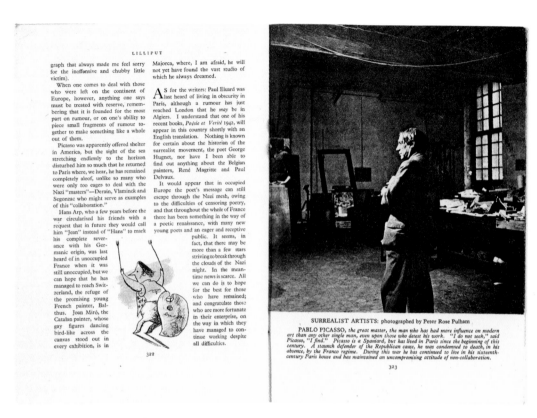

105 'Surrealist Artists: photographed by Peter Rose Pulham', *Lilliput*, October 1943

point ties in with the demise of the leading British photographically illustrated magazine, *Picture Post*, in 1957, and the inception of the first Sunday 'colour supplement' in 1962.

Photographers

Bacon formed friendships with several well known photographers, including Cecil Beaton, Dan Farson and John Deakin in the 1950s, and Peter Beard, whom he went on to paint many times, in the 1960s. Less celebrated is Peter Rose Pulham, whom Bacon had met by 1943. Pulham trained as an architect, but in 1932 he switched to fashion and portrait photography.[37] Five years later he took up painting and moved to Paris, where he produced highly competent paintings indebted to Max Ernst and Giorgio de Chirico. He also made shadowy neo-Romantic photographs of Picasso, Dalí, Mesens, Derain, Ernst, Balthus, Berman and Cocteau, which were published in *Lilliput* in 1943.[38] On the eve of the occupation of Paris, Pulham returned to London, where contact with Bacon effected a radical change in his paintings. Their amorphous, bony anatomies have affinities with Bacon's

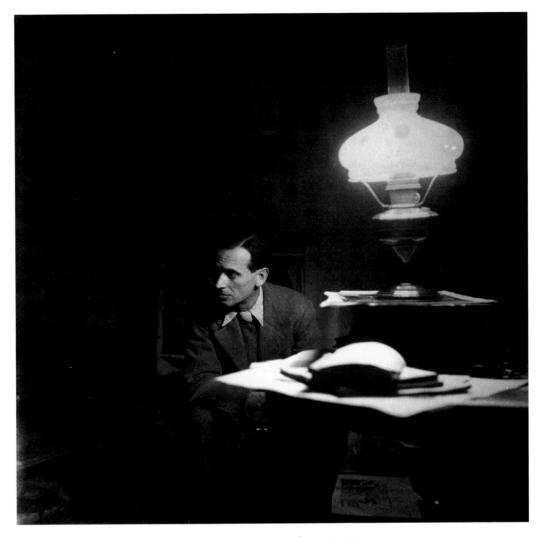

106　Peter Rose Pulham: Graham Sutherland, *c.*1946

Studio Interior (*c.*1936) and may have been related to other works that Bacon subsequently destroyed. Mechtild Nawiasky, who had studied art in Munich and was picture editor of *Picture Post* and *Lilliput* in the 1940s, stayed with Pulham and his wife at their farmhouse near Redgrave, Suffolk, during the war, and commissioned his photographs for *Lilliput*. Evidently she was also friendly with Bacon, for just before he left London for Monte Carlo in 1946 she gave him 'a lovely book on Rembrandt with some superb drawings'.[39]

The script of a BBC radio broadcast by Peter Rose Pulham, published in *The Listener* in 1952, was, according to Bacon, 'the finest thing ever written about photography'.[40] David Sylvester combined elements from it with ideas he had discussed with Bacon in preparing lectures for the Slade School of Art and the Royal College of Art which served to reinforce Bacon's links with photography as well as his burgeoning reputation among London's art students. But Pulham's original text was overlong, and a segment that carried strong echoes of Bacon's practice had to be deleted: 'Latterly I have been most charmed by really bad Press photographs reproduced through a coarse screen on bad paper; they seem, making an

107 Daniel Farson: Bacon at the Soho Fair, London, c. 1953

unintentional selection, suppression of detail, much more convincing than the "see every pore" school.'[41] The elasticity of Sylvester's definition of 'realism' was demonstrated by his inclusion of two paintings by Pulham in the exhibition 'Recent Trends in Realist Painting' at the Institute of Contemporary Arts (ICA) in July 1952. Pulham had by then returned to live in France and reverted to his Ernstian idiom, inflected by the Ecole de Paris.

'Recent Trends in Realist Painting' was conceived mainly as a challenge to John Berger's Marxist 'Social Realism'. Ironically Walter Benjamin – whose theories underpinned Berger's *Ways of Seeing* (1971) – had drolly observed twenty-one years previously that, irrespective of photography's claim to be an art, Social Realism indubitably aspired to the condition of photography.[42] Bacon found himself at the centre of a dispute that focused not on the relative merits of photography and painting but on whether realism was the preserve of art's social or aesthetic functions. In a 'Points of View' debate on Bacon at the ICA, Berger contended that people looked at Bacon's paintings instead of visiting Belsen – which presumably he considered the logical and practicable alternative – and that Bacon had failed to arouse indignation or stir the public conscience over such atrocities. The rivalries between British art critics in the 1950s have been discussed at length in recent publications: while these have illuminated the political divisions, they have tended not to engage with the question of the relative mediocrity of many of the artists whom John Berger supported at that time. In his self-appointed rôle as Bacon's nemesis, it was Berger who compared Bacon

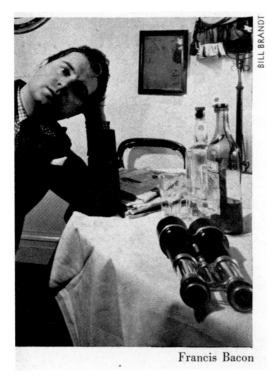

BILL BRANDT

Francis Bacon

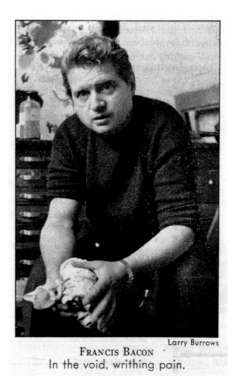

Larry Burrows

FRANCIS BACON
In the void, writhing pain.

108 Francis Bacon, photographed by Bill Brandt,
Harper's Bazaar (US edition), August 1952

109 Francis Bacon, photographed
by Larry Burrows, *Time*, 19 October 1953

with Walt Disney in 1972.[43] By then Bacon was being spoken of in terms of his national or international eminence, but prominent detractors included, besides the consistently antagonistic Berger, Peter Fuller, Clement Greenberg and Hilton Kramer.

Confirming photography's currency in the London art world, it was the topic at another 'Points of View' at the ICA in March 1952, at which Pulham was one of the speakers, together with Rodrigo Moynihan, Douglas Glass and the critics Michael Middleton and John Davenport. Again Pulham advocated that the most interesting photographs were the artless *trouvés* that fascinated Bacon. 'Emotional and haphazard chance are the best conditions for good photography. The perfect photo is of a national calamity, when the camera is knocked out of the photographer's hand, develops itself in the gutter and is immediately published in the newspapers, where its impact as a smudged image is immediate. Afterwards, the negative is stored in the police archives.'[44] By the early 1950s popular magazines were becoming alert to Bacon's cult status and commissioned eminent photographers to take his portrait. Observing them at work may have affected his thinking about the medium and how it might inform his paintings. Among those who photographed him were Cecil Beaton, Bill Brandt, Larry Burrows, Henri Cartier-Bresson, John Deakin, Daniel Farson, Douglas Glass and Nigel Henderson, a list to which Richard Avedon, David Bailey, Peter Beard, Don McCullin, Hans Namuth, Irving Penn and Lord Snowdon would later be appended.

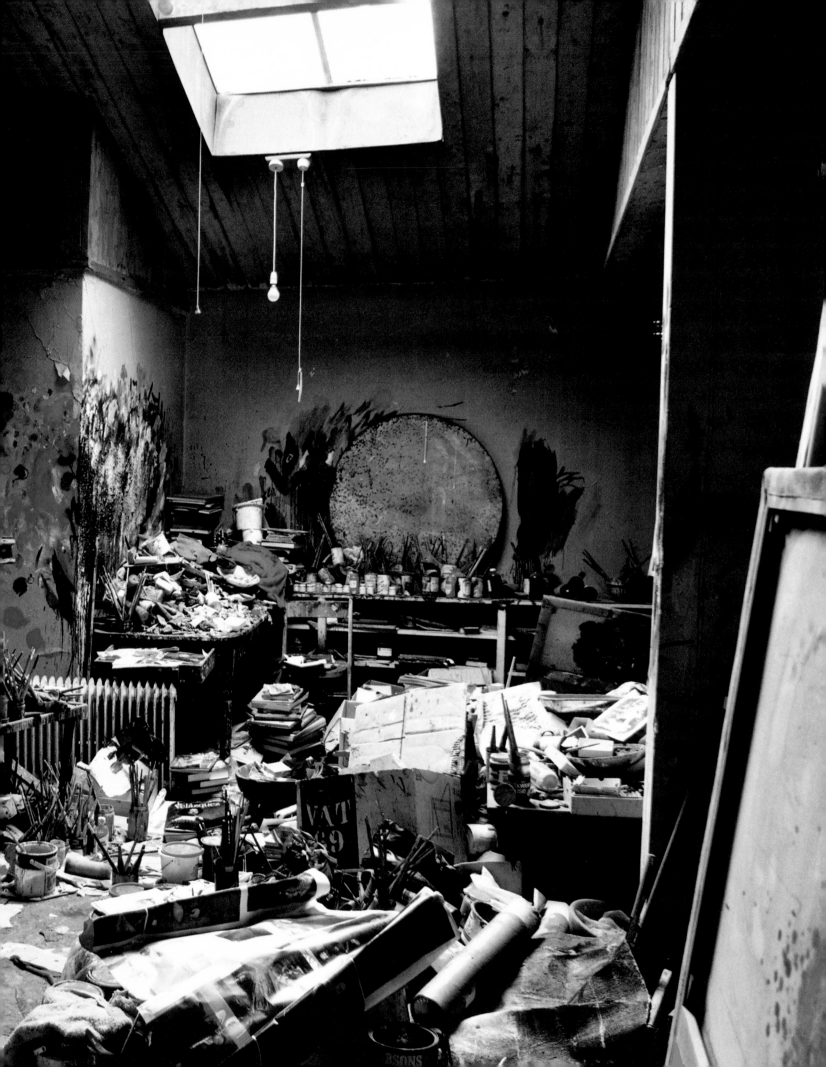

IN CAMERA

To connect Bacon's paintings with the rooms in which they were made, and their spatial organization with interiors he encountered or inhabited, risks absurd reduction. Yet he acknowledged that he was 'very influenced by places – by the atmosphere of a room',[1] and that 'the places I live in, or like living in, are like an autobiography'.[2] Furthermore he believed that the memory of 'beautifully curved rooms' at the back of his grandmother's house, Farmleigh, near Abbeyleix, Co. Laois, may have been echoed in the curved backgrounds in his paintings (he also told John Edwards that the house of a relative in Suffolk, where he stayed as a child, was significant in this respect). In *The Poetics of Space*, Gaston Bachelard discusses 'house and universe' in the context of maternal nostalgia, and quotes from a poem by O.V. de Lubicz Milosz containing the lines:

> *I say Mother. And my thoughts are of you, oh House*
> *House of the lovely dark summers of my childhood.*[3]

Conversely, Bacon's oedipal spaces were sites for the re-enactment of infantile traumas, rooms in which he projected his 'nervous system' onto canvas. As a child he was a hidden witness to what seemed to him a brutal sex act. Recounting this story as an adult he was asked if he was not traumatized by the episode, but replied, 'On the contrary. It was the making of me.'[4]

While the spaces in Bacon's rare excursions into landscape painting – the open vistas of the South African bush or the seafront at Monte Carlo – are almost agoraphobic in their vastness, his principal theme devolved on the inner realities of people confined in rooms. In the small Reece Mews studio he occupied from 1961 he blacked out the two streetside sash

110 Perry Ogden: Bacon's studio, 7 Reece Mews, 1998

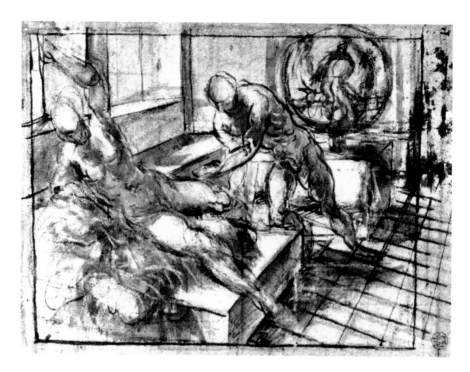

111 Jacopo Tintoretto, sketch for *Vulcan Taking Mars and Venus by Surprise*, c.1550.
Tintoretto used a *piccola casa* as a compositional aid for this preliminary drawing

windows. He had a small roof-light cut through, for although he no longer painted from life he preferred to work by daylight and no doubt found the Rembrandtesque quality of the overhead source conducive. Yet the paintings he made there were not concerned with *chiaroscuro*. The studio was a type of *camera*, but it afforded no exterior view and instead of a lens the circular mirror Bacon designed for his first studio in 1929 – latterly desilvered and patinated – cast back from its central position on the end wall a dim, interrupted reflection of the interior. In the reconstruction of the room in Dublin, peep-holes have been inserted into the wall at strategic points to enable visitors to see inside the studio: in an intriguing reversal of the camera obscura principle, the onlooker is outside the 'box', peering in. Curiously, in *New Atlantis* his collateral ancestor Sir Francis Bacon listed among the scientific advances of the seventeenth century: 'We have also perspective-houses, where we make demonstrations of all light and radiations....'[5] Although Bacon's priorities lay neither in the analysis of perspective nor with arranging figures accurately in space, his *camera* (studio) is analogous to Tintoretto's *piccola casa* and to Poussin's *grande machine*. In his theatre-of-action, figures arose from his imagination occupying perverse spaces and assuming distorted attitudes, fuelled by the images that spilled across the floor.

In 1929 Bacon's first mews studio was lit by barred windows, but from the few surviving photographs the early interiors he designed appear not to resemble the airy sun-traps of his modernist peers, but rather enclosures – claustrophobic spaces in spite of their

112 Peter Beard: Bacon's studio, 7 Reece Mews, 1975

sleek lines – in which he substituted circular mirrors for windows. The transposition of eye, lens (window) and mirror is comparable with the metaphors of vision employed by Dziga Vertov in *Man With a Movie Camera* (1929). In one of the brief sequences in which a close-up of the cine camera's lens fills the whole frame it does not reflect back to the viewer an external scene but the eye of the cameraman – of Vertov himself (see pl. 115). Bacon played out his authorial self-identification in the camera of his studios.

Confinement

The aerial 'space-frames' that Bacon said were formal devices for 'seeing the image more clearly' nonetheless encouraged the perception that his 'silently shrieking figures' were symbols of contemporary anxieties and individual isolation, and by 1949 they were being discussed by Neville Wallis in the context of existentialism.[6] In a freehand axonometric-like diagram by Bacon of 7 Reece Mews (pl. 117), the premises are rendered as a kind of space-frame, supported by the steep staircase. Its spaces would haunt many of his paintings (see pls 113, 114 and 118). His internal frame structures are frequently related to Giacometti, whose *The Nose* (1947) has recently been cited as an influence,[7] but their geometry was already present in embryo in *Three Studies for Figures at the Base of a Crucifixion* (see pl. 36). In this context, Picasso's wire constructions of 1928, or Giacometti's light metal frameworks of the early 1930s, are equally plausible as stimuli. More significant for the development of

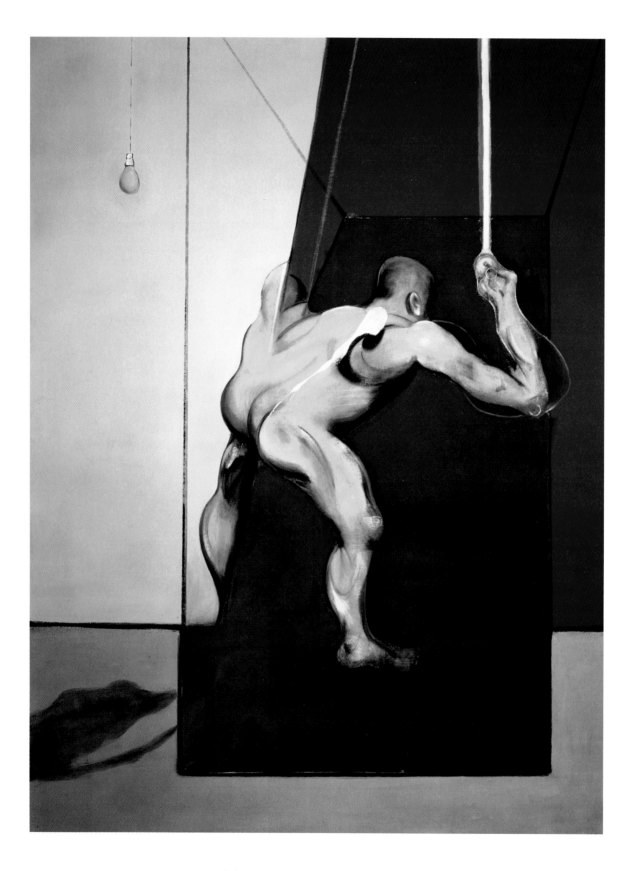

113 *Study for the Human Body (Man Turning on Light)*, 1973
In addition to the space of Bacon's Reece Mews stairwell, this painting incorporates references
to the light-switch and unshaded light-bulb in his studio (see pl. 110)

114 Perry Ogden: Staircase at 7 Reece Mews, 1998

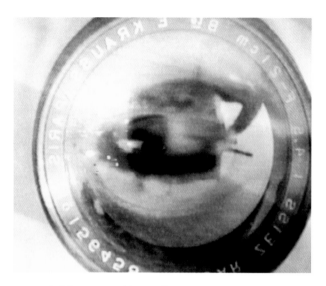

115 Still from *Man With a Movie Camera* (Dziga Vertov, 1929) 116 Daniel Farson: Bacon playing a fruit machine, Soho, 1955

his linear internal framings was his fascination with delimited sporting arenas. He played tennis in Ireland (the Bacons had a private court at Straffan Lodge), watched cricket with Eric Hall and, later, attended bullfights. The *corrida* entered his iconography in 1969, as did cricket paraphernalia in the 1980s, specifically the batsman's (or wicket-keeper's) pads, with their surgical appliance and sadomasochistic connotations. Bacon also hoarded countless images of physical contact sports – of soccer players, boxers, wrestlers – that were contested within precisely delineated fields of action.

The circular or elliptical shapes that define areas of activity, and the tubular railings that form skeletal plinths to separate and lift the subject, as in *From Muybridge 'The Human Figure in Motion: Woman Emptying a Bowl of Water / Paralytic Child Walking on all Fours'* (1965), probably had similarly atavistic origins. The curved fencing of the Kildare racecourses (Punchestown, The Curragh) that Bacon frequented as a youth, and possibly later, appear to have informed his circular barriers. Also the Bocquentin family, with whom Bacon stayed in the late 1920s, lived close to the Musée Condé, which houses Poussin's *Massacre of the Innocents* and is adjacent to the famous equestrian centre at Chantilly. In Bacon's drifting years in London in the 1920s he was befriended by Geoffrey Gilbey, racing correspondent of the *Daily Express*, and worked for a while as his secretary. Horse racing is, of course, associated with gambling, as is the second source proposed here – the barrier around roulette tables. Games of chance punctuated Bacon's life, and he believed that the 'incidental marks' on his paintings were the result of chance. Though he never wore his hair long, he let it fall down in a boyish forelock: the classical bronze statue of Kairos was sculpted by Lysippos as an allegory of opportunity, time and chance, and Kairos's attributes are his globe, razor and forelock.

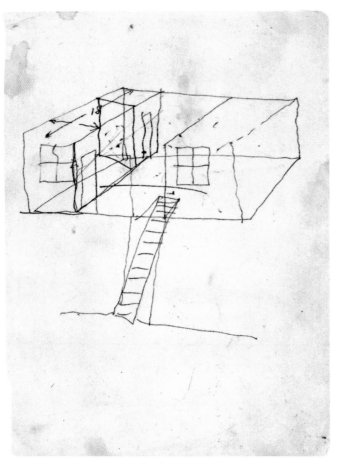

117 Diagrammatic sketch of 7 Reece Mews, c.1961

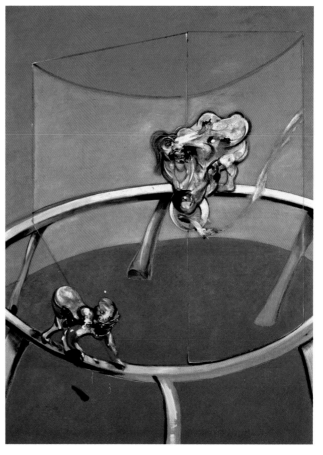

118 *From Muybridge 'The Human Figure in Motion: Woman Emptying a Bowl of Water/Paralytic Child Walking on all Fours'* (1965)

119 Postcard (formerly belonging to Francis Bacon) of the Casino at Monte Carlo, c.1935

Bacon probably made the sketch of 7 Reece Mews when he first acquired the property. His architectonic conception of space, in combination with other geometrical frameworks – metal railings, racecourse fencing – underpinned many of the paintings he made there.

120 *Van Gogh in a Landscape* (1957)

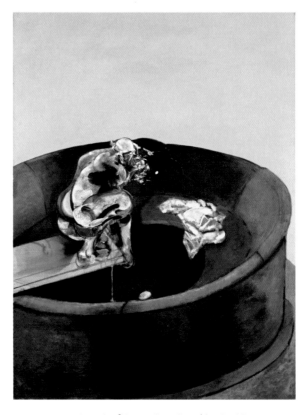

121 *Portrait of George Dyer Crouching* (1966)

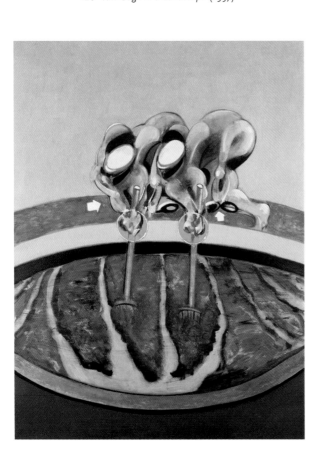

122 *Two Men Working in a Field* (1971)

123 Max Ernst,
Rêve d'une petite fille qui voulut entrer au Carmel (1930)

The ellipse in *Van Gogh in a Landscape* (1957), defined, from its high viewpoint, by the boundary of a footpath, coincided with Bacon's strong interest in Chaim Soutine. The swirling vortexes of Soutine's densely impastoed landscapes, such as *Houses at Céret* (*c.* 1920–21), informed both his vigorous application of paint and the exploration of elliptical internal boundaries. *Portrait of George Dyer Crouching* (1966) is a more psychologically complex reworking of the crouching figure in the first of Bacon's ellipses, *Figures in a Landscape* (1956–57). In this arresting painting of despair, the 'well' is reminiscent of the engraving of a zoopraxiscope appropriated by Max Ernst for his collage novel *Rêve d'une petite fille qui voulut entrer au Carmel* (1930).[8] There are many alternative sources for Bacon's elliptical enclosures. Besides those illustrated here, they may also have been informed by photographs of operating theatres, which, although none were found in Bacon's studio, he would have encountered in the medical books that fascinated him. The ellipse in *Two Men Working in a Field* (1971) is fused with one of Bacon's more unusual borrowings, a 'field' based on a photograph of an irrigation system in an agricultural manual, *Fundamentals of Soil Science* (1943). He found this at his sister's farm in Rhodesia (present-day Zimbabwe) in 1967, where he liked to sit on the porch reading farming books; his sister recalled his fascination with the country's field patterns and richly saturated ochre soils.[9] The protagonists in this impressive painting appear to be 'muckraking', and as Bunyan's Interpreter in *Pilgrim's Progress* informed Christiana, the Muckraker who 'could look no way but downwards' was demonstrating 'his Carnal mind'. But *Two Men Working in a Field* appears, irrespective of its title, to be set in a constricted interior, the abrupt demarcation between the 'field' and background eliminating realistic spatial recession – a *plein-air camera*.

The signs of comfort and relaxation usually associated with notions of domesticity were rigorously eliminated from the rooms in Bacon's paintings. Even when his figures are situated on couches, benches or beds they are seldom at ease. The studio at Reece Mews was a monastic cell where Bacon practised his engagement with flesh, and the living areas were similarly spartan – *unheimlich*. Regardless of his increasing prosperity they remained sparsely furnished, austere: colourful Moroccan bedspreads were his sole concession to luxury, analogous, perhaps, to the Turkish carpets or token ornament he allowed into some of his paintings. Both in his life and art these functional, bachelor pad interiors, 'machines for living in', recalled his Corbusian origins. Analyzing the shifting viewpoints and overlapping frames in the original photographs of Le Corbusier's Villa Savoye, Poissy (1929), Beatriz Colomina drew attention to the items – a hat, cigarettes, sunglasses – left, apparently casually, on the flat foreground surfaces. These traces of human presence are echoed, in Bacon's later paintings, by the – ostensibly incidental – incorporation of mundane items such as ashtrays, sculpture or discarded papers, forensic evidence of human activity.[10]

Atmosphere

Among the many early paintings Bacon destroyed was *Wound for a Crucifixion*, which had been included in the 1934 exhibition at the Transition Gallery. Thirty-seven years later it was the single work he 'still speaks of with great attachment and regrets having destroyed'.[11] *Wound for a Crucifixion* was 'set in a hospital ward, or corridor, with the wall painted dark green to waist height and cream above, with a long, horizontal black line in between. On a sculptor's armature was a large section of human flesh: a specimen wound, and a "very beautiful wound" according to Bacon's recollection.'[12] In the 1930s he submitted to surgery on the roof of his mouth to relieve a sinus problem. Was the draconian (and unsuccessful) operation the spur for *Wound for a Crucifixion*? Even an artist as adept at transforming the quotidian as Bacon did not filter out entirely from his work events in his life, and another painting he destroyed at this time depicted the 'dead body of Christ bandaged and laid on a table'.[13] Bacon, who frequently suffered beatings and drunken accidents, painted *Self-portrait with Injured Eye* in 1972 and continued the visual autobiography with *Sleeping Figure* (1974). In spite of his ability to withstand pain, he had a terror of hospitals: even visiting close friends or relatives in hospital was a traumatic duty. But he had to undergo a gall-bladder operation in 1974, and *Sleeping Figure* was painted from a photograph taken while he lay on the hospital bed. Naked and vulnerable, teetering precariously across the edge of a clinical, rudimentary bed, he is illuminated by an equally naked lightbulb in the bare, antiseptic room. It is like a painting of a nightmarish out-of-body experience, in which Bacon's theatre of operations became literally an operating theatre. But this disarming and unusually self-revelatory invitation to invade his privacy is partly withdrawn. We are denied an unimpeded gaze at the patient and instead have to peer through a glass door, painted, he said, as 'an afterthought'.[14] The screen is a typical Bacon deflection, a barrier like the glazing of his paintings, penetrable by the eye or the imagination but not physically.[15]

Bacon's recollection of 'beautifully curved rooms' assumes increased significance if it is applied to specific works. During the first half of his career only one painting incorporated curved bay windows with their light excluded by blinds, *Painting 1946* (pl. 47). They occur next in *Lying Figure* (1961), which may be a self-portrait or may depict Peter Lacy, and six months later recur in *Seated Figure* and *Three Studies for a Crucifixion* (pl. 167), both 1962.[16] *Painting 1946* and *Three Studies for a Crucifixion* were pivotal: Bacon considered them two of his most important paintings, and prime exemplars of the operation of chance or accident. But when he sold *Painting 1946* to Erica Brausen in 1946 (then with the Redfern Gallery, she became Bacon's dealer two years later), he did not attempt to build on this explosive breakthrough and instead left immediately for Monte Carlo, spending most of the next two years gambling. It was as though he recoiled from the pressure of following up on the

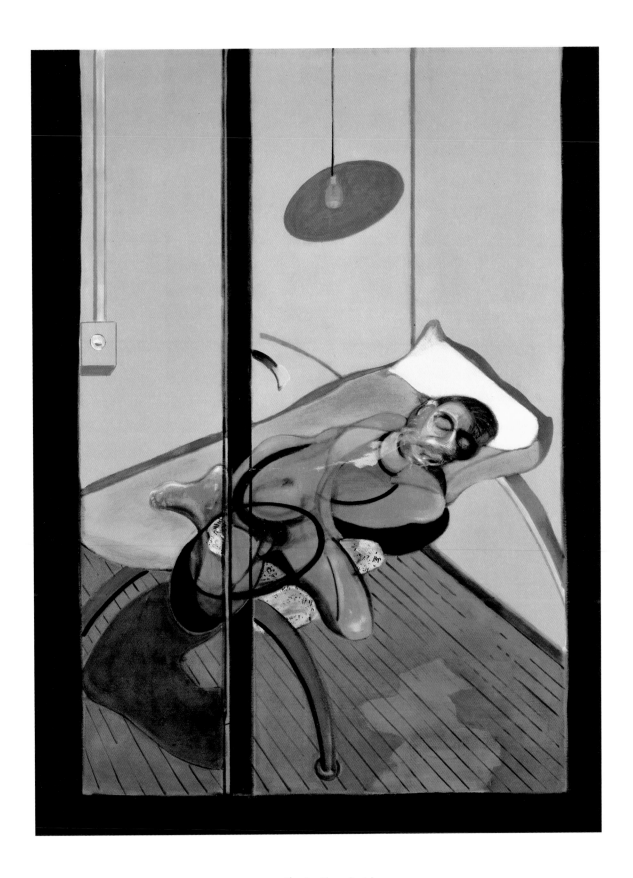

124 *Sleeping Figure* (1974)

125 E. O. Hoppé: Ground floor interior, 7 Cromwell Place, c. 1925

expectations his achievement had raised. *Three Studies for a Crucifixion*, completed in two weeks, was 'one of the only pictures I've been able to do under drink'.[17] The decisive work following the move to Reece Mews, it prefigured in many respects the paintings he made over the next thirty years, especially the voyeuristic and spectacular triptychs.[18]

Bacon's removal in 1943 to the ground floor of 7 Cromwell Place, South Kensington, affirmed his new sense of purpose, and it was there that he painted *Three Studies for Figures at the Base of a Crucifixion* (1944). Cromwell Place was built in 1861 as part of a speculative development by the architect Charles James Freake. Several of the properties were provided with large daylit artists' studios, and no. 7, comprising twenty-seven rooms, was taken by the Pre-Raphaelite painter John Everett Millais and his family. Millais moved to an even larger house in Palace Gate in 1877 and a succession of artists occupied the property – James Archer, Hermann Schmiechen and Margaret Murray Cookesley – until in 1912 it was leased by the eminent photographer Emil Otto Hoppé, who, trading on its historical cachet, renamed no. 7 'Millais House'. In 1936 the studio was taken over by the gifted ballet photographer (and brother of the dancer Ninette de Valois) Gordon Anthony.[19] Thus its previous occupants had been a prophetic mix of painters and photographers.

Bacon leased only the ground floor at Cromwell Place and could not at first, as is often assumed, paint in the former studio, for 'when the war started and the bombs came,

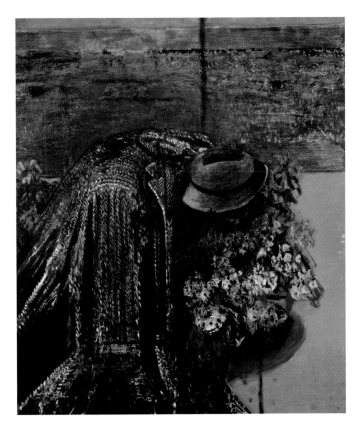

126 *Figure Study I* (1945–46).
The herringbone tweed overcoat in *Figure Study* (*c.*1945), *Figure Study I* (1945–46) and *Figure Study II* (1945–46; pl. 250)
appears to have been suggested by the sight of a coat slung over a cast-iron radiator, perhaps to dry out after a storm

the whole of the roof…was blown in'.[20] Instead he worked in the original billiard room which, like most of the ground floor, had been considerably modified by Hoppé. The artist Arthur Norris occupied the first floor, with Mrs Jesse and her son John on the second floor and the Misses Fletcher at the top. Betty Jesse was secretary to Tambimuttu, editor of *Poetry London*, a magazine distinguished by its artistic as well as its literary content. Tambimuttu was a regular wartime visitor to no. 7, as was Quentin Crisp, who on one occasion had to be patched up by Bacon and Miss Lightfoot after he had been beaten up. Only seven of the paintings Bacon made here between 1943 and 1948 have survived, and three of these were abandoned: *Figure Getting Out of Car* and the destroyed *Figure Study* (*c.* 1945) are known only from photographs taken by Peter Rose Pulham.[21] The arch form in their backgrounds is similar to a wall of the Cromwell Place studio, and until Bacon left for Monte Carlo in June 1946 the backgrounds of his paintings appear to combine elements of the former billiard room with rooms he remembered from the past (the painting studio was rebuilt at some time between 1946 and 1948, and latterly Bacon was able to reoccupy its larger space).

In November 1950 Bacon re-established contact with his mother, who lived in South Africa. He stayed there for four months, and also visited his sister Ianthe in Louis Trichardt. When Nanny Lightfoot died in June 1951 Bacon was devastated. Plunged into an emotional crisis, possibly exacerbated by guilt, he felt unable to stay in the space they had shared for

eight years and reacted by selling the lease of the studio to the painter Robert Buhler. He soon regretted this decision, and spent the next four years in self-imposed exile, enduring a nomadic existence as he continually moved between apartments and borrowed studios. He returned to South Africa in Spring 1952 where, inspired by the vast, open, bushed plains of Northern Transvaal, he stored up images that he would paint on his return to London. Unfortunately none of the photographs he took of the wild bush landscape, and of eland and baboons, have come to light. Landscapes formed the nucleus of his exhibition at the Hanover Gallery in December 1952, a selection that raised the hopes of timid critics, only to dash them, that his subject matter was becoming less disturbing. He preferred open, flat landscapes that recalled those of Counties Laois and Kildare, where he had grown up,[22] and in England, when inclined to temporarily forgo his distaste for the rural, he gravitated to the lowlands of East Anglia (he took a house near to his friends Dennis Wirth-Miller and Richard Chopping at Wivenhoe, Essex, in 1972, and bought a farmhouse in West Suffolk for John Edwards, where he stayed in the adjacent 'hut' and the dogs and cats kept by Edwards prevented his remaining for more than one or two days at a time). After the South African interludes he made only sporadic essays in landscape painting, mostly in Tangier. The mysterious, indecipherable forms in the marvellous *Landscape near Malabata, Tangier* (1963) are blurred as though caught in the vortex of a dust-devil: his impressive return to the genre with *Landscape* (1978) was sustained in the 'seascapes' he painted over the next decade (see pl. 130). Lengthy absences from London in the 1950s increased the pressure he felt under when obliged to complete work for exhibitions. Annoyed at Erica Brausen's understandable demands for new paintings, he sold privately through David Sylvester and exhibited with Helen Lessore at the Beaux-Arts Gallery in 1953, perhaps in a token rebellion.

It must be admitted that few of the paintings that Bacon began or completed in Berkshire, Oxfordshire and London between 1953 and 1955 support the hypothesis that his paintings and environment are correlated. The thematic of individual isolation in the seven versions of *Man in Blue*, painted while Bacon was staying at the Imperial Hotel, Henley-on-Thames, is not specific to that place, although it may have reflected his loneliness in a hotel room. But Bacon struck up a friendship with a well-known local character in Henley, the station master Alec Livingston. Since Livingston was familiar with *Study for a Dog* (1954) and *Figure with Meat* (1954), it may be gathered that they, too, were painted in Henley. Again they have no affiliations with the town, unless in regard to *Figure with Meat* it is relevant that in 1954 and 1955 Bacon stayed at 9 Market Place, Henley, a Georgian dwelling incorporating a delicatessen on the ground floor and next door to a butcher's shop at no.7. Bacon's unexplored fascination with railways, evinced in material such as pages from the *Railway Magazine* found in his studio detritus, may have informed *The End of the Line*

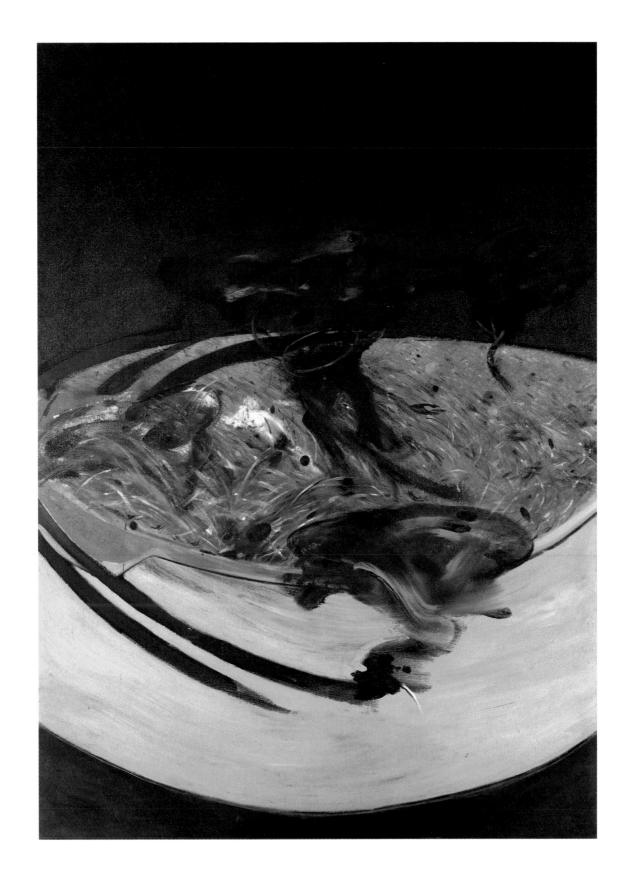

127 *Landscape near Malabata, Tangier* (1963)

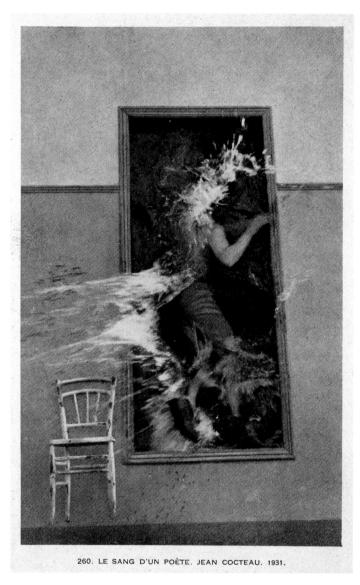

260. LE SANG D'UN POÈTE. JEAN COCTEAU. 1931.

Convergence.

128 Still from *Le Sang d'un Poète* (The Blood of a Poet) (Jean Cocteau, actual date 1930), reproduced in Nicole Vedrès, *Images du cinéma français*, 1945

129 'Convergence', plate of a reservoir, from Amédée Ozenfant, *Foundations of Modern Art*, 1931

In *Jet of Water*, Bacon aimed to reconfigure the essence of a breaking wave. He placed it within an artificial structure in order, paradoxically, to intensify its realism, to make it more 'factual'. He said he made the painting, of which he was exceptionally (if justifiably) proud, after seeing the sea break while staying in the South of France, but images such as the Cocteau still and the plate from Ozenfant (*above*) may also have been in play. The 1979 version of *Jet of Water* having been sold, he painted another version of the subject in 1988, to enable it to be included in his retrospective exhibition at the Central House of Artists, New Tretyakov Gallery, Moscow.

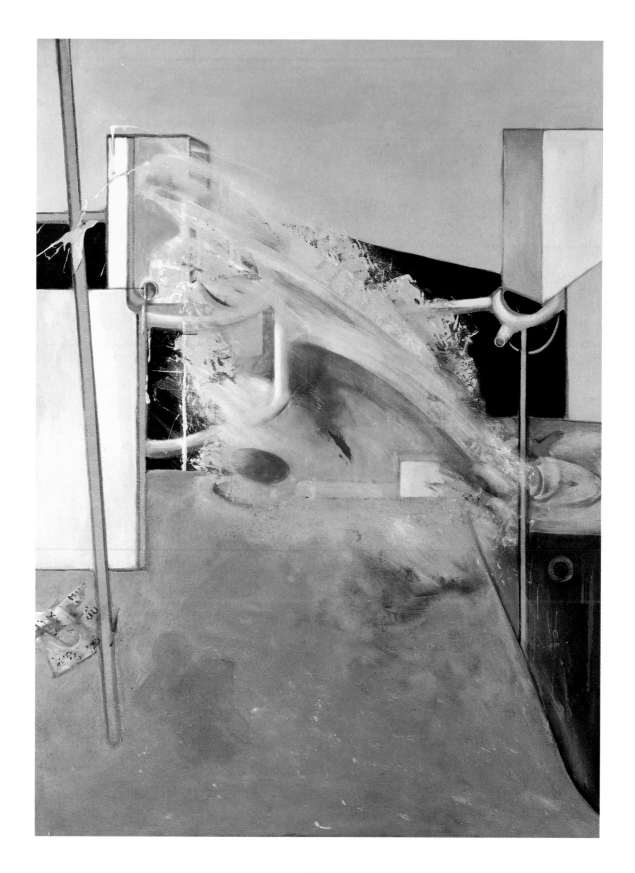

130 *Jet of Water* (1979)

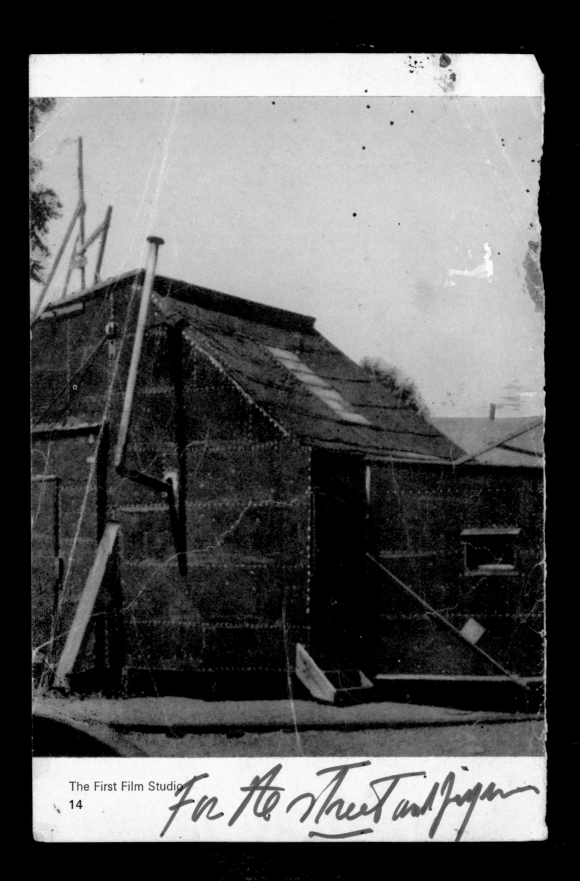

The First Film Studio

14

For the Street and fingers

131 Working document: 'The First Film Studio', page 14 from Liam O'Leary, *The Silent Cinema*, 1965, with annotation. W. K. L. Dickson's 'Black Maria' studio was erected in 1894 at Thomas Edison's laboratory at West Orange, New Jersey

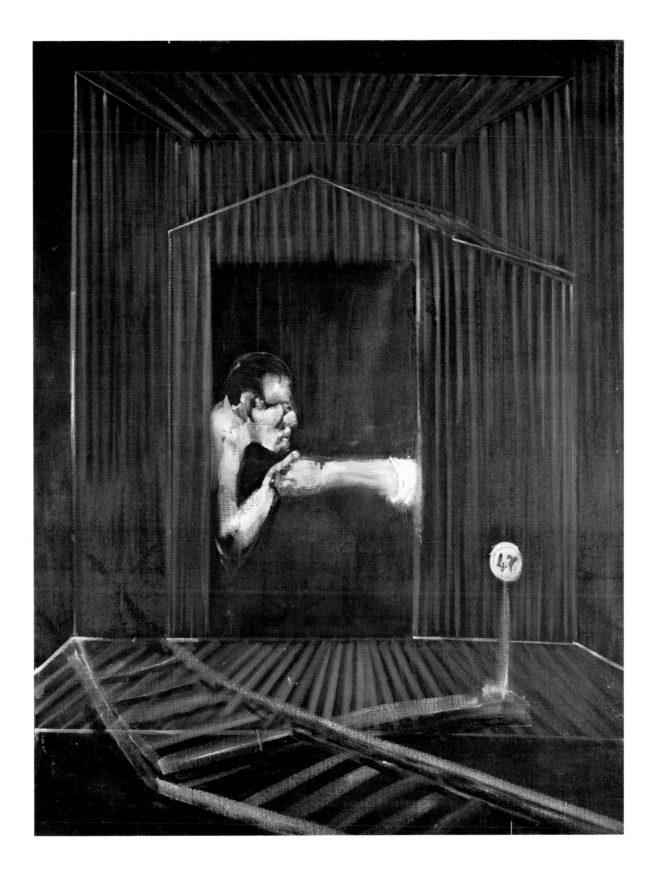

132 *The End of the Line* (1953)

133 Working document: photograph by John Deakin of Peter Lacy, *c.*1959

(1953). The original railway station at Henley-on-Thames (of which Alec Livingston was master) stood directly opposite the flamboyant late-Victorian Imperial Hotel. Henley was, moreover, a terminus, at the end of a branch line from Twyford. But the atypical *The End of the Line* poses several problems of interpretation. The ambiguous hand gestures – is this a kiss or a punch? – appear to be freely improvised from a drawing in *Phenomena of Materialisation* and may refer to the dead hand proferred by Ferdinand in Webster's *Duchess of Malfi*.[23] They would certainly conform with what is known of Bacon's relationship with Peter Lacy. The significance of the number '47' remains elusive (but see the production shot of *The Sheik*, pl. 48), while the corrugated shed structure appears to be related to a photograph of the 'first' film studio, W. K. L. Dickson's 'Black Maria', constructed in 1894. Bacon annotated a 1965 reproduction of this 'For the street and figures' and, although it is difficult to imagine the subject of *The End of the Line* fitting that description, Ronald Alley noted of the painting that 'Bacon had in mind to paint a series of street scenes'.[24]

Bacon remembered his sojourns in the district sourly, as 'just one luxury pub after another'.[25] He went there to be near to Peter Lacy, with whom he had fallen in love and who owned a cottage in Hurst, eight miles south of Henley, between 1951 and 1955. Although Lacy was 'the love of his life',[26] he called their affair a 'total disaster', his obsession with Lacy's beauty and wit as 'like having some dreadful disease'.[27] In one of the frankest of his remarks to be published, Bacon recalled Lacy's invitation to abandon painting and live 'in a corner of

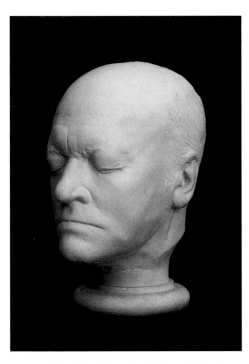

134 J. S. De Ville, *Life-mask of William Blake*, 1823 135 *Study for Portrait III (after the Life Mask of William Blake)*, 1955

my cottage on straw. You could eat and shit there.'[28] Lacy's cottage was situated next door to a pub, The Jolly Farmer, the proximity of alcohol doubtless helping to induce their violent rows. The abandoned canvases *Study of a Figure* (1954) and *Seated Figure* (1954) both represent caged men: it is hard to resist reading *Seated Figure*, in which a naked, startled figure, half-child, half-adult, squats in a kind of cot, as one of Bacon's most autobiographical paintings, a depiction of the life Lacy intended for him. (Bacon's characterization of the 'neurotic' Lacy was contradicted by the novelist Sidney Bigman, who met Lacy in 1961 and said he had never met anyone more in love or more destroyed by the break-up of that love.[29])

A series of studies from a life-mask of William Blake was apparently Bacon's final project in Henley. He eventually painted at least seven versions of Blake's head, of which five survive. They were undertaken as a favour to Gerard Schürmann, a protégé of the composer Alan Rawsthorne who had married Bacon's friend Isabel Lambert in 1954. Schürmann asked Bacon to provide a cover illustration for the score of his *Nine Poems of William Blake* and proposed as a model the 1823 life-mask of Blake by the sculptor and phrenologist James S. De Ville, which he took Bacon to see at the National Portrait Gallery, London. Bacon's paintings were not, however, done from De Ville's original plaster cast but from black and white photographs he obtained from the gallery. The copy of the cast (now in Dublin City Gallery The Hugh Lane) that is discernible in photographs of Bacon's Reece Mews studio was a gift from Lawrence Gowing, who bought a modern cast from the National Portrait Gallery

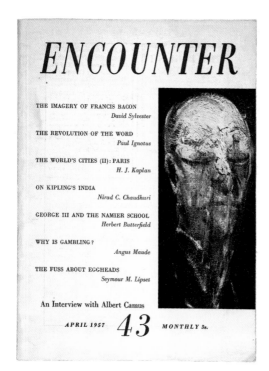

ENCOUNTER

THE IMAGERY OF FRANCIS BACON
David Sylvester

THE REVOLUTION OF THE WORD
Paul Ignotus

THE WORLD'S CITIES (II): PARIS
H. J. Kaplan

ON KIPLING'S INDIA
Nirad C. Chaudhuri

GEORGE III AND THE NAMIER SCHOOL
Herbert Butterfield

WHY IS GAMBLING?
Angus Maude

THE FUSS ABOUT EGGHEADS
Seymour M. Lipset

An Interview with Albert Camus

APRIL 1957 *43* MONTHLY 3s.

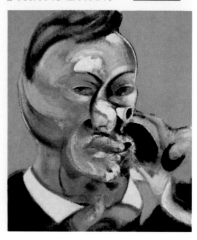

GERARD SCHÜRMANN
*Six Studies of
Francis Bacon* novello

136 *Encounter*, April 1957, front cover
including *Study for Portrait IV
(after the Life Mask of William Blake)*, 1955

137 Gerard Shürmann, *Six Studies of Francis Bacon*,
1969, score cover including
Study of Gerard Schürmann (1969)

in what he confessed was a misguided attempt to persuade Bacon to paint from the actual object. He doubted that it was unpacked at the time, but it may have been a catalyst in the shift towards increased plasticity in Bacon's figures later in the 1950s. The first three studies *After the Life Mask of William Blake* were painted in Henley, their small canvas size (24 x 20 in.; 61 x 51 cm) an eminently practical project for Bacon's makeshift studio. The etherealized heads have the appearance of X-rays, and their fluid, *grisaille* brushstrokes are augmented by flecks of pink (and eau-de-nil in the final version, painted in 1956). The flat, dark ground conforms to the backdrop in the gallery's photographs. In the event Schürmann's music was not published, although three of the songs were reworked in 1996–97 into *Six Songs of William Blake*. Bacon gave three of the Blake paintings to Schürmann, but borrowed them back for his exhibition at the Hanover Gallery in 1957, whereupon all three were sold at the private view. This does not seem to have impaired their friendship, for Schürmann composed *Six Studies of Francis Bacon* in 1968 and reproduced Bacon's *Study of Gerard Schürmann* (1969) on the cover of the score.

By March 1955 Bacon was back in London. His portrait of Robert Sainsbury, painted partly from life, was made in Michael Astor's studio at 28 Mallord Street, Chelsea, built in 1928 by the Dutch architect Robert Van t'Hoff for Augustus John. Astor, who had

138 Bacon's studio, 80 Narrow Street, overlooking the River Thames, *c.*1970 (photographer unknown)

recently embarked on his parliamentary career, was attempting to combine speaking in the House with attending art classes under Victor Pasmore at Camberwell School of Art. Bacon's preference was to paint by daylight rather than under artificial lighting, but uneven or interrupted illumination disturbed him, and the north-facing skylight of the otherwise 'beautiful studio' at Mallord Street was partly obscured by a canopy of trees that swayed in the wind 'so that in the studio the light moved and it was like attempting to paint a picture under water'.[30] Bacon said that giving up his Thames-side studio in Narrow Street, Limehouse, which he owned from 1969 until 1985, was one of 'two regrets in my life',[31] but again the sunlight reflected from the river prevented his painting there. In the 1950s he had found it similarly impracticable to paint in Tangier, under what Paul Bowles described in *The Sheltering Sky* as the 'merciless light' from 'a metal dome grown white with heat'. In the autumn of 1955 Bacon's picture-framer, Alfred Hecht, asked Peter Pollock and Paul Danquah if they could offer his artist friend the use of a room in their flat, 9 Overstrand Mansions, Prince of Wales Drive, Battersea. Although Bacon was frequently absent in Tangier until 1959, pursuing the increasingly doomed relationship with Peter Lacy, he at least had a London base in which he was able to paint, if only intermittently, during the next six years.

On Abstract Ground

In October 1958 Bacon, claiming he needed to pay off a £5,000 gambling debt, 'double-crossed'[32] Erica Brausen and left the Hanover Gallery to sign a contract with Marlborough Fine Art Ltd. His first one-man show at the Marlborough was scheduled for March 1960, and as the handing-in date approached it induced in him the customary sense of panic. He had probably completed only six paintings by September 1959, when he travelled to Cornwall to look for a studio. In addition to his anxiety about the impending deadline there may have been personal motives for Bacon's uncharacteristic decision to eschew the metropolis for the coast. By now resigned to the futility of his relationship with Peter Lacy, he was also tiring of his current boyfriend, 'Ron', and hoped to shake him off there. He felt constrained, too, by his Overstrand Mansions studio, which was only twelve feet (4 metres) square. He rejected Penzance as a location and moved on to St Ives, intending to seek the advice of Barbara Hepworth (with whom he was unacquainted) about renting a space there. She recommended her ex-pupil, the sculptor John Milne, but in The Sloop, a favourite pub among the town's artist colony, Bacon chanced upon William Redgrave, whom he had met six years earlier at the Caves de France in Soho. Since 1955 Redgrave had been running the St Peter's Loft art school in St Ives with Peter Lanyon: Redgrave gave instruction in figurative painting and Lanyon in abstraction, but although Redgrave resisted sharp distinctions between the two (and experimented with abstraction), he has been marginalized as 'anti-abstract'.[33]

After a lean year, and with student numbers in decline as winter approached, Bacon's offer of six months' advance rental for 3 Porthmeor Studios, where Redgrave taught life drawing, was readily accepted. Redgrave's wife Mary, known familiarly as 'Boots', arranged living accommodation for Bacon in a flat above the Irish abstract painter Patrick Dolan. Bacon had elected to relocate – although he claimed to have been unaware of their presence there – amid the leaders of a reinvigorated school of abstract landscape painting. This was in spite of placing landscape at the bottom of his hierarchy of subjects, and his scorn for abstraction, which he dismissed as 'pattern-making'. In the previous year he had written: 'Abstract art…is itself an illustration or accident about nothing – it has only decorative values.'[34] He considered that abstraction appealed only to the aesthetic senses and should be restricted to the backgrounds of paintings, as a base for a figurative image. The greatest art, he believed, was driven by the tension between paint and subject. For his part William Redgrave, patronized by his peers in 'this fortress of abstraction' on account of his isolated pursuit of figuration, was delighted at the prospect of such eminent and eloquent support.

Porthmeor Studios were occupied at various times by notable abstract painters including Ben Nicholson, Wilhelmina Barns-Graham, Terry Frost and Tony O'Malley. They are long, tunnel-like spaces – camera obscuras again – each with a large rectangular north-

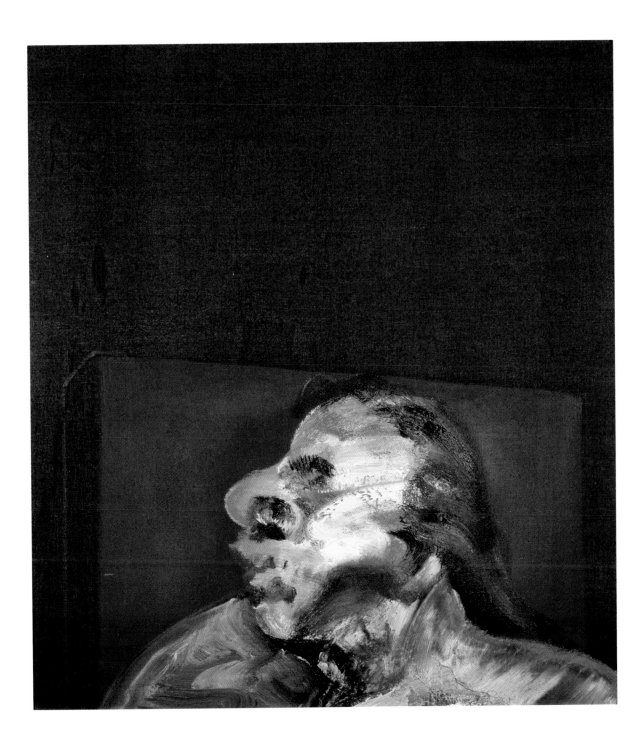

139 *Miss Muriel Belcher* (1959)

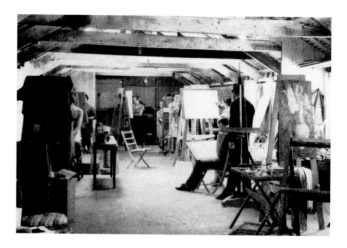

140 Roger Mayne: Wilhelmina Barns-Graham
at 3 Porthmeor Studios, St Ives, 1954

141 St Peter's Loft Art School, St Ives,
from Denys Val Baker, *Britain's Art Colony by the Sea*, 1959

light window letting out onto the horizontal planes of sand, sea and sky across St Ives Bay. Their interiors and the exterior view were probably decisive factors in determining the simplified planar grounds of the paintings Bacon made in St Ives. Among those that survive, *Miss Muriel Belcher* (1959) and the first of three portraits of Mary Redgrave (all three are titled *Head of Woman*, 1960; see pls 157, 158) deploy flat, geometrical backgrounds in different shades of viridian, their slightly inclined screens resembling the space dividers that are employed to this day in Porthmeor Studios. In *Study from Portrait of Innocent X by Velázquez* (1959) the Papal throne is stripped of its grandeur to become another Porthmeor screen, and Bacon retained this schematized formula in the six serial Popes he painted in 1961. The simple geometry of the backgrounds developed in St Ives persisted for a while following Bacon's return to Battersea in January 1960, probably on canvases begun in St Ives, for example *Homage to Van Gogh* (1960), and he retained the vividly saturated Winsor Green grounds throughout most of 1960. Twenty-five years later he continued to refer to this colour as 'Belcher's Green'.[35]

The St Ives artists were fiercely competitive. When the Redgraves sought Peter Lanyon's approval for the proposed arrangement with Bacon, he replied, 'Yes, certainly – he so loathes Patrick Heron.' In 1959 abstract art was perceived to be in the ascendant, with influential critics such as Lawrence Alloway committed to incorporating its British exponents within an international context. By the time of Bacon's Tate Gallery retrospective in 1962, the critical tide was turning back in his favour but, if only briefly, he had perceived a threat.

142 St Ives Bay: view from Porthmeor beach

143 Porthmeor Studios, St Ives

Redgrave noted that Bacon expected his arrangement with Marlborough to end in a year, 'and he'll be out as they are going to invest in Abstraction'.[36] His maverick reputation had preceded him to St Ives. Neither his cult success nor Ben Nicholson's chagrin at being ousted by Bacon from prime position at the 1954 Venice Biennale (Bacon owed this to the support of Lillian Somerville, Director of Art at the British Council) had escaped notice there. And he was more than equal to the taunts he had to endure from the local artists. One night Redgrave was in conversation with Bacon, Roger Hilton and Bryan Wall when Hilton announced he had wanted to meet Bacon because 'you are the only non-abstract painter worth consideration, although of course you are not a painter – you don't know the first thing about painting.' "Good," retorted Bacon, "I think my work is perfectly horrible. Now we can get together; you teach me how to paint and I'll lend you my genius." '[37]

According to Louis le Brocquy, Bacon's greatest antipathy was reserved for Patrick Heron, whom he would greet derisively in London, saying 'Look! Here comes the Prince of Colours and he simply loathes me.'[38] But he was sincere in his low opinion of the St Ives painters, and privately concurred with Redgrave's assessment that Terry Frost's series of *The Three Graces* was weak in conception, finding in its energetic application of paint only the simulation of pain, struggle, intellect or self-analysis. Yet he seldom bothered to censure artists to whose work he was totally indifferent. He stayed in St Ives for just over three months, and appears to have used the experience to push the transition begun in the Van Gogh paintings – the jettisoning of the all-over sepulchral space – the 'black cavern'[39] with

 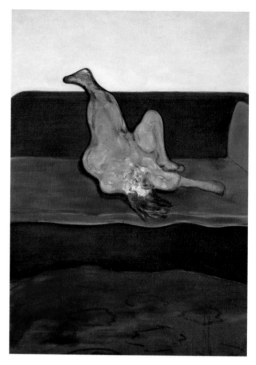

144 *Lying Figure* (1959) 145 *Reclining Woman* (1961)

its looming figures – and consolidated the shift towards flatter, simpler, brighter grounds and a greater distinction between the more painterly 'image' and the 'abstract' ground.

The paintings by Mark Rothko and Barnett Newman in 'The New American Painting' exhibition at the Tate Gallery, February–March 1959, have been proposed as catalysts for this change, but if this was the case it was not manifested in Bacon's paintings until after his arrival in St Ives. On the contrary, any effect the Americans had on Bacon was probably mediated through the work of the younger St Ives painters. The cool, Constructivist wing of the St Ives tradition initiated by Naum Gabo and Ben Nicholson in the 1930s had been supplanted by a more gestural idiom developed by Heron and Lanyon among others, inspired by the vigour of American Abstract Expressionism. Fortuitously – or was it, after all, intentionally? – Bacon's time in St Ives coincided with the period when its international profile was at a peak. Two distinguished Americans had stayed there shortly before Bacon's arrival, Mark Rothko visiting Peter Lanyon and the critic Clement Greenberg, high priest of Abstract Expressionism and 'shallow space', staying with Lanyon's great rival, Patrick Heron. Evidently Bacon suspended his animosity long enough to spend Christmas Day 1959 with Heron and his wife Delia at Eagles Nest, Zennor. In fact he socialized with many of the St Ives painters and must have become aware of

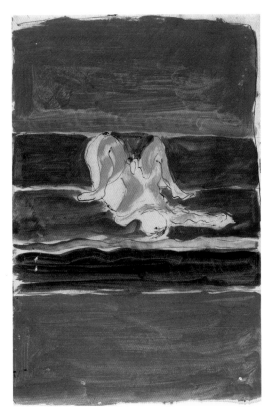

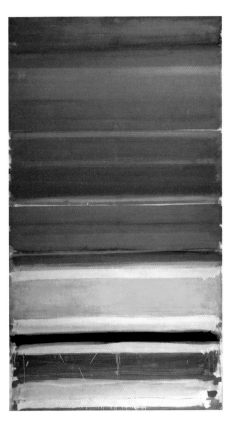

146 *Reclining Figure, No. 1 (c.* 1959–61)

147 Patrick Heron, *Horizontal Stripe Painting:*
November 1957–January 1958

their work, and he could not have missed Heron's paintings, since their studios were adjacent to one another.

Further compelling evidence of the significance of the St Ives phase is embodied in the 'Lying Figure' paintings begun in 1959. Four variants on this theme survive, three painted in 1959 and one in 1961, in which an awkwardly inverted nude lies against a couch with one leg raised and the other bent at the knee. In three of them Bacon placed the figure stretched out on a curved couch, which is identifiable as such and painted in perspective. But in the *Lying Figure* (1959) painted in St Ives, the couch is abstracted into three horizontal planes (pl. 149). Like Bacon's associated and probably contemporaneous sketches of reclining figures, its affinity with, say, Patrick Heron's *Horizontal Stripe Painting: November 1957–January 1958* is unlikely to have been entirely coincidental.

Bacon's simplified abstract backgrounds helped facilitate the transition between the recessive spaces and his later, flatter grounds but, while the importance of his backgrounds should not be over-emphasized, the distortion and idiosyncratic articulation of the lying figures reveal his strong interest in the sculpture of Rodin, a topic that has attracted little comment.[40] William Redgrave recounted Bacon's confrontation at St Ives with Brian Wall, who a year previously had been the first British sculptor to experiment with 'abstract' welded steel

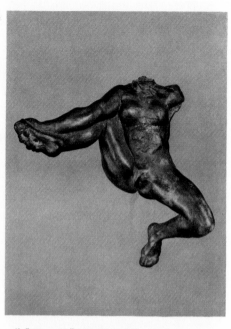

40. Figure volante (Iris messagère des dieux)
(1890-1891)

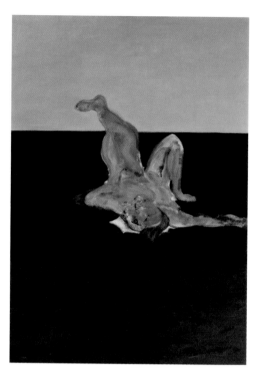

148 Auguste Rodin, *Iris, Messenger of the Gods* (1890–91), Fig. 40 from Henri Martinie, *Rodin*, 1927

149 *Lying Figure* (1959)

structures: 'I saw Bacon's long arm go round Wall's shoulders, and with his most disarming smile [he] asked him what he did. "I'm a sculptor." "How interesting," Bacon said, "actually there are only three: Michelangelo, Rodin and Brancusi." '[41] Rodin's dialogue with the human body, his exaggerated limbs, fractured forms and articulation of transitional movement, were evidently of vital importance to Bacon in the 1950s. A reproduction of *The Thinker* (1880) was among the items photographed by Sam Hunter in Bacon's studio in 1950. Rodin's extension of the energy field of the rectangular matrix in the *Gates of Hell* (1880s) is, moreover, a viable prototype for Bacon's arenas of action. Several of the works on paper in the Tate collection appear to represent intermediate stages between photographs of Rodin's sculpture and the transcription of animated lying, crawling, crouching and sleeping forms into the spatial frameworks that Bacon was in the process of revising. In Bacon's 'Lying Figure' series the splayed limbs and exposed genitals have clear parallels in two Rodins, *Flying Figure* (1880–81) and *Iris, Messenger of the Gods* (c. 1880–81). *Flying Figure* is identified specifically in the annotations he made between 1957 and 1959 in a copy of V. J. Stanek's *Introducing Monkeys*: 'use figure volante of Rodin on sofa arms raised' and on the same page he inscribed, 'Figure as Rodin figure on sofa in centre of room with arms raised'.[42] In the 1950s Bacon extended Rodin's Bacchanalian couplings into representations of sexual ambiguity, blurring male-female distinctions and roles. The 'Lying Figures' metamorphose from male, through androgyne in

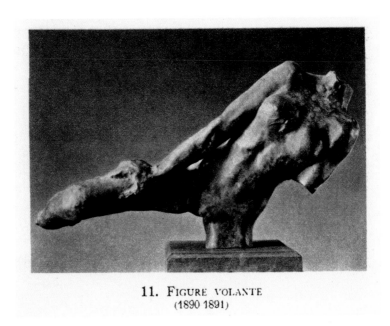

11. FIGURE VOLANTE
(1890 1891)

150 Auguste Rodin, *Flying Figure* (cast of 1890–91), Fig. 11 from Henri Martinie,
Rodin, 1927. Martinie's book was distributed in Britain by the Soho Gallery, London

the St Ives version, to ostensibly female in *Reclining Woman*, which, in spite of its title, has male genitals. Soon after, Bacon's mutated genderings polarized almost to the point of caricature. Rodin was a catalyst for a crucial adjustment in Bacon's syntax of the body. Formerly, though subject to his kinetic transformations, the postures of his figures (popes, businessmen) were relatively static, but about 1959 they started to become more animated in their gestures, more deformed, and were realized with greater sculptural plasticity. His human forms would develop within these revised parameters throughout the rest of his life.[43]

Rodin's synthesis of parts of the body – building from fragments – has been related by Hélène Pinet to the photographic technique of isolating a subject and framing it in the viewfinder.[44] Like his contemporary Medardo Rosso, Rodin was closely involved with the photographic representation of his sculpture, in which he collaborated with Eugène Druet, Jacques-Ernst Bulloz, and Haweis and Coles. Druet and Haweis and Coles employed highly interpretative, hand-manipulated *sfumato* effects in their prints, yet Rodin was seldom satisfied with his photographers, although he thought Edward Steichen's famous silhouetted portraits the work of 'a very great artist'.[45] Stephen Haweis, an artist briefly married to the poet Mina Loy, frequented the Parisian milieu of Rodin and Eugène Carrière and briefly assisted Alphonse Mucha. The almost art nouveau sinuousness of Bacon's figures around 1960 may reflect the *fin-de-siècle* aspect of Rodin as much as his vaunted modernism. The gum

151 Working document: photograph of Lee Miller by Man Ray, from *Minotaure 3–4*, 1933, mounted on a sheet of paper

From 1955 women began to occupy a more prominent place in Bacon's iconography, at first as portrait subjects and from 1957 as nudes; at least four of the paintings he began or completed at St Ives were of women. Icon and muse of the Surrealists, Lee Miller was already becoming a photographer, under Man Ray's tutelage, when he took this portrait of her, and she had also appeared in Jean Cocteau's *Le Sang d'un Poète* (see pl. 128). She was in many respects a prototype of the powerful, independent and creative women Bacon admired, such as Isabel Rawsthorne, Sonia Orwell and Joan Leigh Fermor.

152 Working document: reproduction of a George Platt Lynes photograph of Christopher Isherwood, 1946, pasted onto an unidentified French journal.
Isherwood's pose, inverted, is comparable with that of Bacon's *Lying Figure* (1959; pl. 149)

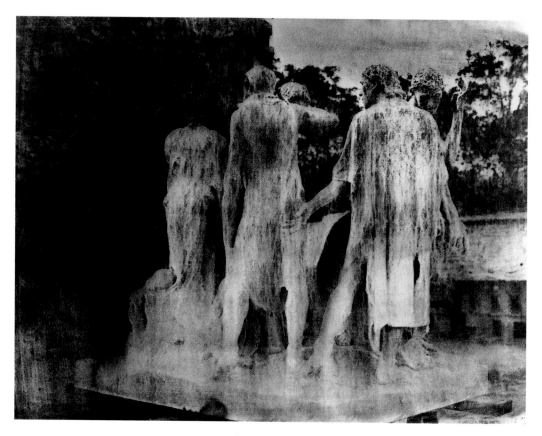

153 Jean-François Limet: Rodin's *The Burghers of Calais*, c. 1908

bichromates of *The Burghers of Calais* (*c*. 1908) taken by Rodin's *patineur*, Jean-François Limet are remarkable for their softened edges and disintegrated surfaces – instant patination – and again recall the symbolist paintings of Eugène Carrière. The dematerialization of forms in these photographs corresponds with the imperfections Rodin liked to retain in his sculptures, their accidental surface markings and 'unfinished' aspect. While the *photography* of Rodin's sculpture as such may not have registered with Bacon, fragmentation and erosion were fundamentals of his engagement with the human body: indeed he frequently studied the Elgin Marbles and 'often wondered' whether they struck him as 'more beautiful because they're fragments'.[46] *Flying Figure* was presented by Rodin as an autonomous fragment – the female torso severed from its source, *Avarice and Lust* in the *Gates of Hell*.

While sketching, Rodin roved around his models, who were themselves encouraged to move, recording their fugitive motion while constantly mobile himself – a technique that presaged the hand-held camera snapshot and the cinema's Steady-cam. Cecil Beaton noted that, while Bacon was painting his portrait, he worked 'with great zest, excitedly running backwards and forwards to the canvas with gazelle-springing leaps – much too bouncing';[47] neither, Beaton added, did he 'seem interested in my keeping still'.[48] His observations permit a glimpse of Bacon in the process of evolving his mature portrait style, in which he substituted photographs taken from multiple viewpoints for his own movement around the sitter. By the

154 Reclining figure, possibly Dionysus or Heracles (*c.*447–442 BC), one of the Elgin Marbles

time he painted *Three Studies for Portrait of Henrietta Moraes* (1963) this transition was complete. An aspect of German 'New Vision' photo-literacy that Bacon assimilated early in his career was flexibility in the framing and reframing of events, which he exploited in the radical cropping and readjustment of the field of his paintings. He adverted to this in 1946 when he wrote from Monte Carlo to Graham Sutherland: 'I am just banging the piece of canvas on the wall and it seems quite pleasant not to have the tyranny of the stretcher and be able to alter the dimensions as one wants.'[49] He told Cecil Beaton (whose portrait he later destroyed), that he 'hoped I wouldn't be alarmed by the size of it but that the portrait could be cut down, if necessary, when he had finished it'.[50] *Head of Woman* (1960) was 'cut down' after its return from St Ives. Its present dimensions are unique (35 x 27 in., 89 x 68.5 cm), but a photograph of Bacon in his Battersea studio, February 1960 (pl. 155), shows broad swathes of green at the bottom and left of the canvas. Bacon must have cropped off these 'superfluous' passages shortly before the painting was dispatched for exhibition.

The journalist Giles Auty rented a space near to Bacon in St Ives in 1959 and remembered 'talking with him during a long, sunlit afternoon largely on the subject of Bonnard'.[51] David Sylvester said Bacon praised Bonnard so highly 'that I had the impression that there was no twentieth-century painter he preferred'.[52] Shortly after Bacon returned from St Ives, Cecil Beaton was sitting to him in Battersea when 'from the piles of rubbish on

155 Cecil Beaton: Bacon in his Battersea studio, February 1960 (detail from a contact sheet of photographs). In the left-hand frame, *Head of Woman* (*opposite*, plate 158) is shown in its original state – before 'cropping'

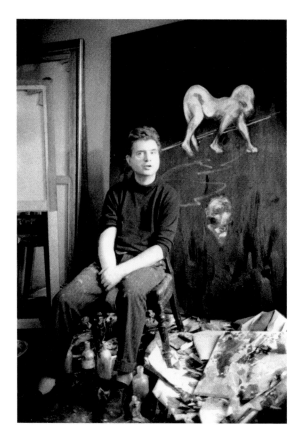

156 Douglas Glass: Bacon in his Battersea studio, early 1960. Bacon is seated in front of a version of the Muybridge paralytic child that incorporated a Pope figure. It was an odd conjunction, and Bacon evidently destroyed the painting, of which this photograph is the only record

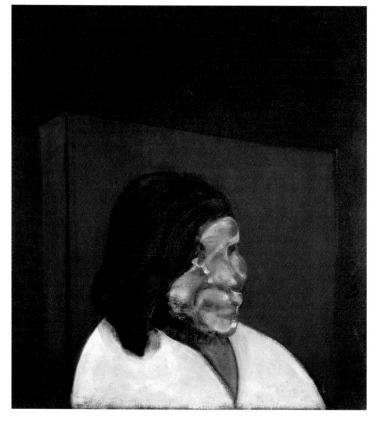

157 *Head of Woman* (1960)

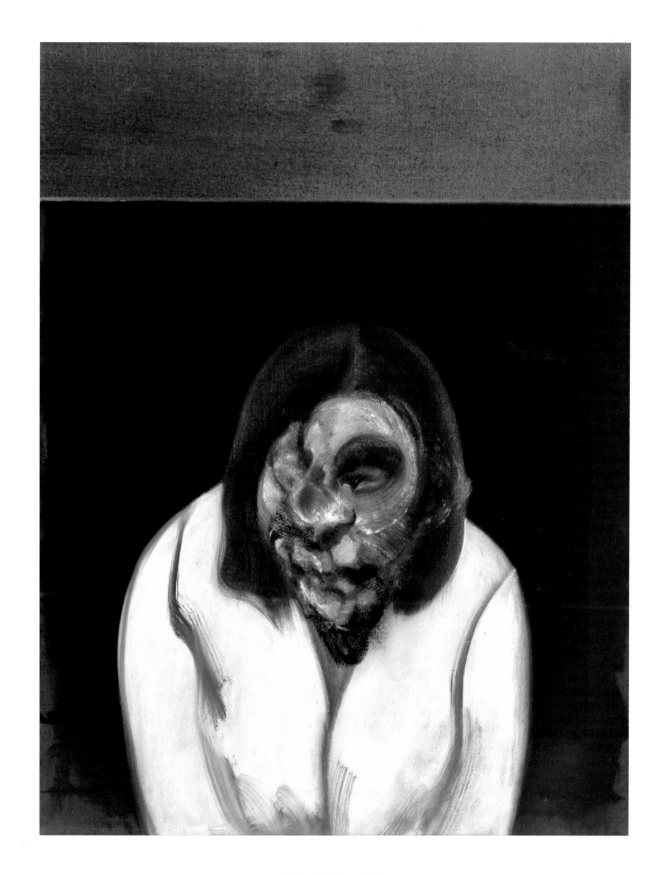

158 *Head of Woman* (1960)

159 3-D image from *Lilliput*,
December 1953–January 1954

160 3-D image from *Picture Post*,
21 November 1953

161 *London Life*, June 1949, front cover

162 *London Life*, June 1949, back cover

The unusual anaglyphic shadow in Bacon's *Two Figures in a Room* (1959) (*opposite*) may have been inspired by the 3-D film boom, which began in Hollywood in 1953 and continued in Britain until 1957. Comics and magazines also exploited the craze, and were issued with free spectacles that had red and green 'lenses'. 'Kinemacolor', a two-colour film process that also used red and green filters, had been developed in the early 1900s. Two-colour printing was seen in British magazines such as *London Life* from the 1930s. Bacon explored similar red and green combinations until the 1960 painting *Homage to Van Gogh*, occasionally returning to the idea, for example in *Four Studies for a Self-portrait* of 1967 (pl. 189).

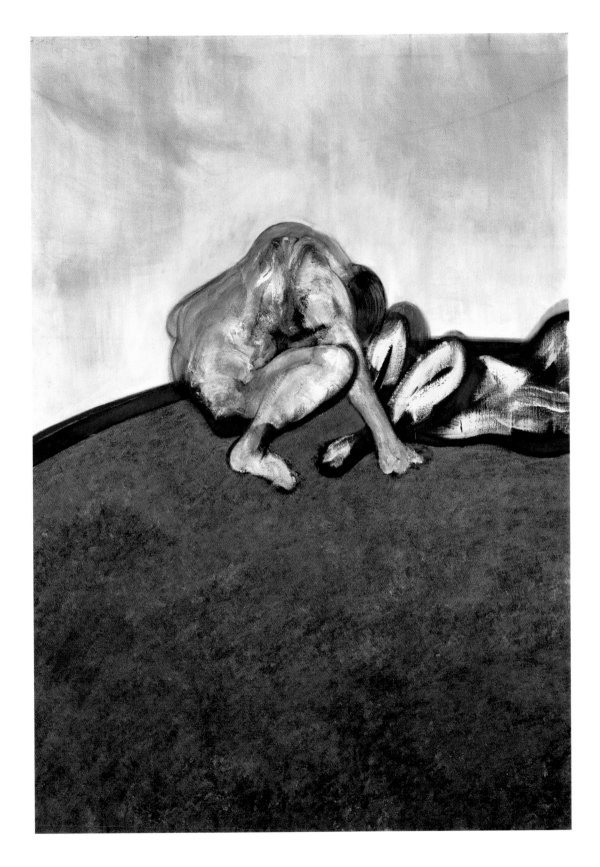

163 *Two Figures in a Room* (1959)

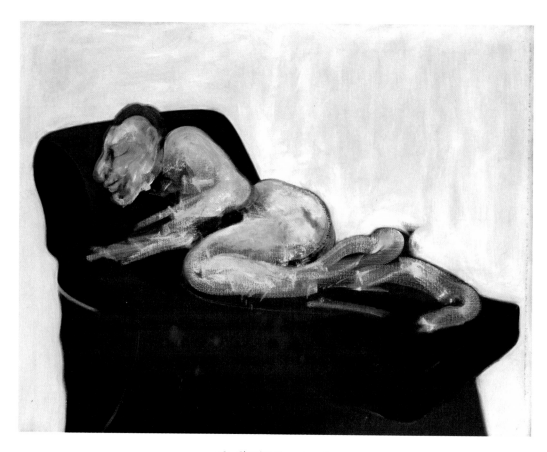

164 *Sleeping Figure* (1959)
Painted in St Ives, the landscape format of *Sleeping Figure* is unique in Bacon's œuvre post-1936

the floor Francis extracted a colour reproduction of a Bonnard he had cut out of *Paris Match* and stuck onto a piece of cardboard. The colours were vivid: oranges, reds, red-browns, brilliant blues... With outstretched arms, Francis enjoyed the picture to its fullest. "You see, people don't appreciate paint today...".'[53] Although Sylvester thought Bacon 'never seems visibly influenced by Bonnard',[54] his predilection for orange and scarlet in the mid-1940s was Bonnardian (if not exclusively) and his distorted, mobile anatomies of the 1950s may have been informed by Bonnard's nudes of the 1920s. Furthermore, the diffuse painting of the dappled carpet in *Man Carrying a Child* (1956) is comparable with the iridescent background of Bonnard's *Nu sombre* (1942–46). This distinctive carpet motif recurred, in even softer-focus variations, in Bacon's paintings over a long period, for example in the foreground of *Three Portraits: Posthumous Portrait of George Dyer, Self-Portrait, Portrait of Lucian Freud* (1973).

Of the works Bacon completed in St Ives, *Head of a Man* (1959) was painted from life and others may have been, although he could also have obtained photographs of his models. In terms of the wider impact of Bacon's ideas it may be significant that William Redgrave noted in his diary for 5 December 1959 that he had painted Winston Churchill 'using a *Sunday Times* photograph...the first picture I have painted from a photograph'. In response

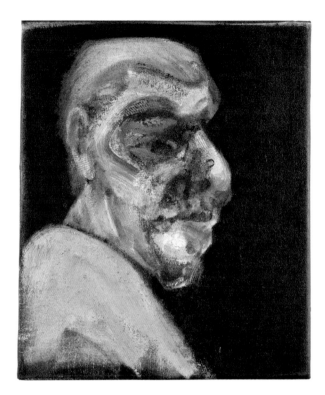

165 *Head of Man* (1960)

166 William Redgrave, *Francis Bacon* (1959), cast 1960s

to Bacon's encouragement to take up sculpture, Redgrave made a clay model of Bacon's bust which he fired in terracotta (St Peter's Loft incorporated a pottery) and subsequently cast in two bronze editions.[55] The sculpture's aptly Baconian immediacy was widely admired, by Bacon himself and also by Eric Estorick, Sir John Rothenstein and Sir Robert Sainsbury, who regarded it as a 'quite extraordinary likeness'.[56] No documentation has been found for Bacon's *Reclining Man with Sculpture* (1960–61), but it appears to be a self-portrait, and the sculpture in the foreground may have been painted from Redgrave's bust of Bacon.

Atavism

Bacon returned to London from St Ives on 4 January 1960. Following the first one-man show at Marlborough Gallery he did not exhibit again until the Tate Gallery retrospective in May 1962. The last paintings he made at Overstrand Mansions mostly reprised familiar themes, although the unexpected *Study of a Child* (1960) and the earliest known versions of the disturbing *Paralytic Child Walking on All Fours (From Muybridge)*, 1960, also belong to this period. The heads in *Pope no. 2* (1960) and *Study for a Head* (1960) are comparable with Gauguin's portraits of his friend, the artist Meyer de Haan. Gauguin's quasi-oriental

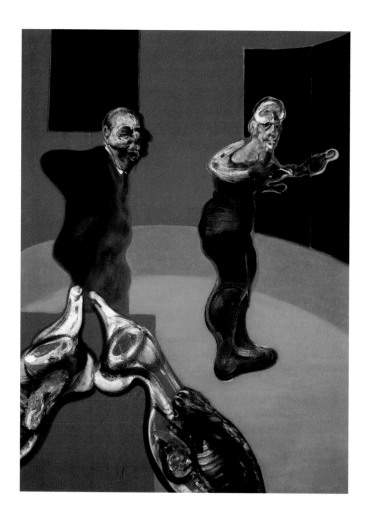

167 *Three Studies for a Crucifixion* (1962)

physiognomies (evident also in his self-portraits) are discernible in several of Bacon's paintings at this time: the period between 1956 and 1962 marked his closest engagement with Post-Impressionism. Among the last works Bacon completed at Battersea were the six Popes painted in 1961 – the compulsion to paint Popes was not relinquished until *Study of a Pope (Second Version)*, 1971. But with his rising international profile and a major Tate Gallery exhibition in prospect, there was a pressing need for a permanent work space. When he inspected what was to become his Reece Mews studio, in South Kensington, from 'the moment I saw this place I knew I could work here'.[57] The move to 7 Reece Mews in August 1961 brought to an end the ten-year period without a permanent studio of his own, and the change in circumstances was to have a profound effect on Bacon's life and art.

Immediately prior to the opening of the Tate Gallery retrospective in May 1962, Bacon completed *Three Studies for a Crucifixion*. It was his most ambitious painting since moving to Reece Mews, and 'a momentous turning-point in his development'.[58] Given that *Painting 1946* and *Three Studies for a Crucifixion* were so pivotal, the commonality of the curved background and drawn blinds (and their childhood associations) assumes increased

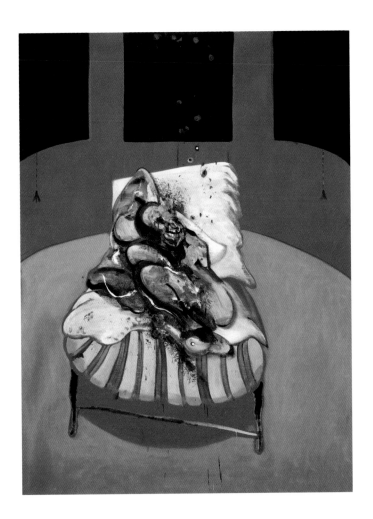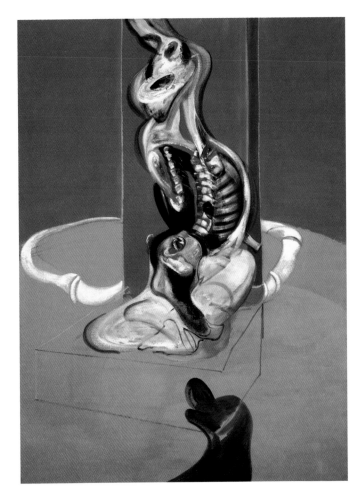

significance. Moreover, both paintings emerged from subconscious or altered states of mind, one through an aleatory process, the other from inebriation. And continuing the self-referencing, the painting that most clearly anticipated the simplified image/ground relationship in *Three Studies for a Crucifixion* was *Three Studies for Figures at the Base of a Crucifixion* (1944; pl. 36). *Three Studies for a Crucifixion* may embody further autobiographical meanings. In the central panel, lying on a striped mattress covering a brass bedstead, is a bloodied, fractured and distorted figure, foetal in its invertebrate writhing, which appears to conflate his birth with the bedrooms he maintained as ascetic arenas for masochistic sex. As Bacon commented, 'The very fact of being born is a very ferocious thing.'[59] The image in the right-hand panel resulted from his radical intervention onto Cimabue's *Crucifixion* (1272–74), a painting that reminded him of 'a worm crawling down the cross'. The undulating body metamorphoses into a flayed carcass, from the eviscerated 'abdomen' of which a head emerges in a reiteration of the natal motif, screaming as if in the pangs of birth. Michael Peppiatt convincingly read the triptych as a narrative sequence, and suggested that the left-hand panel depicted Bacon's expulsion from the family home by his father.[60]

168 Hans Bellmer, *La Poupée* (1936), cast 1965

169 *Diptych 1982–4: Study from the Human Body, 1982–4; Study of the Human Body after a design by Ingres, 1982*, right-hand panel

Besides their etymological link with homosexuality, Bacon's inverted bodies, beginning with the sexually ambiguous 'lying figures' in 1959, have obvious Freudian connotations in the reversed primacy of the oral and genital areas, and there were modernist antecedents for this in the work of Bellmer, Duchamp and Picasso. Bacon also owned two copies of Desmond Morris's *Manwatching*, 1977, which discusses breast-buttocks mimicry. The right-hand panel of Bacon's *Diptych 1982–4: Study from the Human Body, 1982–4; Study of the Human Body after a design by Ingres, 1982* is as much a response to Freud and to Bellmer as to Ingres, the source he was prepared to disclose in the title. In *Three Studies for a Crucifixion* the inverted form in the right-hand panel may have been informed by paintings of the *Crucifixion of St Peter*. St Peter's martyrdom, which at his request was performed head downwards on the cross, was a popular subject in religious art, and Bacon almost certainly saw three in the original. Towards the end of 1954, although Bacon was unsettled by Peter Lacy's decision to move to Tangier, they travelled together to Italy. They seem, however, to have parted in Ostia. Perhaps Lacy resented Bacon acting as his cicerone, but Bacon stayed on alone for two months, depressed and kicking his heels in Rome, where, in spite of his loathing for churches, he spent most of his time wandering around St Peter's. On this visit he famously denied himself the opportunity to see the original of Velázquez's *Pope Innocent X* in the Palazzo Doria. If this painting stood for *Il Papa* or Captain Bacon, evidently he had no desire to confront his father. But three versions of the *Crucifixion of St Peter* belonged to the

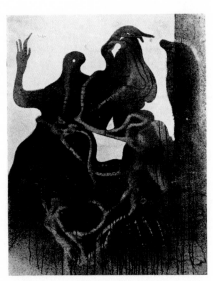

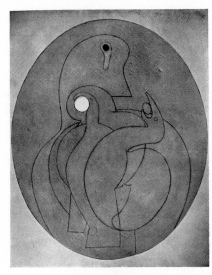

108. MAX ERNST
Couple zoomorphe en gestation. 1933

109. MAX ERNST
A l'intérieur de la vue: l'œuf. 1930

170 Double-page spread from Herbert Read, *Art Now*, 1933 (revised edition of 1948), showing works by Max Ernst

Vatican, a panel by Giotto on the Stefaneschi Altarpiece, Michelangelo's mural in the Cappella Paolina and Guido Reni's more dramatic and sensual treatment of the theme. Given Bacon's turbulent emotional state he may have been receptive to such powerful images of a painful death, and when he came to paint *Three Studies for a Crucifixion* another Peter – Lacy – was only a month away from drinking himself to death.

The biomorph lurching into the corner of the right-hand panel of *Three Studies for a Crucifixion* became a recurrent Baconian motif, a 'spectator' and a signifier of death shadowing life. The black sheep in Gauguin's *Le Christ Vert* (1889) is almost identical in orientation with Bacon's shadow, and Max Ernst's bird heads, such as *Bonjour Satanas* (1928) are comparable in form. Among the Surrealist painters, Bacon paid the closest attention to Ernst and to André Masson. His birds often resemble Ernst's, and the chronophotographs in Marey's *Le Vol des Oiseaux* (1890), a key source in the Surrealist pantheon, may have inspired both artists. Less perverse depictions of motherhood were a preoccupation of Henry Moore, the head form of whose sculpture *Mother and Child* (1936) is comparable with Ernst and with Bacon's shadow (the link is only speculative, but Bacon's equivocal interest in Moore is not negligible). *Mother and Child* was bought in 1937 by Roland Penrose, who erected it in the front garden of his house in Hampstead and aroused the hostility of his less *avant-garde* neighbours.[61] Despite having rejected Bacon for the 1936 International Surrealist Exhibition, Penrose contributed a text to the catalogue of Bacon's first Paris exhibition at the Galerie

Rive Droite in 1957. By then he had moved the sculpture to his country house in Sussex, where it remained in 1962, having provided Bacon with ample opportunity to see it. *Three Studies for a Crucifixion* announced a greater affinity between Bacon's presentation of forms and sculptures on display. His often-discussed plans to make sculpture never materialized, but in 1962 he experimented with making small-scale, three-dimensional maquettes. About five inches (13 cm) long, they fitted in the palm of the hand ('as though you're God'), and some incorporated a found object. These 'sketch-models', possibly intended as preliminaries to larger sculptures, appear to have been conceived to function serially, and probably related to the diptychs and triptychs he began to paint at this time, as well as to his mangled figures.[62]

Using Photographs

Before 1962, in spite of his exhaustive sifting of mass-media imagery and reproductions of paintings, Bacon seldom made use of original photographic prints – either his own or anyone else's. He had not, 'though he used the odd snapshot of Peter Lacy…quite got the idea'[63] of extending the camera's usefulness. The human forms painted by Bacon in the first half of the 1950s could be described as appearing and disappearing – in cinematographic terms as *dissolving*. In the latter part of the decade, when they referenced sculpture rather than photography, they *melted* on the surface of their flat grounds. But the transformation in his paintings in the 1960s was convergent with both the greater sophistication of his incorporation of photo-derived information and commissioning John Deakin to photograph models in predetermined poses. Engaging a third party was consistent with Bacon's habit, the arm's-length engagement with process analogous to all of his barriers and deflections. He later extended this practice, directing photographs taken by his friend John Edwards and by others. Regrettably little is known about the photographs taken by Bacon himself. He was capable of operating a camera, as attested by his surprisingly romantic photograph – more, perhaps, a visually literate snapshot – of his second cousin Diana Watson, taken at Byland Abbey, Yorkshire, about 1938, from which he painted the atypical *Miss Diana Watson* (1957). The painting is unusually mimetic of the photograph, and may, too, have influenced his thinking on the use of photographs and how their information might be assimilated into a non-literal transcription of a likeness. In the 1960s he took a series of carefully composed and technically proficient documents of his sister, Ianthe Knott, probably with a professional-quality medium-format camera, but no paintings from them have been identified.

Bacon explained that when painting a portrait, even of a friend, he preferred to use photographs as *aides-mémoire* since he found the presence of another person inhibiting. Photographs, he said, were more intimate, and besides he did not 'want to practise before them the injury that I do to them in my work',[64] although he went on to dispute 'whether the

171 Francis Bacon: Diana Watson,
Byland Abbey, Yorkshire, c. 1938

172 *Miss Diana Watson* (1957)

173 Working document: photograph, by Bacon, of Ianthe Knott, c. 1967

174 *Sketch for a Portrait of Lisa* (1955)
Bacon considered this his most successful use of 'shuttering'

175 Working document: plate from an
unidentified book, bust of Pthames

distortions which I think sometimes bring the image over more violently are damage…I don't think it is damage. You may say it's damaging if you take it on the level of illustration, but not if you take it on the level of what I think of as art.'[65] The familiar interviews with Bacon date from 1962 or later, when he had begun to use photographs almost exclusively, rather than paint in front of a sitter. But this was not always the case, especially in the 1950s. *Man Drinking* (1955), a study of David Sylvester, was painted partly from life, as were several other portraits in this decade, for example *Sketch for a Portrait of Lisa* (1955), the commissioned portraits of Mme. Suzy Solidor (1956) and Cecil Beaton (1960), as well as *Head of a Man* (1959).

Following wartime service in the Army Film and Photographic Unit, the painter-turned-photographer John Deakin had arrived in London in 1945. Bacon probably met him shortly after, either in one of their shared Soho drinking haunts or through the wealthy American Arthur Jeffress (Jeffress, who had been Deakin's lover and travelling companion before the war, was Erica Brausen's partner in the Hanover Gallery, established in 1948). Deakin worked briefly as a photojournalist, but in 1947 he was hired by *Vogue* and contributed fashion photographs and portraits to the magazine until 1954. Bacon's high regard for Deakin's photographs – he called his portraits the 'best since Nadar and Julia Margaret Cameron'[66] – may have contributed to misapprehensions concerning the nature of their collaboration. There is no evidence that Deakin's photographs affected Bacon's paintings, unless his first portrait of Bacon, taken in January 1952, suggested *Figure with Meat*

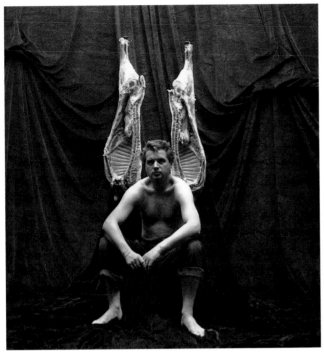

176 John Deakin: Francis Bacon, 1952

177 *Figure with Meat* (1954)

(1954), which would make this the unique instance of a 'painting-photograph-new painting' reciprocity. The photograph was taken at the Rathbone Place studio of *Vogue* magazine, with Bacon situated in front of elaborate black velvet drapes and flanked by carcasses of meat – props sanctioned by the carcasses in Bacon's *Painting 1946* (see pl. 47). Deakin's photograph was intended for an article on leading British painters written by Michael Middleton, and was due to be published in *Vogue* together with Deakin's portraits of Prunella Clough, John Craxton, Lucian Freud, Patrick Heron, John Minton, Victor Pasmore, Ceri Richards and Keith Vaughan. But according to the leader writer, Bacon 'was adamant in refusing to be photographed',[67] which was not entirely true, though whether Deakin had missed the deadline, Bacon disliked the photograph, or had temporarily turned shy of publicity, is a matter for speculation.

Soon after, in the same studio, Deakin made a striking portrait of Bacon's artist friend Isabel Lambert wearing a mysterious dark veil. In August 1952 he took the tightly cropped head shot of Bacon that has been widely disseminated and become one of the 'iconic' images of the artist. It was in the starkly incisive confrontational idiom that earned Deakin's portraits the epithet of fellow photographer Dan Farson that they resembled 'prison mugshots taken by a real artist'.[68] Described by Barbara Hutton as 'the second nastiest man in the world', Deakin was fired by *Vogue* in 1948, but re-hired four years later. After being sacked for the last time in 1954 he had no regular source of income, and several of his Soho comrades

178 John Deakin: Muriel Belcher, *c.*1964
Bacon probably referred to this photograph when painting the left-hand panel of *Three Studies of Muriel Belcher* (1966)

sought to find work for him. Bacon's voluble and witheringly sarcastic censure, even of his friends, was balanced by loyalty and generosity. He was probably motivated to employ Deakin as much out of sympathy for his plight as respect for his abilities as a photographer. Photographs were, after all, regarded by Bacon essentially as found objects and the question of their authorship was secondary, if not irrelevant.

Deakin's photographs did, however, contribute to Bacon's evolution into a major portrait painter. Somewhat tentative essays in the 1950s had scarcely established Bacon's credentials in this respect, although the verve and intensity of the painting in the obliquely perceptive likenesses of Muriel Belcher and Mary Redgrave (both 1959) presaged the more sustained attention he paid to portraits four or five years later. And as he pored over Deakin's contact sheets, two aspects of portrait photography may have reverberated with him. Deakin's 'models' were Bacon's closest friends: the Proustian poignancy of the peremptory click of the shutter, the morbid instant that betokened a fugitive moment in the life of his friends, inspired his musings on transience and loss. 'One of the great fascinations of old photographs,' Bacon said, 'apart from the texture, the scratches and stains and the general quality of them, is that you think, "Now they're all dead." '[69] More significantly, the hand-held camera's flexibility, its ability to rapidly switch viewpoints and catch its subjects' shifting positions, helped generate his revisionist assault on Analytical Cubism in the multiple perspectives and sweeping brushstrokes – arcing and slicing – of the great portraits of his maturity.

The first commission Deakin carried out on Bacon's behalf was to photograph Henrietta Moraes, nude on her bed, probably in late 1962. The sitting took place in the house she had inherited from John Minton, 9 Apollo Place, Chelsea, where Bacon himself had lived for a short time in 1955. Deakin, Bacon and Moraes had been friends since soon after the inception of the Colony Room, and Bacon must have known Deakin's nine-foot (3 metres)-high blow-up of Henrietta Bowler (as she then was), which was a prominent feature in David Archer's poetry bookshop in Greek Street, Soho. In 1956 Archer had staged an exhibition of 'John Deakin's Rome' that elicited an enthusiastic review from David Sylvester in *The Observer* and a rhapsodic one in *The Times* by Colin MacInnes, who spoke of Deakin's 'fund of affection, and at times of pity' and the absence of 'condescension or sentimentality'[70] from his photographs. But as Moraes confirmed, Deakin was carrying out Bacon's precise instructions regarding the poses she should adopt. Shortly after the first sitting the three of them were drinking at the Colony Room and Bacon announced that 'this blithering nitwit has reversed every single shot of you that I wanted'. He asked if Moraes would let Deakin 'do the whole thing all over again, but the other way up this time?'[71] The first painting whose origins can definitely be attributed to these photographs, *Lying Figure with Hypodermic Syringe* was completed by February 1963. It ended a five-month hiatus in Bacon's

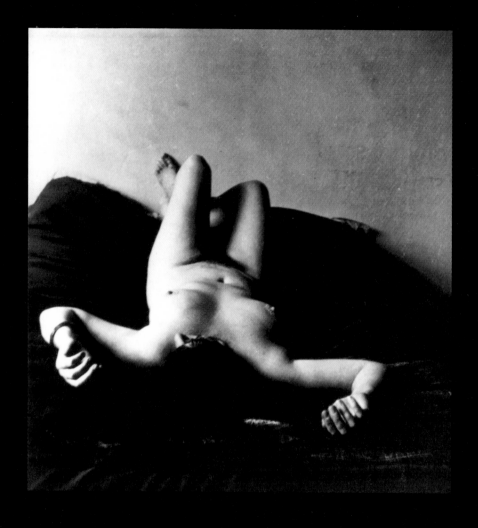

179 John Deakin: Henrietta Moraes, *c.*1963

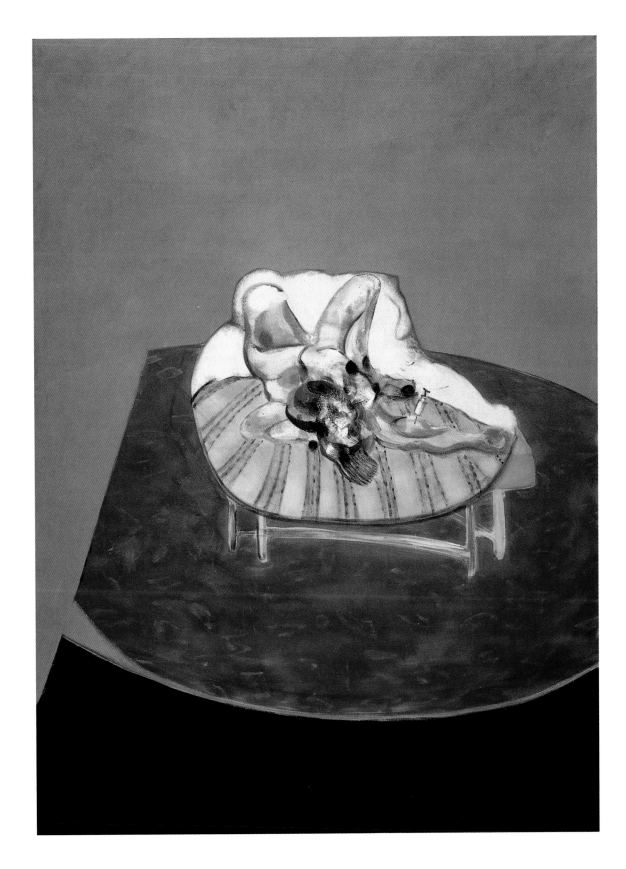

180 *Lying Figure with Hypodermic Syringe* (1963)

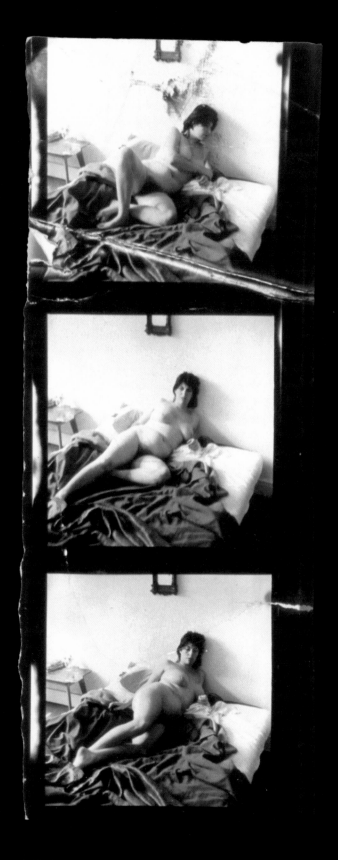

181 Working document: contact sheet of John Deakin's photographs of
Henrietta Moraes, *c.*1963, commissioned by Bacon (detail)

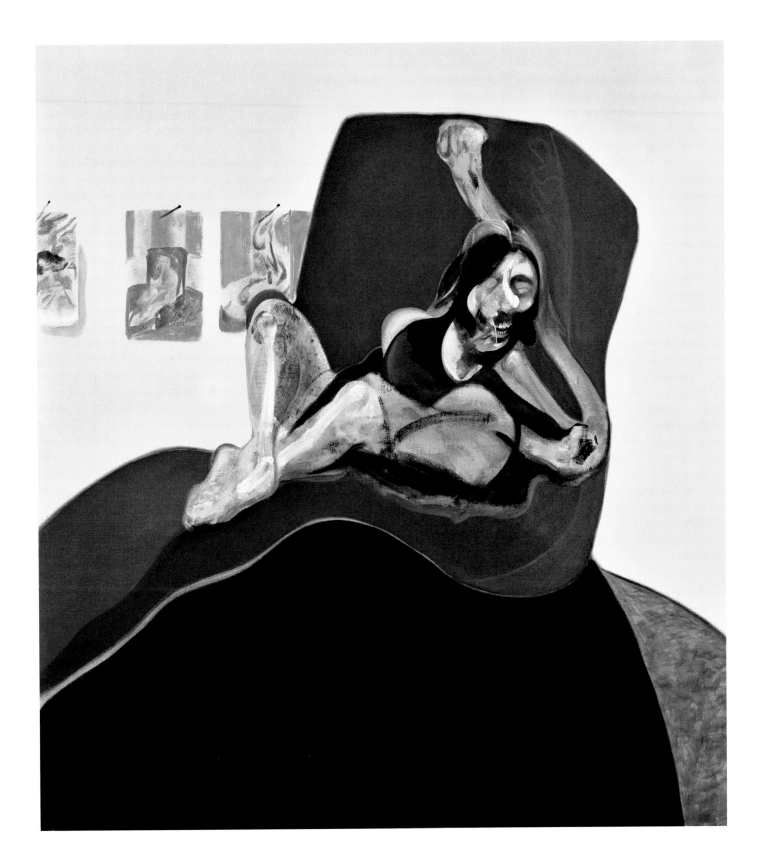

182 *Study for a Portrait* (1967)
Bacon, as was his usual practice, has combined limb positions from several of Deakin's exposures

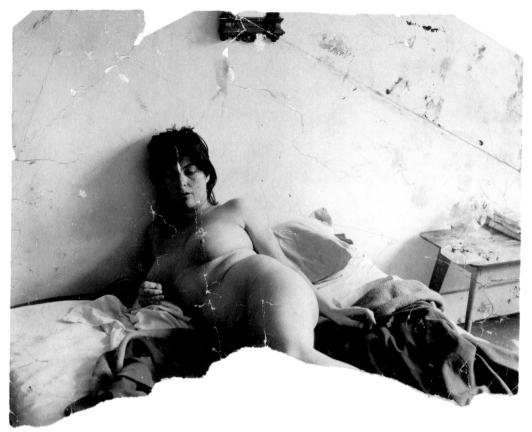

183 Working document: photograph of Henrietta Moraes by John Deakin, *c.*1963

production, when he was perhaps considering future paintings and how the information retrieved from Deakin's photographs might be integrated into them. The disparities between the photographs and the paintings complicate (or do they elucidate?) the analysis of Bacon's sources. The inversion of the figure was directed by Bacon, the limb positions are all altered in the painting, both bed and room space are reconfigured, and the provocative (and according to Moraes, prophetic) addition of the syringe was also Bacon's idea, adopted, as he disingenuously rationalized, because he wanted 'a nailing of the flesh onto the bed'.[72]

It should be stressed, too, that the reliance on Deakin's photographs was neither total nor immediate. *Three Studies for Portrait of Henrietta Moraes* (1963), for example, although painted slightly later than *Lying Figure with Hypodermic Syringe*, was done partly from life, and this may have been the case with other paintings around this time. Bacon probably saw the photographs as augmenting his cumulative image-bank of the human body, as a means of refining and developing postures, and providing accurate descriptions of foreshortened perspective. The nude photographs of Moraes, for example, deviate only minimally from the Rodinesque distortion of *Untitled (Reclining Figure)*, 1960. Since Bacon was no longer prepared to paint people with whom he was unfamiliar, and even among his intimates lengthy sittings were inimical to spontaneity, engaging Deakin to make photographic 'studies' under his guidance presented an ideal solution. These photographs fall into three categories: nudes, portraits and what might be termed 'street photographs' – semi-reportorial images taken in

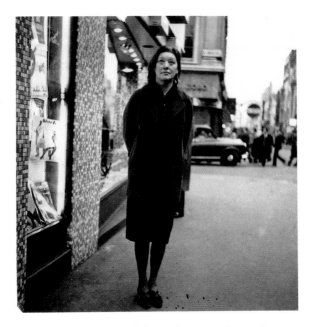

184 John Deakin: Isabel Rawsthorne in Soho, c.1965

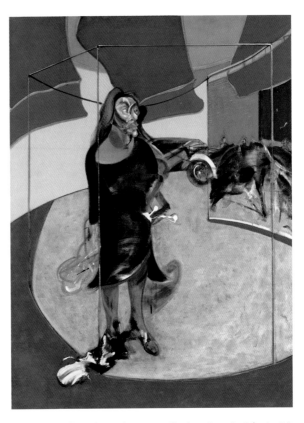

185 *Portrait of Isabel Rawsthorne Standing in a Street in Soho* (1967)

and around the streets of Soho. Deakin's *plein-air* photographs were used by Bacon in pictorially complex paintings such as *Portrait of Isabel Rawsthorne Standing in a Street in Soho* (1967), but neither in this case nor in the case of the profile head of George Dyer in *Three Studies for Portrait of George Dyer (on pink ground)*, 1964 (pl. 187), does the photograph appear to have been taken with a specific painting in mind. The head of Dyer (pl. 202) was cut out by Bacon from an existing photograph taken in Soho to make a template that was reused in several paintings. It was analogous, therefore, to a profile silhouette, a fashionable branch of portraiture that had been rendered obsolescent by the birth of the portrait photography studio in the 1840s.

Fundamental changes in Bacon's paintings from 1962 onwards are apparent on several fronts. The successful return to the triptych format in *Three Studies for a Crucifixion* encouraged further experimentation with plotless serial imagery, and thereafter the majority of his most prominent paintings were conceived in triptych form. Although Bacon thought Etienne-Jules Marey's chronophotographs – superimpositions of multiple images on a single plate – had depicted motion better, he preferred Muybridge's *Animal Locomotion* plates because the images were presented serially, and he believed (though he tended to select the single most suggestive image) that they may have influenced him to paint triptychs. It was of course expedient to cite Muybridge when deflecting questions about the relationship between his triptychs and religious altarpieces, but the triptychs insist on a kinetic reading in that the gaze is required to shift across the three panels.

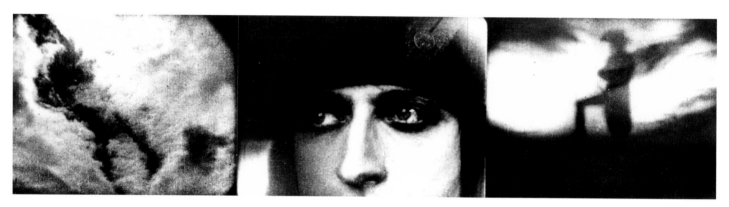

186 Still from *Napoléon* (Abel Gance, 1927), triple-screen sequence

Other factors may have contributed to the proliferation of triptychs. On the sheets of contact prints supplied by Deakin the twelve images from each roll of film were arranged in four rows of three – that is, reading laterally, as four 'triptychs'. Also, much earlier, in the 1920s, Bacon had seen Abel Gance's epic silent film *Napoléon* at the Paris Opéra, where it was premiered in April 1927. The film was originally shown through three projectors, producing a composite 'triptych' image, juxtaposing simultaneous close-ups and long shots (it also employed innovative *cinéma-vérité* hand-held camerawork, wide-angle and telephoto lenses, superimposition, single colour toning and hand-tinting). Gance himself acted Saint-Just, Antonin Artaud played Marat and the score was by Arthur Honneger. It is impossible to gauge the effect Gance's 'Polyvision' had on Bacon, but conceivable that he carried with him the memory of images flickering and pulsating on triple screens through to the 1960s.[73]

In 1964 the portrait head became one of Bacon's principal subjects. He followed his usual practice of standardizing a format (the greatly reduced scale, compared to his 'subject' paintings, of 24 x 20 in.; 61 x 51 cm) and although he painted them as single canvases and diptychs, triptychs predominated, usually arranged in a left profile-front face-right profile sequence – 'rather like police records',[74] as Bacon observed. The triptychs he painted of Muriel Belcher, George Dyer, Lucian Freud, Henrietta Moraes and Isabel Rawsthorne, and numerous self-portraits, formed a large proportion of his output in the 1960s, and he continued with this format well into the 1980s. Bacon's interest in taking self-portraits in automated photo-booths originated at approximately the same time as Deakin's portraits.

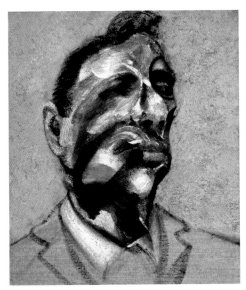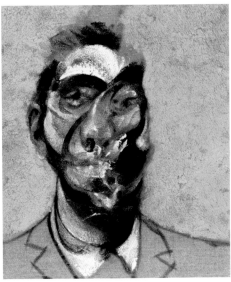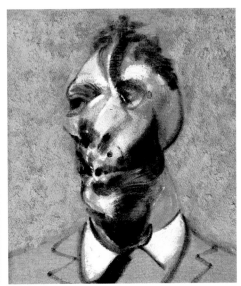

187 *Three Studies for Portrait of George Dyer (on pink ground)*, 1964

He also persuaded his friends to enter the cramped kiosks, and the resulting strips of images informed paintings such as *Three Studies of George Dyer (on pink ground)*, 1964. An upright, four-frame variant, *Four studies for a Self-Portrait* (1967; pl. 189), Bacon's only explicit reference to the Photomat strip as a vertical polyptych, was inspired by Photomat images he had taken of himself while visiting Stephen Spender in Aix-en-Provence in 1966. Photographs, painted in black and white, started to appear on the walls of the rooms in Bacon's paintings that had formerly been occupied by paintings of paintings – normally free variants of his own paintings. A *c.* 1970 black and white self-portrait, taken with a Polaroid Land 900 camera, became the basis for the right wing of an outstanding *Triptych March 1974* (pls 190, 191).

Photographs, then, appear to have accelerated Bacon's rationalization of the spatial organization in his paintings, as his interior spaces evolved from perspectival 'cages' to shorthand ciphers of rooms, denoted schematically by bare walls and perhaps a doorway or rear windows. In a further modification of his techniques, from the late 1960s Bacon began to use acrylic paints for his backgrounds, which, whether in acrylics or thinned oils were invariably rendered as simple, flat planes with little or no differentiation of tone. These changes fed into a further modernization of his idiom, in which his palette, generally higher in key than in the 1950s, was critical. The non-painterliness of the grounds, in addition to balancing the more expressive painting of the images, ensured the continued currency of Bacon's figurative idiom, which might otherwise have been received as anachronistic during the period of the supremacy of minimalism and conceptual art.

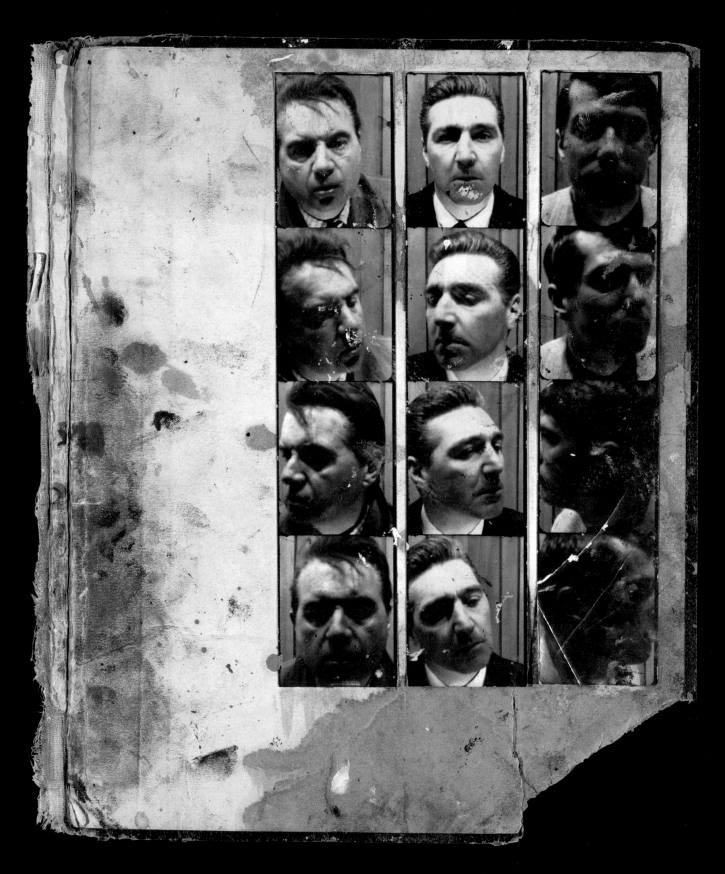

188 Working document: three photomat strips, of Bacon, George Dyer and David Plante, taken in Aix-en-Provence, 1966, pasted onto the inside rear cover of an unidentified book, c.1966–67

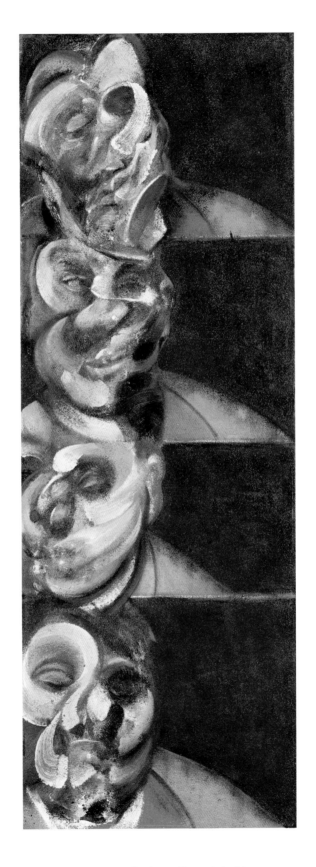

189 *Four Studies for a Self-portrait* (1967)

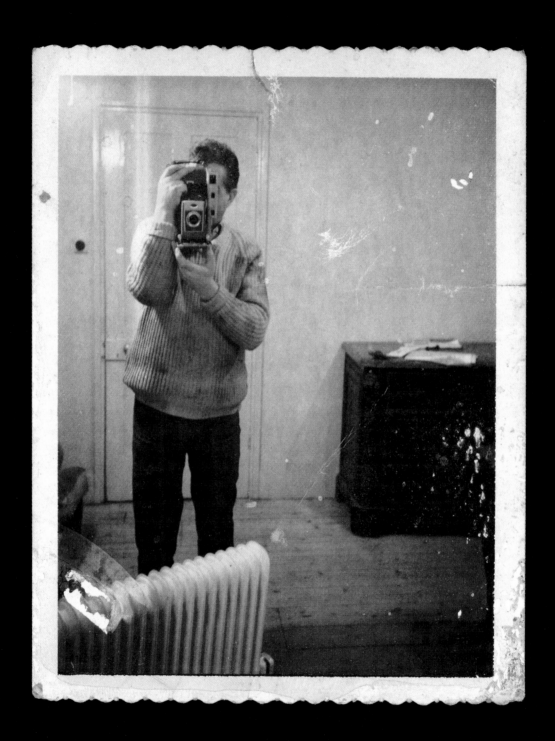

190 Working document: Polaroid self-portrait taken by Bacon in a mirror, *c.*1970

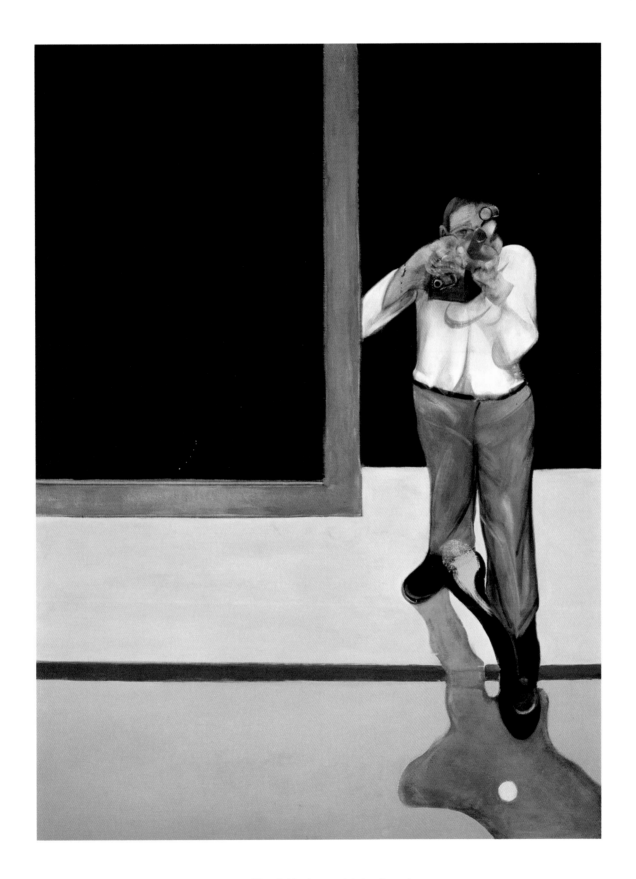

191 *Triptych March 1974*, right-hand panel

192 Working document: plate of
President Poincaré as manifested by Eva Carrière,
Fig. 194 from Baron von Schrenck Notzing,
Phenomena of Materialisation, 1920

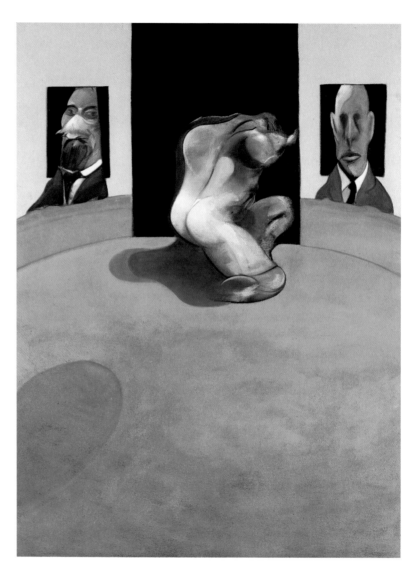

193 *Triptych 1974–77*, centre panel

Concurrently with this formal stylistic adjustment, Bacon acquired a new subject in Peter Beard, whom he had first met in 1965 at the London launch party of *The End of the Game*, the latter's moving documents of the struggle for survival of elephants and other African wildlife. Beard's theme had a special appeal for Bacon, and the two men became good friends and regularly corresponded. Bacon was also attracted to the photographer's handsome appearance. Between 1975 and 1980 he painted him many times, from self-portrait photographs given to him by Beard (see pl. 217), as well as from photographs supplied by Michel Soskine (whose photographs were also used by Bacon for his portraits of Michel Leiris). From 1980 John Edwards replaced Beard, in a sense, as Bacon's muse, though again Bacon never painted him from life. Edwards had been his closest companion since 1976, a friend, protector, confidant and surrogate son. Bacon actively encouraged his amateur interest in photography and came to regard him as 'my photographer'.[75] Among the many valuable documents that resulted from their friendship, and Edwards's intimate access, was a record of one of the few occasions on which Bacon relaxed his rule that forbade photographs (or film) of him in the act of painting (see pl. 216).

Triptych 1974–77 was characterized by David Sylvester as containing 'Bacon's most complex homage to Degas'.[76] A figure originally in the foreground of the centre panel which conflated two Eadweard Muybridge photographs of a 'Man Falling Prone and Aiming Rifle' was painted out by Bacon in 1977, clarifying the panoramic spatial matrix (and refuting claims that the simpler grounds reflected laziness on his part). Sylvester argued that while the 'strip of sea and the horizon are pure Matisse', the incidental details – the horses with riders, umbrellas, shadows – recalled Degas, and that the 'whole atmosphere' was indebted to yet another Degas painting in the National Gallery, *Beach Scene* (c. 1876).[77] *Triptych 1974–77* was Bacon's last homage to his deceased lover George Dyer, whose back view, inspired partly by the 'grip and twist' of the protruding spine in one of Bacon's favourite Degas pastels, *After the Bath, Woman Drying Herself* (c. 1888–92), appears in every panel. Bacon would admit to having foreseen only two elements of this painting, the heads in front of the black projection screens flanking the central figure. The head of Sir Austen Chamberlain (see pl. 6) was lifted from Ozenfant's *Foundations of Modern Art* and the image of another politician, Raymond Poincaré (see pl. 192), from *Phenomena of Materialisation*. Thirty years after painting *Three Studies for Figures at the Base of a Crucifixion*, Bacon was re-combining Degas and photography.

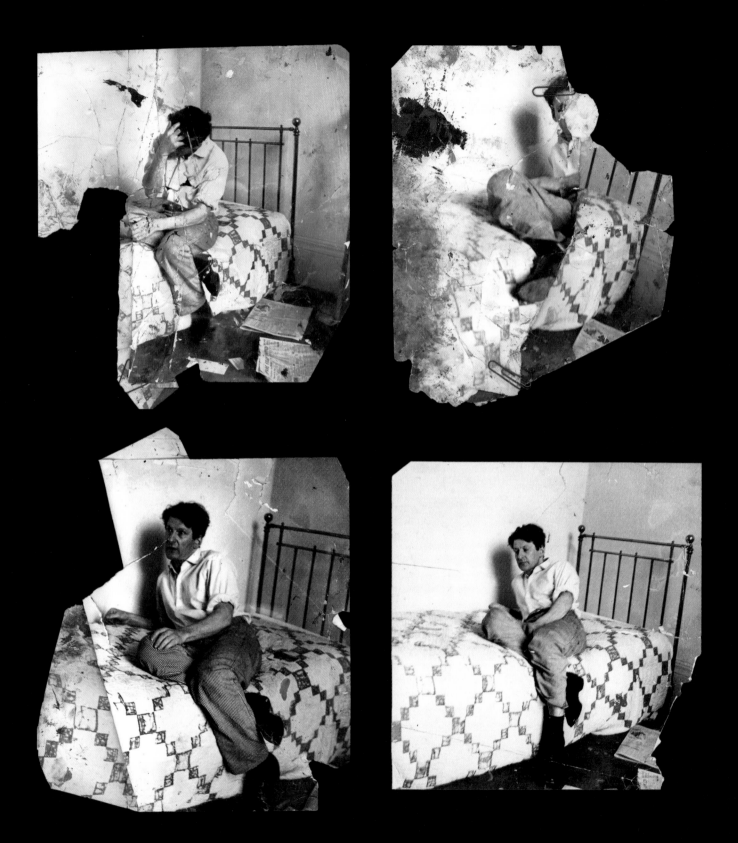

194–97 Working documents: photographs of Lucian Freud by John Deakin, c.1964

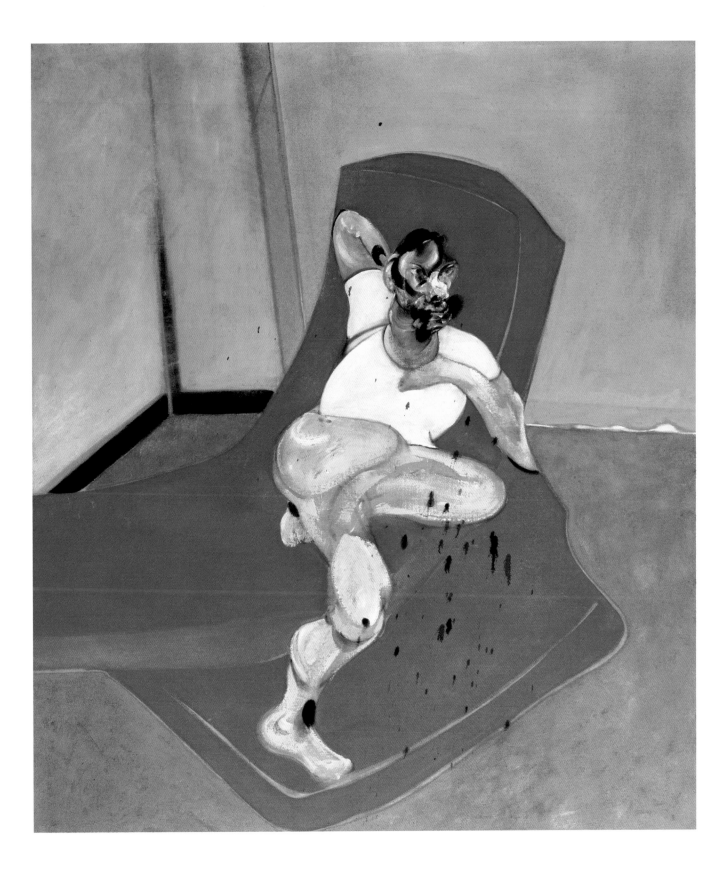

198 *Double Portrait of Lucian Freud and Frank Auerbach* (1964), left-hand panel (Lucian Freud)

199 Sketch drawing in ballpoint, *c.*1964, on an endpaper of G. Schmidt, W. Smallenbach and P. Bachlin,
The Film: Its Economic, Social and Artistic Problems, 1948

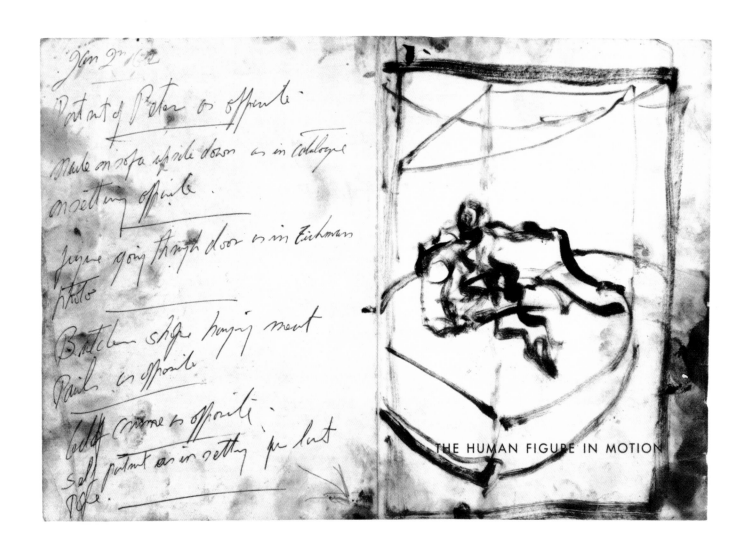

200 Sketch drawing in oils of a figure on a couch, on the half-title page of Eadweard Muybridge,
The Human Figure in Motion, 1955 edition, and on the facing page, a list of ideas for paintings, dated 2 January 1962

The drawing of the man on a couch (*opposite*) may be transitional between Deakin's photographs and a painting, or Bacon may have had photographs taken to conform with this conception. It appears to be related to the Lucian Freud portrait shown in pl. 198. Bacon painted daises similar to that in pl. 200 (*above*) on several occasions, for example in *Red Pope on Dais* (1962), but the figure with outstretched arms in the sketch corresponds closely with the painting *Man on Grey Couch* (1962), which Ronald Alley said was intended as a portrait: it almost certainly depicts Peter Lacy and is probably referred to in Bacon's list on the facing page: 'Portrait of Peter as opposite'.

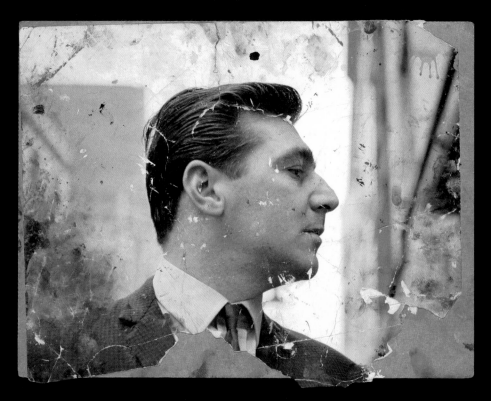

201, 202 Working documents: (*above*) photograph by John Deakin of George Dyer in Soho, *c.*1964,
mounted on card, and (*below*) Dyer's head cut out to use as a template

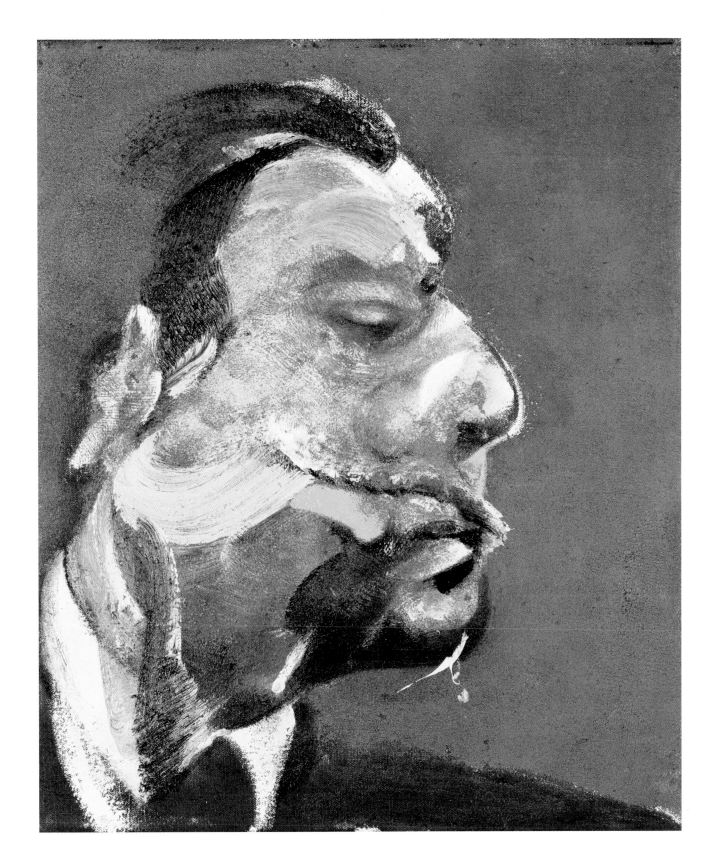

203 *Study for Head of George Dyer* (1967)

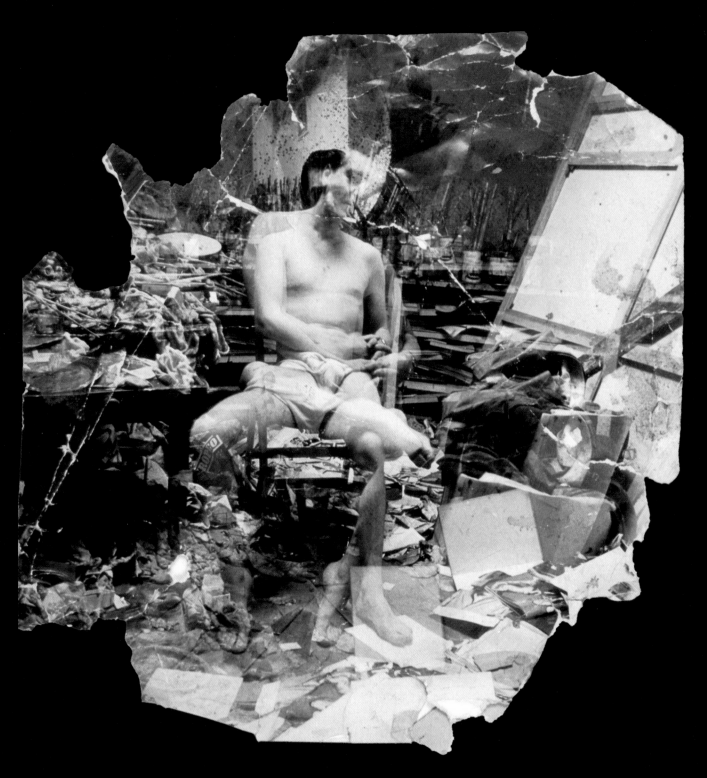

204 Working document: photograph by John Deakin of George Dyer in Bacon's Reece Mews studio, *c.*1965.
Since the multiple viewpoint resulting from Deakin's double exposure is virtually impossible to achieve accidentally
with a Rolleiflex camera, it seems likely that this was done at Bacon's request

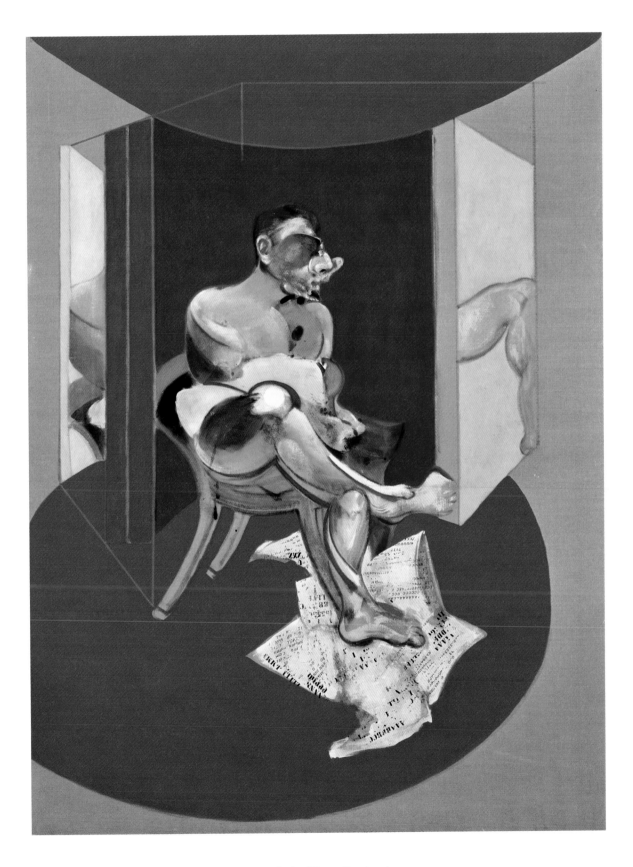

205 *Study of George Dyer* (1971)

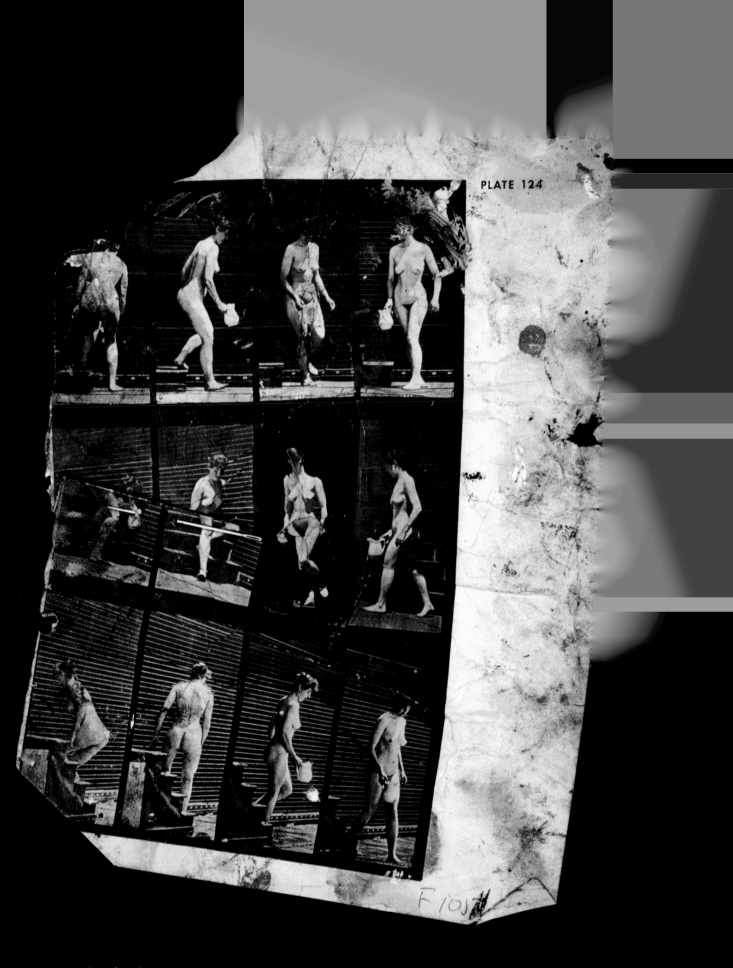

PLATE 124

206 Working document: Eadweard Muybridge, 'Woman Walking Downstairs, Picking up Pitcher, and Turning',
plate 124 from *The Human Figure in Motion*, 1955 edition. Bacon isolated the figure turning, *c.*1965,
in preparation for the figure in the left-hand panel of *Crucifixion* (1965) (opposite)

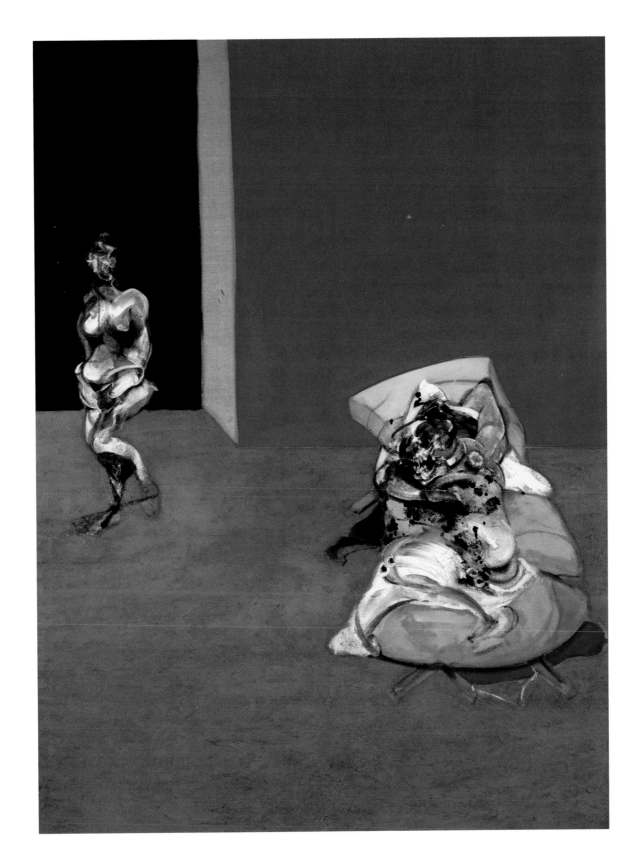

207 *Crucifixion* (1965), left-hand panel

Emmanuello Riva in Alain Resnais' *Hiroshima, Mon Amour*—thwarted love-affair in Japan.

heroine's consciousness the picture that has formed in her mind is shown to us; in this way the pressure of the past upon the present, the connection between what *has happened* and what *is happening*, becomes clear to us. There is a great difference between the flash-back; in *Hiroshima, Mon Amour* Resnais does and the conventional use of flash-back; in *Hiroshima, Mon Amour* present are interwoven in the mind to create the fabric of personality. The idea is fascinating and has many possible applications. (Joyce's *Ulysses* could be filmed by such a method.)

My objection to *Hiroshima, Mon Amour* is that its story is, basically, of the woman's magazine variety; and it is told in that over-wrought manner which is characteristic of some female writers—Marguerite Duras in this case—whose astigmatic vision is the result of a trying to see life entirely through their emotions. In this instance, we have the story of a French woman whose love affair with a Japanese is rather irritatingly blighted by the that true happiness will make her forget completely the German soldier whom she loved a girl and who was killed. While she remembers him, he lives; but to allow his face from her memory is to deny him even the limited life he still has in her mind. This seems me to be romanticism of the mushiest kind and, told in a more straightforward story might have provided a vehicle for Bette Davis in her heyday.

158 In *Last Year at Marienbad*, Resnais tries an even more offbeat technique result that many people found the film incomprehensible. My objection

RMas FIA 40

208 Working document: still of Emmanuelle Riva from *Hiroshima Mon Amour* (Alain Resnais, 1959), plate from an unknown book, paper-clipped onto cardboard, *c*. late 1960s

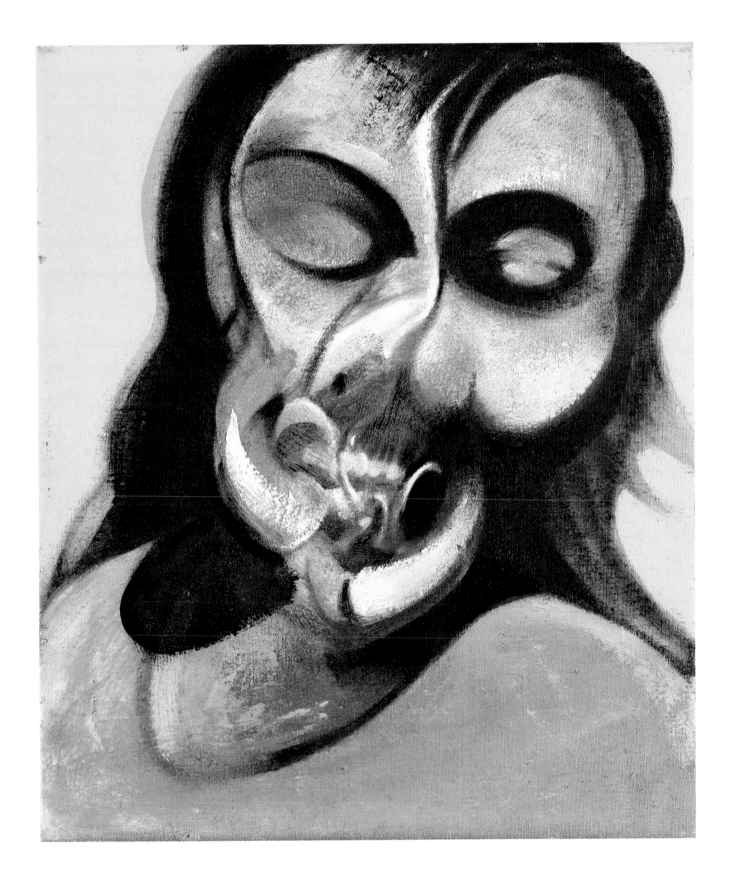

209 *Study of Henrietta Moraes* (1969)

210 Working document: sheet of Edsell Letraset,
found in Bacon's Reece Mews studio

At Roy de Maistre's studio, in about 1932, Bacon met the Australian writer Patrick White, who commissioned Bacon to design furniture for his flat. One afternoon they were crossing the Thames on a temporary footbridge from Battersea when Bacon 'became entranced by the abstract graffiti scribbled in pencil on its timbered sides'. White was 'quite elated' at this observation, and impressed that Bacon found stimulation in an ostensibly inconsequential detail of the urban fabric. Bacon's cousin, Pamela Matthews, testified to the astonishing scope of Bacon's visual fascinations, and the graffiti may have resonated with his interest in Egyptian hieroglyphics: Brassaï's seminal photographs of graffiti were published in *Minotaure* in 1933. Discernible in photographs of Bacon's Battersea studio in 1957 are reproductions of Charles Loupot's striking 'St Raphael' posters, then as now considered milestones of graphic design.

Triptych – Studies from the Human Body (1970) (*opposite*) was one of the first paintings in which Bacon 'sampled' Letraset. His 'collages' of adhesive letters recall Synthetic Cubism, but may have been precipitated by the crumpled newspapers that are often visible in photographs of his studio floor: Bacon stripped these of their narrative connotations in his paintings. They are also redolent of the 'cut-up' technique, developed by Brion Gysin and William Burroughs in 1959 (Bacon's long friendship with Burroughs began in Tangier in the late 1950s, when Burroughs was writing *The Naked Lunch*). Bacon was familiar with the non-linear typographical montages of Marcel Duchamp, Tristan Tzara and Max Ernst, and the British artist Gwyther Irwin had anticipated Bacon's 'collages' in works such as *Letter Rain* (1959). There are also parallels between Bacon's technique and the intercutting of the reportorial 'Camera Eye' sections in the American writer John Dos Passos's 'USA Trilogy', published in the 1930s.

As Bacon referenced photography with increasing self-consciousness, tripods and other photographic paraphernalia figured more prominently in his paintings. The inclusion of a semi-parodic 'camera' – more Sutherlandesque organism than machine – in *Triptych – Studies from the Human Body* allegedly fulfilled Bacon's intention of 'several years standing'.

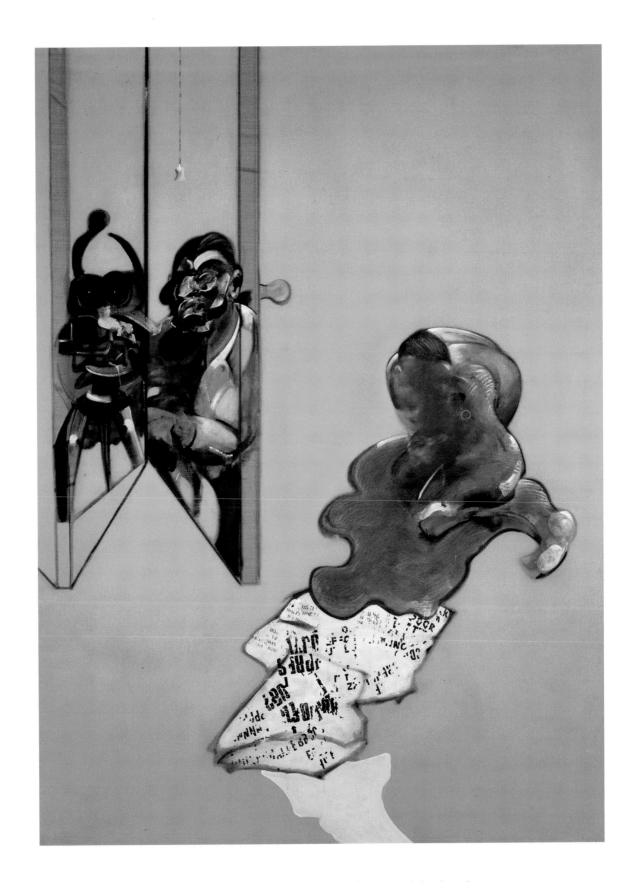

211 *Triptych – Studies from the Human Body* (1970), right-hand panel

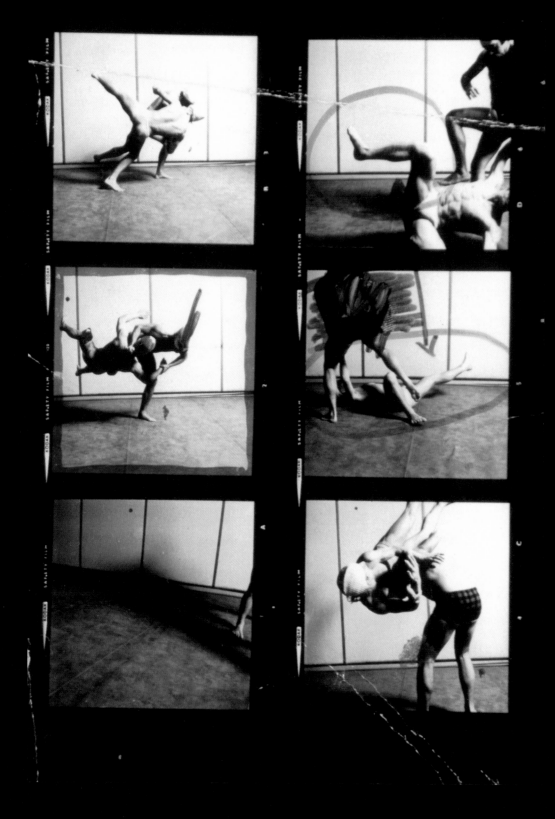

212 Working document: marked contact sheet of photographs of men wrestling in a martial arts dojo, New York,
*c.*1975 (detail). The photographer, as yet unidentified, was commissioned by Bacon to take these photographs

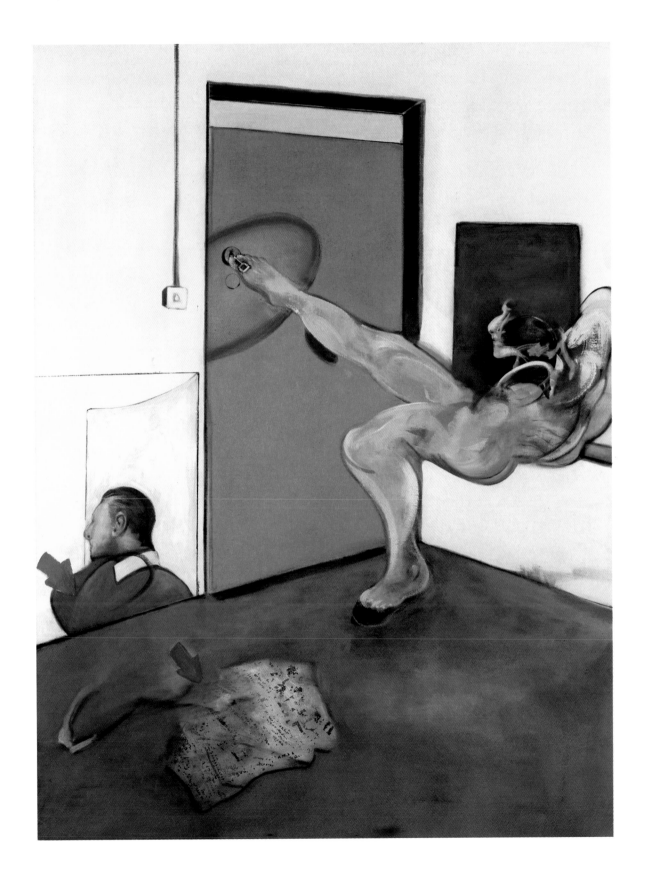

213 *Painting* (1978)

214 Francis Bacon: John Edwards, c.1980
One of a series of carefully composed photographs Bacon took of Edwards at this time, as studies for paintings

215 Bacon photographing John Edwards and Gilbert Lloyd, Berlin, 1986 (photographer unknown)

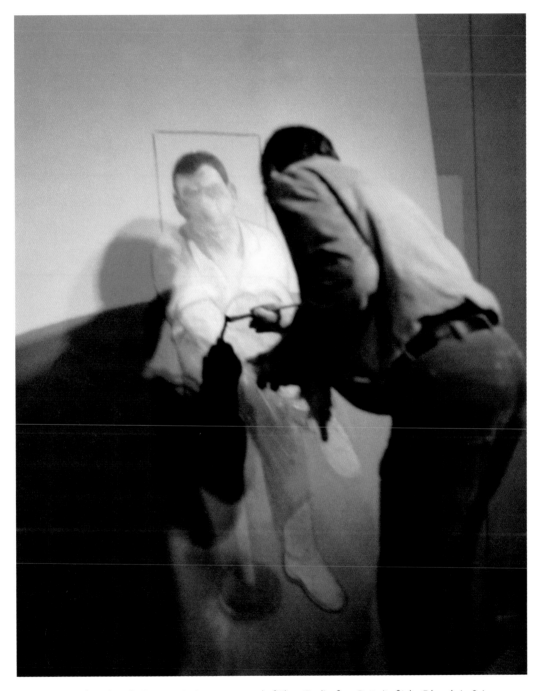

216 John Edwards: Bacon painting centre panel of *Three Studies for a Portrait of John Edwards* (1984)

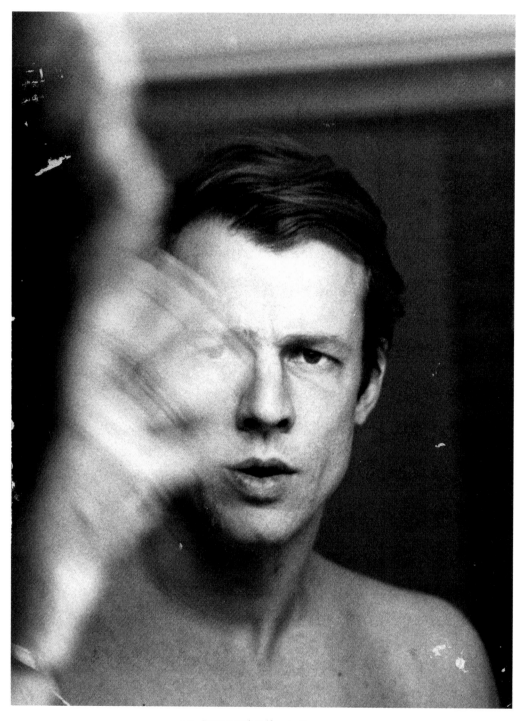

217 Peter Beard: Self-portrait, c.1970

218 (*opposite*) Peter Beard: Enlarged contact sheet of photographs of Bacon on the balcony of his house, 80 Narrow Street, Limehouse, London, March 1972 (detail)

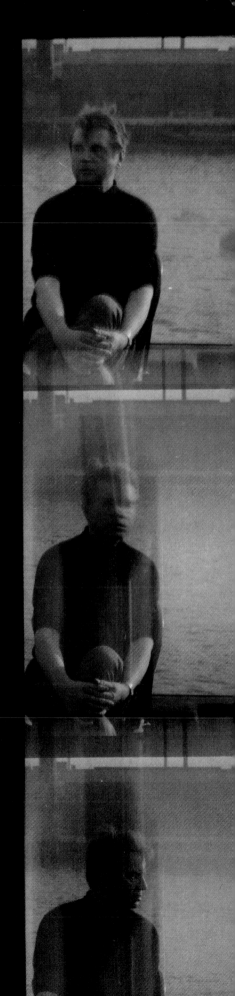

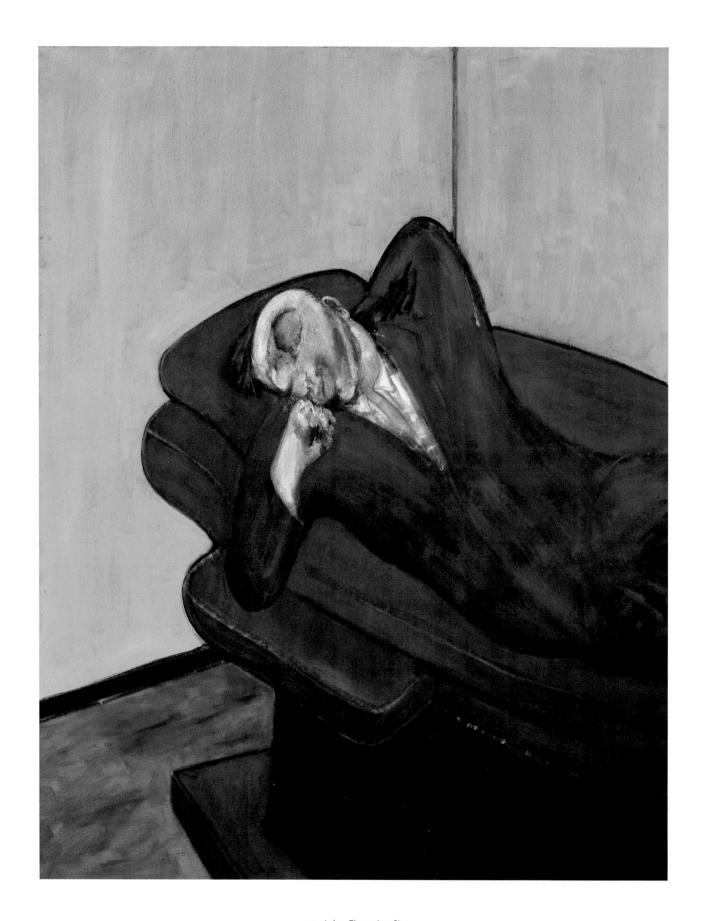

219 *Lying Figure* (1958)
According to David Sylvester, this painting was originally conceived as half of a diptych and represented a man on a psychiatrist's couch

SKIN/FLICKS

The Concise Oxford Dictionary defines a pellicle, derived from the Latin *pellis*, as a 'thin skin, membrane or film'. The French word *pellicule*, which has the same meaning, was adopted in the nineteenth century as the noun for photographic film. In Roland Barthes' analogy between the body, film and the action of light, 'a sort of umbilical cord links the body of the photographed thing to my gaze: light, though impalpable, is here a carnal medium, a skin I share with anyone who has been photographed'.[1] Bacon's often quoted statement, 'I would like my pictures to look as if a human being had passed between them, like a snail, leaving a trail of the human presence and a memory trace of past events as the snail leaves its slime'[2] also evokes connections between photo-chemistry – the light-sensitive emulsion – and memory. It implicitly embodies a correlation between his paintings and photography.

Bacon's attraction to semi-tangible, gossamer-like substances (or ambiguous barriers in his paintings) translates into his predilection for wearing women's stockings beneath his trousers – next to his skin. He said he was ejected from the family home in Ireland at the age of sixteen after his father, already disturbed by his son's fondness for dressing in drag at parties, found him trying on his mother's underwear. The curtains, veils and other deliquescent striations that 'shuttered' the figures in his paintings between 1949 and 1956 are both a protective membrane and a punctured barrier. In Didier Anzieu's reading of Fisher and Cleveland's Rorschach tests they are a legacy of Bacon's troubled infancy.[3] Bacon's visual disturbances are also not unlike the plastic overlays of alternating black and clear stripes that produce kinetic effects – the illusion of movement – in simple optical toys. He related what

he called 'shuttering' to the late pastels of Degas, who 'always striates the form with these lines which are drawn through the image and in a certain sense both intensify and diversify its reality',[4] and also described the technique as a response to the innovations of cinema, which had forced the painter to become 'more inventive...to reinvent realism'.[5] With the kinetic flickering of *Study after Velázquez* (1950) and *Study for Nude Figures* (c. 1950) he was painting a sensation that 'doesn't come straight out at you; it slides slowly and gently through the gaps'.[6] A contemporary analogue for this fractured 'realism', another metaphorical barrier, was the 'Iron Curtain' coined by Winston Churchill. It should also be noted, in this context, that Bacon's first paintings were on *screens* – the folding, tripartite decorative screens that dated from the period when he was an interior designer, in 1929.

Beasts

Another Churchillian metaphor, the 'Black Dog' – code for his depressions – links to the Harpies and Eumenides that were probably signifiers of Bacon's depression as well as of malevolence. The forms of these phantasmagorical creatures vary widely, and they are not always precisely identifiable. It is improbable that Bacon was able to lean on photographic sources for them, although a fusion of Eric Hosking's photographs of owls and William Blake's *The Wood of the Self Murderers: The Harpies and the Suicides* (c. 1824–27) may have provided a model for Bacon's Harpies. Later versions of the Eumenides were possibly indebted to one of the monstrous creatures in Marcantonio Raimondi's *The Dream of Raphael* (c. 1506–10). These malign, oddly lurking presences regained prominence in Bacon's paintings in the 1970s and 1980s, and in the *Triptych Inspired by the Oresteia of Aeschylus* (1981; pl. 249) they were central rather than subsidiary. From an orifice in the Eumenides in the left-hand panel, enigmatically suspended as though in its death throes, blood spurts forth in a dramatic, lyrical but unsettling gesture, in densely impastoed orgasmic paint.

Earthly animals were also important in Bacon's lexicon. There is a simian aspect to some of the men in Bacon's paintings (apparent in *Head III*, 1949) and he painted monkeys in *Head IV* (1949) and *Figure with Monkey* (1951), as well as chimpanzees and baboons. He said his interest in monkeys stemmed 'from the fact that like humans they are fascinated with their own image, and that their interest in themselves is displayed with an abandon and relish rarely equalled by men',[7] though it may be pertinent that in the Middle Ages apes or monkeys symbolized voyeurism, lust, paganism and man's baser instincts. On returning from his second trip to South Africa in 1952, Bacon began to combine elements of the technically fuzzy, telephoto-lens photographs of elephants in Marius Maxwell's *Stalking Big Game with a Camera in Equatorial Africa* (1924) with Muybridge's *Animal Locomotion* images. The small

220 Working document

221 Working document

220–222 Working documents, with interventions

In line with their sporting and animal interests, Bacon's family kept a well-stocked library of Edwardian 'nature and camera' books. Among the leading photographers of animals in their natural habitat were Carl G. Schillings, A. Radclyffe Dugmore and Marius Maxwell. Pl. 220 is from an unknown source; pl. 221 is from *Hutchinson's Animals of All Countries*, 1923; but the charging rhinoceros, pl. 222, is not, as is usually stated, a page from Marius Maxwell's *Stalking Big Game with a Camera in Equatorial Africa*, 1924, although this was a book Bacon consulted, but from A. Radclyffe Dugmore's *Camera Adventures in the African Wilds*, 1910.

223 'Newly fledged long-eared owls', plate from Eric
Hosking and Cyril Newberry, *Birds of the Night*, 1945

224 *Owls* (1956)

225 Working document: plate of a peregrine falcon
attacking a rook, from J. Arthur Thompson,
The Outline of Science, 1922

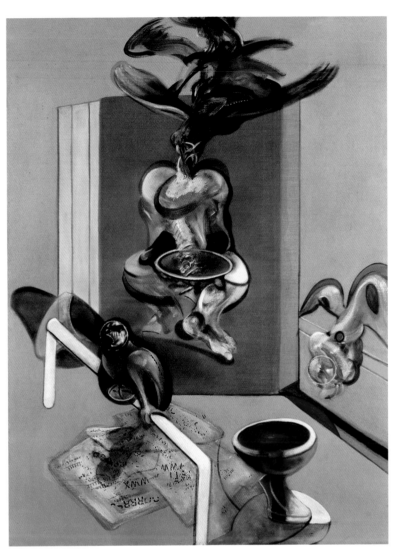

226 *Triptych* (1976), centre panel

painting *Owls* (1956) is an unusually close transcription of Eric Hosking's photograph of fledgling long-eared owls published in *Birds of the Night*, 1945[8], though the night sky was Bacon's invention. Hosking's photographs may also have informed the fierce owl/harpy in *Fragment of a Crucifixion* (1950). On Bacon's infrequent rural sojourns, songbirds merely annoyed him, but he was attracted to predators and the owl was a bird of ill omen, death and filial ingratitude, as well as of night and wisdom. Though later in life Bacon was a less frequent cinema-goer and seldom watched television, according to John Edwards he never tired of watching *Kes* (directed by Ken Loach, 1969) and a Royal Society for the Protection of Birds documentary on the reintroduction of the osprey into Scotland. The fascination with birds of prey was manifested in *Triptych* (1976), in which the birds at the top of the central panel are similar to an image of a peregrine attacking a rook in J. Arthur Thompson's *The Outline of Science*.[9] Bacon told Peter Beard that when he began the blurred, indistinct forms in the right-hand panel of *Triptych – Studies from the Human Body* (1970; pl. 211), he was 'actually looking at a photograph of some birds diving into the sea, and this thing came out of it – this kind of double image'.[10] Birds, like umbrellas, were important ciphers for Bacon, and these symbols of the soul hover, or perch, like slightly less menacing Eumenides, in *Study for Portrait with Bird in Flight* (1980) and *Carcass of Meat and Bird of Prey* (1982).

Camera and Chimera

Having incorporated an X-ray image in a painting as early as 1933, Bacon maintained his predilection for photographs that penetrated the skin – not only X-rays and pathological, forensic or scientific photographs in which the skin was folded back to reveal raw flesh, but also images of the extra-corporeal, the documents of séances conducted by Baron Albert von Schrenck Notzing. The photographs in Bacon's paint-spattered and obviously frequently consulted copy of Schrenck Notzing's *Phenomena of Materialisation*, taken by Schrenck Notzing himself, his patron Juliette Bisson and by 'K', purported to record the manifestation of spirits. Bacon was fascinated by the traces of the action of light on photographs exposed for extended periods, and manifestations of ectoplasm were probably, for him, consonant with the chronophotographs of Etienne-Jules Marey or the Futurist 'photodynamism' of Anton Bragaglia. Bacon characterized painting as a mediumistic activity, and thought of himself as a receptor of images. In describing himself as 'not so much a painter but a medium for accident and chance',[11] he explicitly invoked the aleatory as an external, supernatural force. He was strangely clairvoyant in 'predicting' Henrietta Moraes's drug addiction, and he painted George Dyer on a lavatory in *Three Figures in a Room* (1964) seven years before Dyer committed suicide in that position. He described the problem, in painting portraits, of finding a holistic (or spiritual) technique 'by which you can give over all the pulsations of a

227 Bisson and McConaughy, *Madame X*, 1931,
front cover dust jacket

LES PHÉNOMÈNES
DITS DE MATÉRIALISATION

CHAPITRE PREMIER
COMPTES RENDUS DES SÉANCES

Fig. 1. — Plan de la salle des séances.

1, fauteuil du médium. — 2, lampe électrique rouge à l'intérieur du cabinet. — 3, appareil photographique à l'intérieur du cabinet. — 4, second appareil à l'intérieur. — 5, troisième appareil au-dessus du médium, intérieur du cabinet. — 6, cheminée. — 7, appareil photographique. — 8, appareil pour le magnésium. — 9, appareil pour le magnésium. — 10, appareil stéréoscopique. — 11, appareil photographique. — 12, appareil stéréoscopique. — 13, appareil photographique.

BISSON. I

228 Plan of multiple camera positions employed by Baron von
Schrenck Notzing and Juliette Bisson to photograph séances,
page 1 from J. Bisson, *Les Phénomènes dits de Matérialisation*, 1921

From 1916 onwards, several films, all entitled *Madame X*, were based on Alexandre Bisson's play, *La Femme X*. MGM's version of 1929, starring Ruth Chatterton, is the most highly regarded and was the first film to use a roving microphone. Baron von Schrenck Notzing's collaborator, Juliette Bisson, was married to Alexandre Bisson.

There are further links between the paranormal and early cinema through, for example, George Albert Smith (see p. 95), who began as a hypnotist and 'muscle-reader' in the 1880s. While there is no evidence that Bacon was aware of his activities, many of Smith's experiments have a Baconian resonance. As well as being a pioneering film-maker he was a magic lanternist and portrait photographer who patented a double-exposure system in 1897. His technical tricks enabled him to film convincing ghosts and spirits, and he developed an additive two-colour process, 'Kinemacolor', using red and green filters (see p. 150).

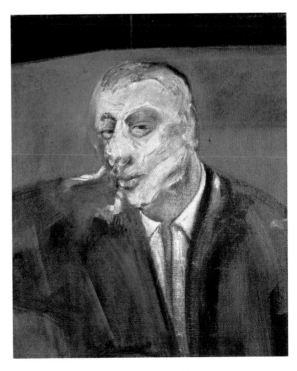

229 *Head I* (1958)
From 1958 onwards, vaporous, smudged 'emanations' began to
exude from, or adhere to, Bacon's heads

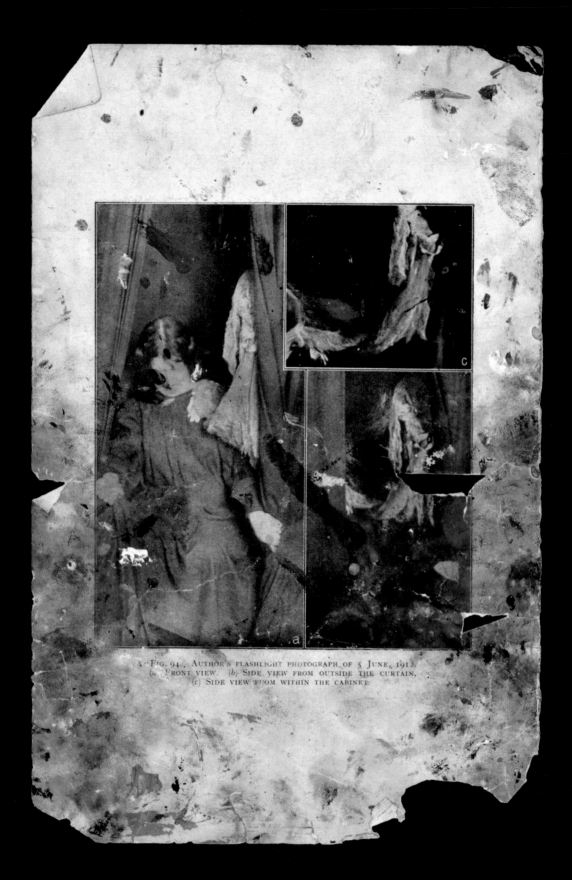

230 Working document: Fig. 94 from Baron von Schrenck Notzing, *Phenomena of Materialisation*, 1920

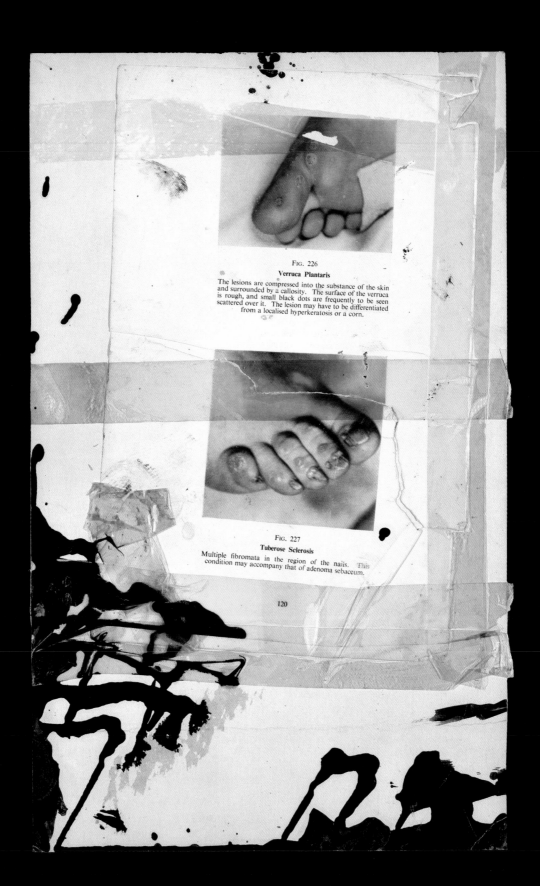

Fig. 226

Verruca Plantaris

The lesions are compressed into the substance of the skin and surrounded by a callosity. The surface of the verruca is rough, and small black dots are frequently to be seen scattered over it. The lesion may have to be differentiated from a localised hyperkeratosis or a corn.

Fig. 227

Tuberose Sclerosis

Multiple fibromata in the region of the nails. This condition may accompany that of adenoma sebaceum.

120

231 Working document: leaf from an unidentified medical book, taped onto card

person'.[12] He added, 'When I look at you across the table I don't only see you, I see a whole emanation and everything else.'[13] Spiritualism and the investigation of psychic phenomena were current when Bacon was growing up in the aftermath of World War I, its huge death toll having left many relatives anxious to contact the deceased, and in the revival of spiritualism after World War II Bacon was aware of a well-known British medium, Jack Webber.[14] Besides specific quotes from *Phenomena of Materialisation*, Bacon's ectoplasmic effects are generically related to its ghostly, risible photographs. Diffused through low quality, coarse-screened reproductions, its images were semi-prepared for his further transmutations in paint.

Breathless

The anguished cries in *Study for Portrait* (1949; pl. 235) and *Study after Velázquez* (1950; pl. 101) are all the more affecting because Bacon eschewed mannerist or expressionist gestures: energy is suppressed, the scream is silenced. Bacon refuted that his Popes *were* screaming, saying they may have been yawning or sneezing, yet he consistently made reference to the desperate cries in *Massacre of the Innocents* and *The Battleship Potemkin*: he may have intended the stifled screams to suggest onanistic ecstasy, a private and secret act. He gazed at the Poussin in a silent gallery; the distress of Eisenstein's nurse pre-dated synchronized sound: the screams of his protagonists are their aphonic equivalent. The mute helplessness and apparent indifference to their fate of his caged figures mirrored Bacon's view of late twentieth-century mankind as bereft of hope. But the confined, airless spaces occupied by Bacon's other 'father-figures' and vacant businessmen also evoke the gasping for breath of the asthmatic. Bacon was a lifelong sufferer from asthma and, although he bore it with his habitual stoicism, he said, 'It's been with me longer than painting has and it's a daily experience.'[15] His sister Ianthe's first memory of him dates from 1923, when stramonium powder was dramatically ignited to relieve one of his asthma attacks.

The sinister dogs Bacon painted – based on Muybridge's action photographs of a mastiff, 'Dread' – reflected, in their pent-up sense of threat, his ambivalence towards an animal that since his childhood (his father bred red setters) had been a potential cause of an asthma attack. He was similarly at risk from horse dander, etymologically linked both to skin and to anger (dander=dandruff=skin flakes), and in French back to *pellicule* (skin, film): in 1915 J. B. Berkart had warned of the danger to asthmatics of the 'malodorous atmosphere of stables'.[16] Bacon was turned down by the Army in World War II and then out of the Chelsea branch of the reserve service of the Air Raid Precautions on account of his asthma. 'If I hadn't been asthmatic,' he commented, 'I might never have gone on painting at all.' 'So then I was on my own,' he added enigmatically (although on another occasion he acknowledged the unfailing encouragement and support of Eric Hall), and 'it was then, about 1943–44, that I really started to paint'.[17] Ironically the condition was aggravated by the dust in which he

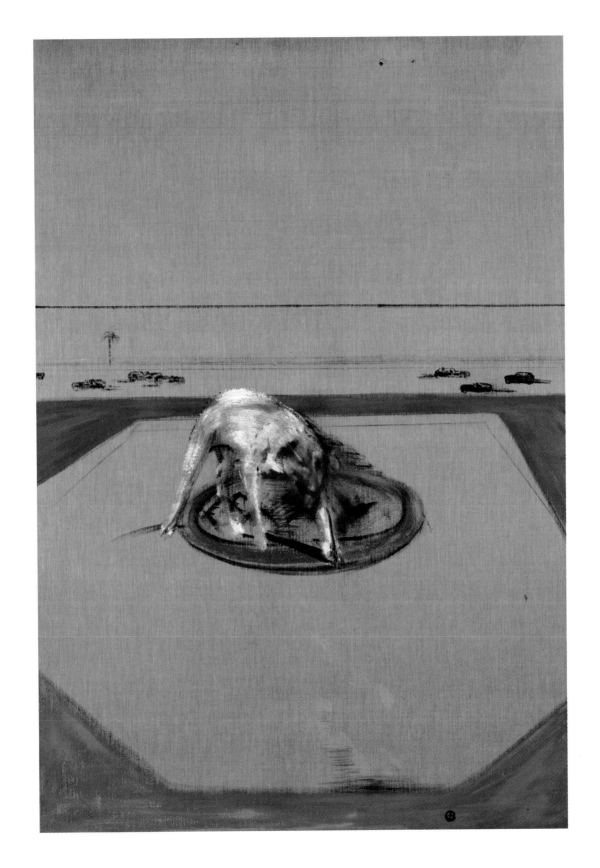

232 *Study of a Dog* (1952)

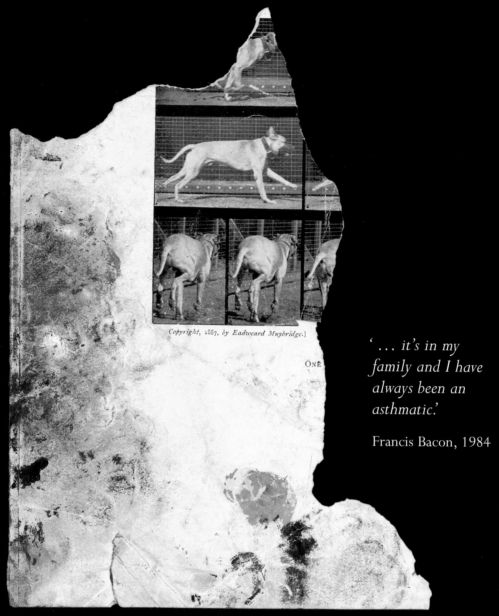

Copyright, 1887, by Eadweard Muybridge.]

ONE

'… *it's in my family and I have always been an asthmatic.*'

Francis Bacon, 1984

233 Working document: torn leaf from an early edition of
Eadweard Muybridge, *Human and Animal Locomotion*

234 Instruction sheet for Bacon's asthma inhaler, used as a bookmark in his copy of
Ernest Jones, *The Life and Work of Sigmund Freud*, 1984

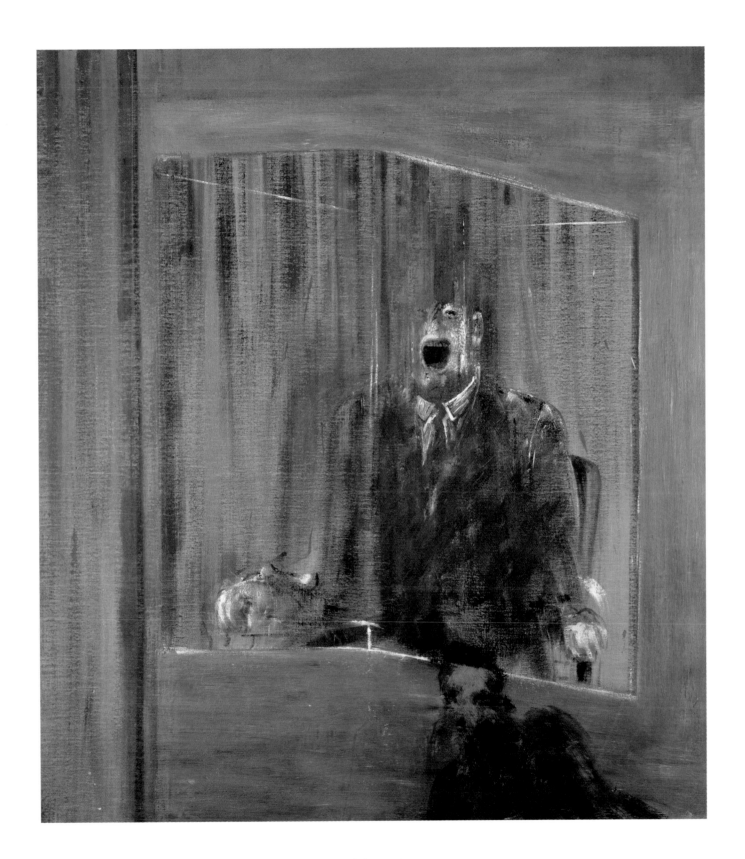

235 *Study for Portrait* (1949)

worked (and which he used as a medium), and by cadmium, a constituent of his favourite colour, orange. The morphine he was administered to treat his allergy as a child would have provided both a massive relief from his asphyxia and acted as a spur for the intense dreams of images which he had for the rest of his life, and which he sometimes tried to recapture by writing them down on awakening. He said that he had only ever felt relaxed when under the effects of morphine or, later, of alcohol, which may have helped to achieve a similar state – a suspension of consciousness in which images, in a daydream, would fall into his mind.

Communication Barriers

By insisting his paintings were saying nothing, Bacon sought to distance himself from the depiction of linear narratives. He considered art that illustrated stories (citing Fuseli) irredeemably prosaic.[18] Refusing to interpret his paintings, he claimed not to know what they meant himself, yet their non-literalness and complexity invite interpretation. Neither would he discuss his subconscious impulses or the psycho-sexual analysis of his paintings. Sensing an interview about to turn in this direction, he abruptly altered his body language, becoming alert, defensive, ready to terminate the probing with a peremptory and tetchy dismissal, such as, 'You'll have to ask Freud.' Yet he applied different criteria in the case of other artists, for he said that from looking at a Rembrandt, 'I feel I know very much more about Rembrandt than the sitter.'[19] He also admitted that he was projecting onto canvas his nervous system, and that 'the greatest art always returns you to the vulnerability of the human situation'.[20] He conceded, too, that his Crucifixions expressed 'feelings and sensations, really you might say it's almost nearer to a self-portrait – you are working on all sorts of very private feelings about behaviour and about the way life is'.[21] He was more forthcoming about what he did not intend. In denying his subject was horror, he compared his paintings with Grünewald's Isenheim altarpiece, which he found 'so grand it takes away from the horror', adding that 'grand horror' is 'so vitalizing'. People, he added, 'came out of the 'great tragedies of Greece, the "Agamemnon"…as though purged into a fuller reality of existence'.[22]

Though he accepted it enabled his gallerists to identify them, Bacon disliked titles that compromised the ambiguity or open-endedness of his paintings. In 1956 David Sylvester complained that the Tate Gallery was exhibiting *Three Studies for Figures at the Base of a Crucifixion* (1944) under the title *Three studies for a larger composition*. The gallery feared, he explained, that the original title might cause offence, but a request on Bacon's behalf to rename it *Three studies from the human figure* was turned down.[23] As noted earlier, the impulse to paint the Eumenides in *Three Studies for Figures at the Base of a Crucifixion* stemmed partly from Bacon's reading of Aeschylus. W. B. Stanford's commentary *Aeschylus in his Style* is subtitled *A Study in Language and Personality*, and the Eumenides painting was the first to

236 Working document: reproduction, from an unknown book, of Rembrandt van Rijn, *Self-portrait* (1660)

Bacon considered the self-portraits Rembrandt's greatest works, and believed that the liberties an artist could take in painting a self-portrait provided the optimum conditions for combining the fact of appearance with psychological insight. He expressed more than once his admiration for the 'anti-illusional' aspect of the deeply shaded eye-sockets in Rembrandt's unfinished *Self-portrait with Beret* (*c*.1659) in the Musée Granet, Aix-en-Provence.

carry the 'Studies' prefix. The proportion of his paintings Bacon went on to entitle 'Study' is open to multiple interpretations. It indicates provisionality, even tentativeness or diffidence, but also the assurance to exhibit work that was 'incomplete' or verged on the plastically weak. Bacon was defiant, offhand, provocative. He painted rapidly, impatient to transmit urgency and spontaneity onto the canvas. The areas of his canvases he left raw, unpainted, were an extreme manifestation of a preoccupation of many young artists in the early 1950s with painting as rough denotation, not completely fulfilling an idea or pursuing it to a mundane conclusion.

Bacon said he destroyed 'all the better paintings' in attempting to 'take them further', when they 'lose all their qualities…the canvas becomes completely clogged…and one just can't go on', and, significantly, he drew an analogy between the clogging of paint and falling into 'bogs' or 'marshland'.[24] An articulate conversationalist, Bacon nevertheless expressed himself obliquely at times. Recalling a childhood experience of a British cavalry regiment 'galloping up the drive' of his grandmother's house at the time of the Irish 'troubles', he said 'I was made aware of what is called the possibility of danger even at a very young age.'[25] The conflict must have been traumatic for a child of a prominent Protestant family, and since in Kildare they were surrounded by boggy, marshy country the experience was possibly connected with his later descriptions of clogged paint. The parenthetical 'what is called the possibility of danger' was an inherited upper-class mannerism, a blend of nonchalance and elegant understatement when alluding to coarse or unpalatable facts. It may also denote vulnerability, an apparent (or affected) lack of confidence which he exploited as part of his seductive charm. The reluctance to pin things down was a conspicuously Zen facet of Bacon's character. It was also demonstrated in his unhomely studios, the monkish quarters that expressed his non-attachment and self-reliance, in which the mess of images signified his unpreparedness (like the cat that feigns disinterest in its prey), his openness to a multiplicity of possibilities. His insistence on his paintings' non-intentionality – which he described as their reliance on chance – accords with the concept of achieving a transcendent reality through intuitive experiencing, and the Zen philosophy of the essential emptiness of all things, the contingency of their meanings, embodies an emphatically Baconian nihilism.

Gratification

It has been inferred from Bacon's insistence that his paintings were glazed that he wanted to involve the spectator in a kinetic, polysemic relationship with the work. But the glass membrane, while it may invite participation (prosaically, by reflecting back the viewer's own image), is also a threshold that cannot be crossed, a barrier that may not, without violence, be pierced. The layer of glass that renders it more difficult to approach or to discern the painting, and impossible to touch, is a metaphor for Bacon's ambiguousness. Similarly, in

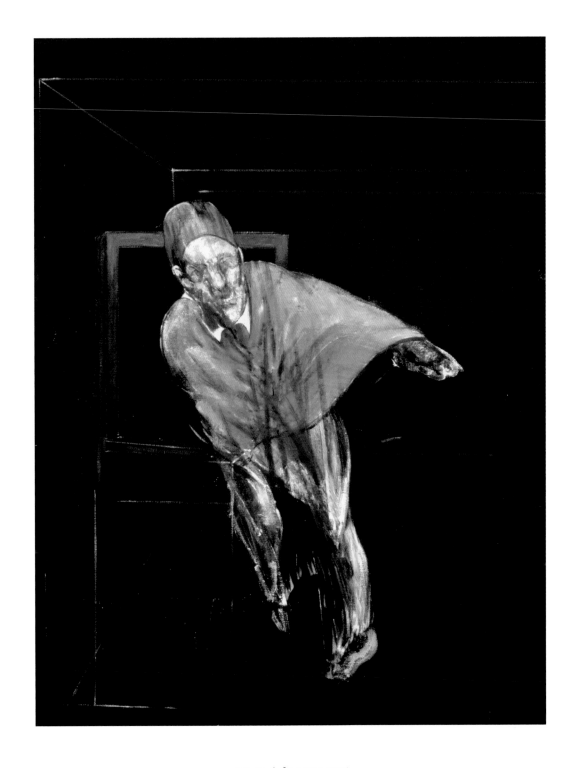

237 *Study for a Pope* (1955)
This startling depiction of the anxious, disjointed body-in-flux succinctly exemplifies both Bacon's provisionality and risk-taking, and recalls superimposed frames from a cinematic tracking shot

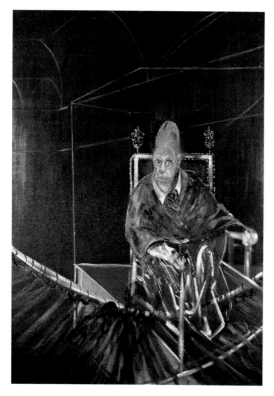

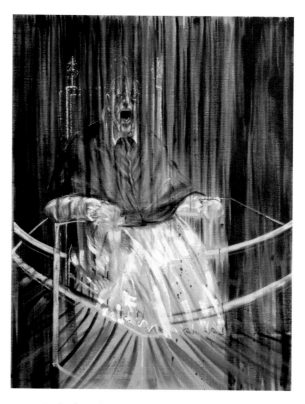

238 *Pope I* (1952) 239 *Study after Velázquez's Portrait of Pope Innocent X* (1953)

some of his most visceral paintings of the human body, the figures are of uncertain gender and seem almost to dematerialize under our gaze, recoiling in their private spaces from contact. Their affective charge is powered by another of Bacon's contradictory impulses – the tension between physicality and non-tactility. After the trauma of birth – the bursting forth from the mother's protective skin – an infant's first method of communication, its source of reassurance, is skin-to-skin contact. In one of his most disarmingly frank remarks, Bacon appears to have inadvertently alluded to his infant psyche. When asked whether his linear cube structures had a psychological dimension, if they were intended to convey isolation or the 'territorial imperative',[26] Bacon explained them, as he usually did, in formal terms as devices for 'seeing the image more clearly'. Yet he continued, '…but people go to bars to be closer to each other. The frustration is that people can never be close enough to each other. If you're in love you can't break down the barriers of the skin.'[27] In a television interview with Gavin Millar he had phrased the desire for closeness even more graphically when he asked rhetorically, 'How can you cut your flesh open and join it with the other person?'[28]

To describe the aim of love-making in terms of penetrating the skin and joining with one's partner's flesh exceeds the ordinary yearning for physical contact. The French word for skin – *cuir* – also means an incorrect liaison, which in Bacon's case would equate with sado-masochistic desire. The most esoteric images he collected – scientific and medical photographs, neutral but brutally factual – connect with his unusual interest in pain. His

frustrations were prefigured in a text with which he was probably familiar, Mario Praz's *The Romantic Agony*, a study of eroticism and decadence in Romantic literature that reverberated among Britain's artists as well as its literati when it was published in English in 1933.[29] Praz's chapter 'La Belle Dame sans Merci' recapitulates the origins in classical antiquity of the concept of 'Fatal Women', and cites the warning in the Choephorae of Aeschylus:

> *When perverse rebellious love*
>
> *Masters the feminine heart, then destroyed is the union*
>
> *Of mated lives for beast or man.*[30]

But Praz was researching and lecturing in England between 1923 and 1934, and became as steeped in Swinburne and Wilde as in Flaubert and Baudelaire. His analysis of *La Belle Dame sans Merci* devolved mainly on Swinburne's 'algolagnia' (masochism), with particular reference to Swinburne's novel *Lesbia Brandon* (1868), in which the male protagonist, Denham, entreats: 'Oh! I should like you to tread me to death, darling... I wish you would kill me some day; it would be so jolly to feel you killing me. Not like it? shouldn't I! You just hurt me and see.' Swinburne, a masochist who identified with the character of Lesbia, has Denham rehearse his sexual desire in a string of images that portend obsessive themes of Bacon's (and of artists he revered). 'He would give...his soul for a chance of dying crushed under her feet...a passion of vehement cruelty... Deeply he desired to die by her if that could be; and more deeply...to destroy her; scourge her into swooning and absorb her blood with kisses; caress and lacerate her loveliness, alleviate and heighten her pains; to feel her foot upon his throat, and wound her with his own teeth...to inflict careful torture on the limbs...bite through her sweet and shuddering lips.'[31]

Bacon was alert to images that nourished his obsessions, and had incorporated three enduring motifs into his cumulative index by the 1930s: the horrified mother in Poussin's *Massacre of the Innocents*, the illustrations of diseases of the mouth, and the screaming nurse in *The Battleship Potemkin*. Yet he did not depict physical violation, only its sometimes bloody consequences. It was the dramatizing of the oral (Bataille called the mouth 'the orifice of profound physical impulses'[32]) that contributed most to the perception that his subject was violence. In discussing teething in the context of the second oral stage of libido development, and the influx of sadism at that stage, Leonard Shengold quoted from K. Abraham's *The Development of the Libido* (1924): 'Undoubtedly the teeth are the first instruments with which the child can do damage to the outer world.'[33] Shengold suggested that the relief from painful tension when the infant's teeth erupt through the mucosa of the gum may condition 'fantasies of explosive cannibalistic penetration, passive and active' and that teeth 'can also connote the terror of passive masochistic annihilation'.[34] Robert Fliess's identification of a site for the castrating phallus of the parent as 'the phallus equipped with

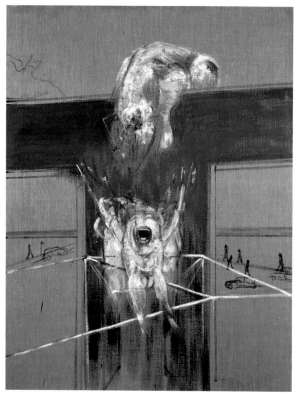

240 *Fragment of a Crucifixion* (1950)

241 *Untitled drawing* (?c.1936)

a mouth'[35] succinctly describes two of the Furies in *Three Studies for Figures at the Base of a Crucifixion* (pl. 36). Bacon, who said he used to despise his father, later believed he had been sexually attracted to him.

The head of the abstracted semi-hominoid in *Figures in a Garden* (1936; pl. 35) has been compared with a photograph of Hermann Goering with his lion cub,[36] and another possible source for the snarling, bloodied rictus was the book of hand-tinted photographs of diseases of the mouth Bacon bought in Paris at this time. This Bacon *leitmotif* also occurs in a drawing that may relate to *Abstraction from the Human Form* (c. 1936; destroyed), but which also appears to represent a transitional stage in the evolution of *Fragment of a Crucifixion* (1950). In Bacon's contorted reworkings, the mouth became a site for sex and for violence. He was aware of – and his more overtly post-Freudian variations were sanctioned by – the obsessive privileging of teeth (*vagina dentata*) in Picasso's work from 1929 onwards, and he would have noted the fetishization of body parts in the Modernist and Surrealist close-up photographs he saw in *Documents*, *Cahiers d'Art*, *Minotaure* and elsewhere.[37] The popular press (in particular, as we have seen, *Picture Post*) also generated a constant supply of images of haranguing, gesticulating politicians from which he selected suggestively orotund mouths.

Captain Eddy Bacon, as Bacon's father styled himself, was described by his son as militaristic, quarrelsome and a strict disciplinarian prone to irrational outbursts of rage. The asthmatic Bacon believed his father rejected him as a weakling. He said that when his younger

Fig. 1

242 Working document: illustration from an unidentified medical book,
possibly the book of diseases of the mouth Bacon bought in Paris in the 1930s

brother Edward died of pneumonia in 1927, 'My father was heartbroken… I think it was the only time I ever saw my father show deep emotion. He loved my brother very much, but he never understood me.'[38] Bacon felt acutely his father's lack of empathy or affection, and was destined to strive for the rest of his life to gain his attention, or to castigate him for having withheld it. It was his perception that his mother, fourteen years younger than her husband, found her marriage unsatisfactory, but he felt similarly neglected by her, since she, too, was preoccupied by her separate social interests, riding and entertaining. He was, however, fondly attached to his nanny (in W. B. Stanford's discussion of *The Choephori*, the Nurse's 'simple-hearted devotion and affection to Orestes heighten the unnatural selfishness of his mother, Clytaemnestra')[39]. But Bacon's attitude towards his parents was also partly generational. He had grown up when, as Miranda Carter put it, there was 'an almost tangible Oedipal fury in the air among the aspiring artists and writers', and what George Orwell described, in a broader socio-political context, as 'among the young, a curious hatred of "old men"'.[40] Violating – and simultaneously deifying – powerful males, Bacon's deformations caught the post-war mood of disaffection in a nation drifting towards the anti-authoritarianism of the 'Angry Young Men'. Thus, while we are drawn into – and our objectivity is compromised by – his 'Oedipal fury', ultimately his paintings of solitary beings transcend their personal, subjective constraints to reflect wider cultural issues and universal psychological and social concerns.

It has been argued that Bacon identified with neither the mother in *Massacre of the Innocents* nor the nurse in *The Battleship Potemkin* but with the threatened children.[41] In Poussin's painting, the asphyxiation of the child is performed by one of Herod's (male) soldiers, and in *The Battleship Potemkin* the cruelty is sparked off by a revolutionary – and predominantly male – political force. It was not the classical poise and exquisite formal arrangement of the protagonists that Bacon found compelling (indeed he disliked Poussin's 'mathematical precision'[42]), but the plight of the child in the throes of strangulation, which resonated with his fear of his father, who, according to Lady Caroline Blackwood, regularly had him beaten. Formerly, on the Feast of the Holy Innocents, the massacre was commemorated by whipping children. In his paintings Bacon transmuted their cries of fear into howls of frustration and despair. His lacerated and screaming reconfigurations of Velázquez's Pope expressed his own pain and anger; the assaults he perpetrated were acts of revenge on the father figures he was adamant the paintings were not intended to represent. Yet although he repeatedly fended off any suggestions of an autobiographical link, he described his obsession with painting the Pope as 'a crush', 'that is, like schoolboys who have a crush on whoever it is – on their housemaster or something'.[43] In fact Bacon's derogation of Innocent X was anticipated by Velázquez: the portrait was famously described as *troppo vero* (too truthful) by Innocent himself, and despite (or because of?) the absolute authority invested in him, his contemporaries found him repugnant, vulgar, choleric and splenetic. The Pope in *Study for Portrait I* (1956) was not painted with bared teeth and glittering gums: his mouth is closed, but he has full, sensuous lips and, of all the Popes, the most carefully delineated eyes. Is the Pope in this less intimidating representation metamorphosing into Bacon's father, or father/lover? And to what extent did Bacon identify with the authority figure? The emotional and psychological ambiguity was rehearsed in *Figure in a Landscape* (pl. 43) and *Painting 1946* (pl. 47) in which the men are seated – in effect enthroned – but, with their faces shrouded under umbrellas, semi-obliterated and stripped of their individual identity.

Bed of Crime

Disinterested goodwill unsettled Bacon, since it confounded his cynicism about human relations and the expectation that he would be betrayed. He mistrusted the motives of Dennis Williams, a young artist who idolized him and who, in about 1950, stayed in a small room adjoining Bacon's studio, seeking to make himself useful. But Williams felt his 'personality had been wiped out' by Bacon's indifference to his ministrations. He believed Bacon was incapable of emotional attachment and that in his clinical (dis)engagement with humanity, 'He sees people as mountains of flesh.'[44] Sir John Rothenstein observed that under

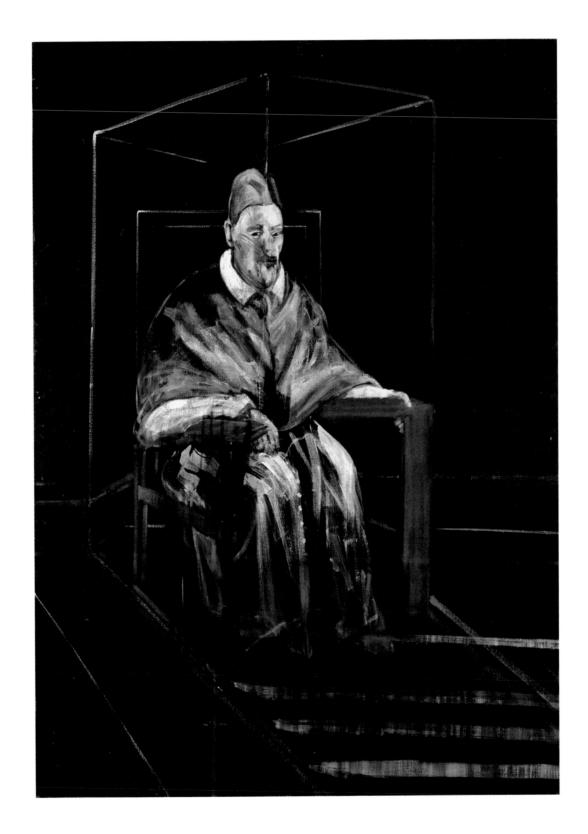

243 *Study for Portrait I* (1956)

244 Working document: photograph of George Dyer by John Deakin, *c*.1965

Max Beerbohm's classification of people as hosts or guests, Bacon was 'emphatically a host'; being a guest, he added, 'frustrates his large impulse to offer hospitality'.[45] George Dyer, who became Bacon's lover and muse in 1964, was semi-literate and an inefficient petty crook who had served several jail sentences. Bacon's unstinting generosity towards him was a sexual ploy and a control tactic – it relieved him of any sense of obligation. He was a grand-gesture giver of gifts who was very uncomfortable about receiving them. Dyer became increasingly dependent on the artist, whom he revered even if he did not fully understand him, and Bacon realized only later that his ostensibly well-intentioned efforts to save Dyer from thieving had removed his *raison d'être* and independence. Dyer's personality, too, was cancelled out, and he committed suicide in Paris in 1971, two nights before the opening of Bacon's exhibition at the Grand Palais. Three posthumous triptychs of Dyer, haunting dark elegies that Bacon painted between 1971 and 1973, are exorcisms, fond memorials and expiations of guilt. Bacon was also intrigued by John Edwards's (exaggerated) reputation for criminality. Bacon's taste for the criminal fringe was shared by many homosexuals (some in prominent public positions), but his perspective was slightly different, for as a young man he had indulged in various kinds of sociopathic behaviour – thieving, allegedly blackmailing, and running an illicit wartime gambling operation from his Cromwell Place studio. Between the ages of about twenty and forty-two Bacon replayed his emotionally deprived childhood under the protection of caring surrogate parents. Then for ten years – between the ages of forty-three

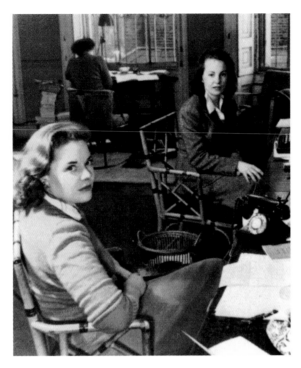

245 Sonia Orwell and Lys Lubbock in the office
of *Horizon* magazine, 1948 (photographer unknown)

246 Jessie Lightfoot, *c.*1945
(photographer unknown)

and fifty-three – his passionate affair with Peter Lacy could be described as an adult romance, a union of 'equals'. At the beginning of the controlling relationship with George Dyer he was nearly fifty-five, and it was only at the age of sixty-seven that he assumed something akin to a paternal rôle (albeit sexually charged) in his friendship with John Edwards. A formidable artist and compelling conversationalist, who cultivated charm, conviviality and courteousness, Bacon was emotionally immature and, in this respect at least, a 'late starter'.

Women

Perhaps because Bacon made some of the most moving portraits of men, his paintings of women have received less attention than they deserve, but they were equally revealing of his sexual orientation and the search for self-identity. In 1951, not only was his formative if complicated relationship with his partner Eric Hall coming to an end, but the death of his former nanny severed a lifelong emotional attachment. In distress, Bacon quit his Cromwell Place studio (another of the few decisions he said he regretted). For fifteen years Bacon had lived in an unconventional triangular relationship with his nanny and co-conspirator, Jessie Lightfoot, and the paternal, supportive Hall. But Bacon was overwhelmed and disorientated by meeting Peter Lacy, the 'love of his life',[46] in 1951 or 1952. Their affair was doomed from the outset by the incompatibility of their sexual tastes (Lacy preferred young men and Bacon was seven years his senior), and had effectively withered some years before Lacy died of

247 Bacon with his mother, *c.*1913
Ianthe Knott thinks the book was *Aesop's Fables*

248 Cecil Beaton, illustrations in *Vogue*, 1 October 1930.
Bacon's early drawings were also of flappers

alcohol poisoning in 1962. It was probably not coincidental that in 1950, with Jessie Lightfoot's health in decline – 'she was deaf and spent all of her time knitting' – Bacon had re-established contact with his mother. He also forged close friendships with the strong and independent women – Muriel Belcher, Isabel Lambert, Henrietta Moraes – whom he would paint many times in the 1960s. There were other women prominent in his life whom he did not paint, Joan Leigh Fermor, Nadine Haim, Janetta Parladé and Sonia Orwell, whom he regarded as 'the person most responsible for my success'.[47]

In Ireland in the early 1920s Bacon drew flappers, the fashionable women of the day, who adopted the masculinized look that Cecil Beaton, who drew them for *Vogue*, likened to the 'pageboy'. In April 1933 an exhibition at the Mayor Gallery, London, 'Recent Paintings by English, French and German Artists', included Bacon's (now destroyed) *Woman in the Sunlight*. Referring to it as 'The Lady', *Time & Tide* commented on her 'tiny piece of red mouse-cheese on the end of a stick for a head',[48] whereas *Harper's Bazaar* described it as an allegory: 'a tiny ray of [sunlight] falling through cosmic darkness on a glass of champagne which denotes a woman'.[49] With the exception of the stylized Neo-Classical or Picassoesque female forms that are present in his work up to 1934, Bacon painted no further women until 1955. That is, no women who are immediately identifiable as such. For on closer examination the gendering of many of his figures in this twenty-year period is either uncertain or predominantly female. In some of his most prominent paintings, women (matriarchs? the mothers after Poussin; Eisenstein's nurse) are as prominent as patriarchs (Popes, business executives).

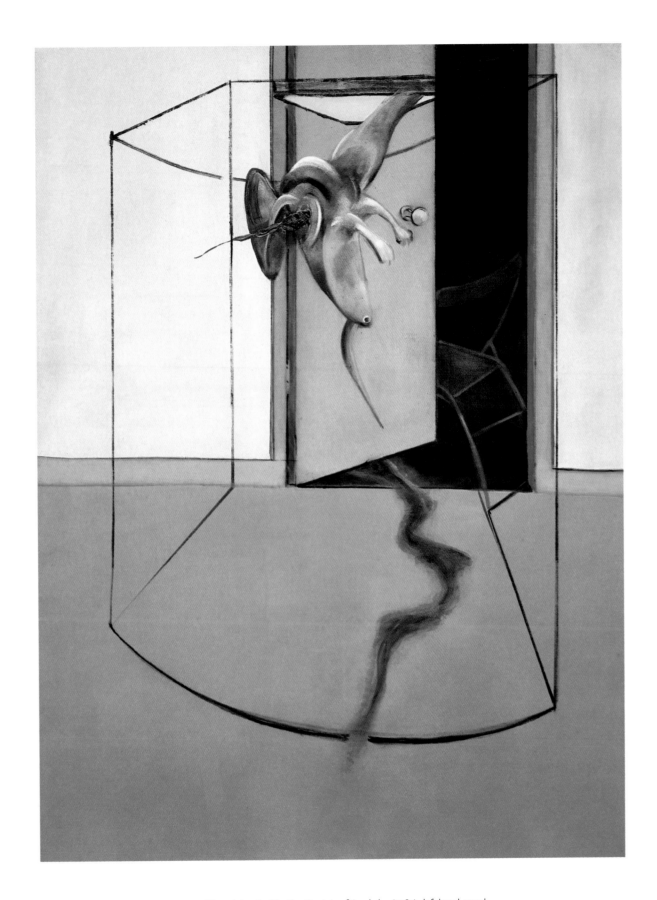

249 *Triptych Inspired by the Oresteia of Aeschylus* (1981), left-hand panel

250 *Figure Study II* (1945–46)

251 *Sphinx – Portrait of Muriel Belcher* (1979)

The Eumenides in *Three Studies for Figures at the Base of a Crucifixion* (1944) are female Furies, and Bacon's Harpies, it may be added, are technically half-woman, a state with which he probably identified. The *Three Studies* have been related to André Masson's *Gradiva* (1939), in which this Surrealist muse, half-statue and half-flesh, could be said to parallel the sculptural aspirations of many of Bacon's paintings.[50] The distorted limbs and violent eroticism of Masson's *Pygmalion* (1938) and *There is No Finished World* (1942) also anticipate the *Three Studies*. If Bacon was aware of these paintings, it is a nice irony that Masson was part of the wartime cultural transfer from Europe to New York and a prime catalyst, therefore, in the origins of the New York School that Bacon despised. After *Figure in a Landscape* (1945) Bacon's next three paintings all depicted indeterminate androgynes, although *Figure Study II* has also been described as *The Magdalene*, understandably if incorrectly. In comparing the simian aspect of Bacon's 'Heads' of the late 1940s with Georges Bataille's conflation of man and animal, Dawn Ades noted Bacon's comment that *Head I* (1948; see pl. 254) represented a woman,[51] in which case it may, as Ades observed, refer back to the 1944 Eumenides.

The figure in *Painting* (1950) has been described above as female (see p. 98), and the heads of the four sphinxes painted in 1953 and 1954 were at least totemically female. However, the dense shadow cast by the sphinx in *Sphinx I* (1953) is, like the shadow in *Painting* (1950), that of a man, and in this instance he is carrying a pistol. The background to the Sphinx paintings was based on a photograph of the stadium prepared for the Nuremberg

252 *Sphinx I* (1953)

rally, and it is possible the gun was incorporated as an oblique reference to Nazi violence. In 1955 and 1956 Bacon undertook commissioned portraits of Suzy Solidor and Lisa Sainsbury, and in 1957 he painted Diana Watson from an old photograph and the nude *Study for the Nurse in the Film 'Battleship Potemkin'*. The portraits of Muriel Belcher and Mary Redgrave followed in 1959 and 1960. *Nude* (1960) and *Nude* (1961) are illuminating transitional works that herald an extended period in which images of women were integral to some of his most important paintings. *Sphinx – Portrait of Muriel Belcher* (1979) was the *terminus ante quem* of this phase, and women occur only occasionally in his paintings thereafter, for example in the intriguing superimposition – are the figures merging or colliding? – in *Study of a Man and Woman Walking* (1988).

Among the twenty works by Bacon exhibited at Galerie Claude Bernard, Paris, in 1977, *Studies from the Human Body* (1975) was the only painting that included a representation of a nude woman. Didier Anzieu was struck by the woman's breasts, 'swollen and dangling with nourishment' which is withheld from the naked child-man tormented, writhing on a comfortless bench, from whom she is detached both in space and behind the indifference of her expression, masked by one of Bacon's trademark 'glass' discs. This was not, Anzieu observed, 'the phantasied incorporation of the nourishing breast, but the primary identification with a supporting object which the child hugs and which supports it: it is the clinging or attachment drive rather than the libido which finds satisfaction'. Anzieu cited J. S. Grotstein's definition of the two forms of primary identification:[52] in one the child's back (the only part of its body it can neither touch nor see) is against the stomach of the support, and in the other its own stomach is against that object's back, so that its fragile abdomen is protected by a screen.

Nude (1960) marked the inception of Bacon's rubbery, mutated and improbably supple bodies in which the women's breasts, defying gravity and anatomy, are ludicrously replete with Anzieu's 'nourishment'. Here the male gaze appears not to be voyeuristic but disengaged or incredulous. This is the inattentive mother, whom Anzieu conflates with Bacon's deliquescent women who appear to lack a spinal axis, a depiction he sees as congruent with the alcoholic's body image.[53] A heavy drinker, Bacon was never diagnosed as clinically alcoholic, although Raymond Mason was among many who witnessed the transformation during prolonged drinking bouts from a 'polite, gentle [look]' to 'a malevolent, aggressive mask',[54] and he was famed for his ability to outdrink anyone. He may, as has been claimed, have engaged in 'the ongoing fight against the stereotyped discourse on masculinity',[55] but this reading underplays the complexity of his representations of both men and women: it should be remembered that most of Bacon's paintings were explorations of selfhood. In his daily life he was, within his chosen circle, respected, revered – held in awe.

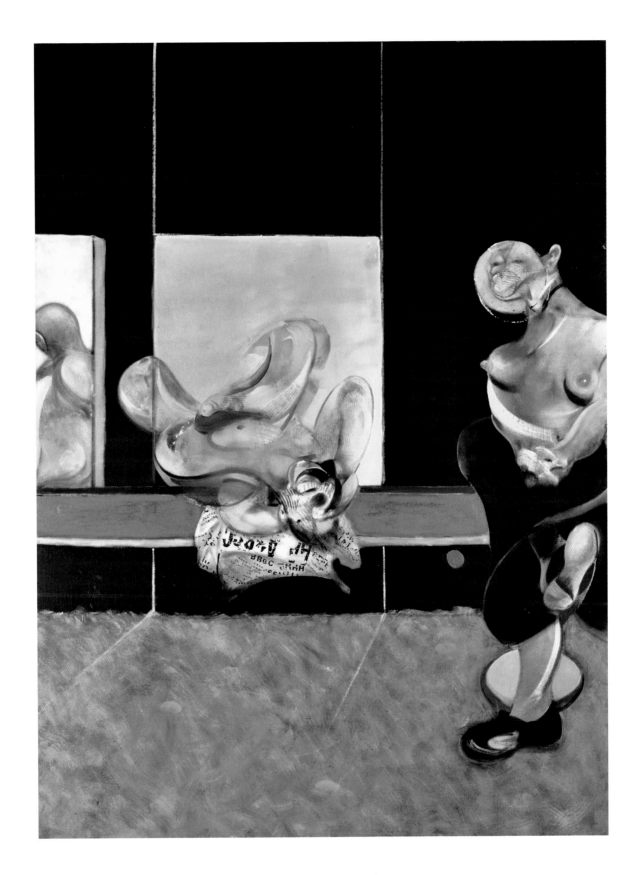

253 *Studies from the Human Body* (1975)

If the authority figures in his paintings were, at one level, the father he feared, they were also self-portraits. In common with many powerful figures (notoriously politicians, judges), after a day of wielding power he liked by night to engage in submissive sex. The melting women he painted were not the 'withholding' mother but the women with whom he identified – the recipients of male sex. He was as extreme in his sexual proclivities – he wore make-up and women's underwear and 'suffered' physical beatings – as in all aspects of his life and art. He conveyed his inner life without compromise, but in code, in his paintings.

Cover-up

Bacon altered transcripts of interviews, vetoed catalogue texts of which he did not approve, and removed vital evidence from his image-bank. While he allowed that his paintings were a balance of order and chaos, he privileged the operation of chance, and in doing so placed greater emphasis on their genesis in accident than appears to have been the case, and in commenting 'I don't know whether poetry is a help; it just makes you conscious of the possibilities of things'[56] he was being similarly duplicitous in regard to his paintings' literary stimuli. Bacon's taste in fiction is well known. After Aeschylus (whom he reproached himself for only having read in translation) and Shakespeare, it ran to Racine, Balzac, Baudelaire, Proust (all of whom he read in French as well as English), Yeats, Joyce, Pound and Eliot. He read (and re-read) Nietzsche, Freud and Van Gogh's letters. His library also contained a wide range of books on other subjects, including a few unexpected items – many volumes of Sylvia Plath's poetry, for example – but almost no light reading; yet he was probably, like Dante Gabriel Rossetti, 'A reader, to be sure, but not a *great* reader'.[57] Nonetheless he was able to rapidly scan a text, abstracting its essence – like the *œuvres* of artists he admired, from which he selected the relatively few works that were meaningful in his own terms.

One of the most potently Baconian connections between poetry and the visual arts was made by Hugh Kenner in discussing Ernest Fenollosa's notes on Chinese poetry. Fenollosa's analogy between ideograms and 'cross-sections cut through actions, snap-shots' was extended by Kenner, who thought Fenollosa's comparison was triggered by the first cine projections, to single ideograms and single cinema frames. Both, he said, 'exist for the sake of their blended succession, the moving picture, the sentence, the poetic line'.[58] It was observed by James Hyman that a Paul Eluard poem, 'Chant du dernier Délai' (Song of the Last Delay), provided a 'staggeringly accurate summation' of the six 'Head' paintings Bacon exhibited in November 1949.[59] Eluard's zeitgeist bleakness may well have appealed to Bacon, and his 'Rocher dans L'Eau' (Rock in the Water) begins equally presciently in terms of Bacon's themes: 'Like a bird upright in an armature / The wind's head caught inside a shadowy cage'. T. S. Eliot's dark pessimism is transposed, normally a loosely Eliotic

'It is impossible to say
just what I mean!
 But as if a magic
lantern threw the nerves
in patterns on a screen.'

T. S. Eliot, *The Love Song of
J. Alfred Prufrock*, 1911

'Painting is the pattern
of one's own nervous
system being projected
on canvas.'

Francis Bacon, 1949

254 Working document: black and white photograph of *Head I* (1948). Bacon may have retained this photograph, which was probably contemporaneous with the painting, as a reference for subsequent images

atmosphere, into many of Bacon's paintings, but occasionally they evoke specific passages: 'Gesture of orang-utang / Rises from the sheets in steam / This withered root of knots of hair / Slitted below and gashed with eyes, / This oval O cropped out with teeth: / The sickle motion from the thighs' (*Sweeney Erect*). One of Bacon's favourite Eliot stanzas was from *The Four Quartets*: '...the half-look / Over the shoulder, towards the primitive terror'.[60]

W. B. Stanford's *Aeschylus in his Style*, which Bacon acquired soon after it was published in 1942 (probably through Eric Hall), was a germinal text in the evolution of his paintings. Stanford's stimulating exegesis discussed Aeschylus in the context of his 'turbulent genius' and analyzed his 'unique and overwhelming use of language', his use of anachronism, metaphor, neologisms, paronomasia, oxymorons and – most relevant to Bacon – of synaesthesia. Its broad historical sweep reflected Aeschylus's linking of antiquity and modernity, and drew in El Greco and Leonardo da Vinci, T. S. Eliot, Virginia Woolf and post-Freudian psychology. Moreover, Stanford stressed how the power and urgency of Aeschylus's style, the expression of 'inner sensations' in his vivid drama of conflict, bloody revenge, guilt and resolution, were conveyed in terms that were shocking, violent and visual. Eliot himself quoted from the Aeschylus hypotext in *The Family Reunion*. The original production, which Bacon apparently saw several times, was censured for the ordinariness of the staging of the Eumenides, a representation echoed in Bacon's quasi-domesticization of scenes that replayed the effects of familial strife. And in *Sweeney Agonistes* (or its unfinished fragments) Eliot quoted Orestes' final speech in 'The Libation Bearers', when he is being pursued by the Erinyes, soon to become the Eumenides, for having committed matricide.

Since Bacon did not make drawings, literary and 'lens-based' imagery functioned as his 'preliminary studies'. Their close equivalent was the lists he made of ideas for paintings, especially when under pressure to produce a new exhibition. He ran close to the deadline, trusting in chance to intervene but introducing an element of order to Nietzsche's aphorism, 'One must have chaos in oneself in order to give birth to a dancing star.' Bacon regarded his chosen medium as 'the most artificial of the arts'[61] but strove, instinctually and irrationally, to achieve a factual realism, comparing art with 'a long affair with objects, images, appearances, sensations... the passions'.[62] His project was described by James Thrall Soby as recording 'our epoch's hysteria...the drama of our contemporary existence',[63] and Bacon surely, as he said his first hero Picasso once had, 'sucked in the psyche of our time'.[64]

'The tabulation of Bacon's sources in Muybridge, medical photography and so forth,' a critic recently claimed, 'has become an unavoidable ritual',[65] and as mere classification it would indeed be a sterile exercise. But the power and undiminished relevance of Bacon's paintings stems, in part, from his renovation of the pictorial language of Velázquez or Degas, and is inconceivable without the 'primitive terrors' and shocking revelations of the history of the twentieth century – as witnessed on film and in photographs.

255 Detail of the lower right-hand section of pl. 254

256 Working document: black and white photograph of *Figures in a Landscape* (1956–57), with overpainting by Bacon, *c.* late 1950s

Bacon was keenly aware of the results of photographic accidents, and exploited them in his paintings. The random accretions of paint on his working documents frequently became marked with his fingerprints. There are also several instances among the photographic prints that Bacon used in which fingerprints on the original negatives were magnified during enlargement greatly in excess of life size. Bacon used a wide range of painting appliances, including household paintbrushes, his fingers, rags and sponges, and although he mainly painted in oil he also used pastels, sand, acrylics and aerosol car paint. The most unusual manifestation of his interest in surface textures, and the shorthand immediacy of semi-industrial techniques, was the hatched effects he achieved (conspicuously in the portrait heads) by pressing a rag or a piece of corduroy into the wet pigment. The similarity between the patterns this produced and enlarged fingerprints seems too close to be coincidental, and was probably suggested by Bacon's observation of the markings on the photographs in his visual archive.

Here a photograph is used as a substitute for a sketch – a typically Baconian short cut. Bacon used this photograph of his own painting as the basis for a new composition, in which the landscape elements of the original were obliterated and the ground was radically simplified. Conflating the poses of several photographs by Muybridge, the first crouching man he painted was *Study for Nude* (1951), but the Degas-like bowed head and down-stretched arm in *Figures in a Landscape* is more closely related to *Study for Crouching Nude* (1952). Bacon's revision of *Figures in a Landscape* may represent a transitional stage in the evolution of *Two Figures in a Room* (1959; pl. 163).

'Love, as it is practised in society, is merely the exchange of two momentary desires and the contact of two skins.'

Chamfort

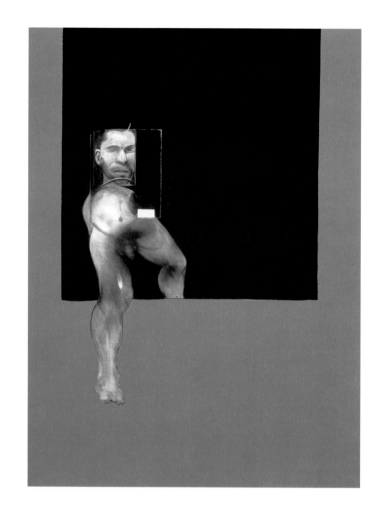

257 *Triptych* (1991)

It is tempting to read this, the most sombre and elegiac of Bacon's late paintings, as a kind of valediction. But the greenish-grey ground and black voids (spatially disjuncted so that the limbs of the figures in the outer wings disappear into the blackness) had replaced his palette of bright oranges and pale blues in 1988.

In his last great triptych Bacon, with poetic circularity, was manipulating the same sources he had been using for more than forty years – a magazine cover (Ayrton Senna's face appears to have been fused with that of Bacon's friend, José Capello), a Muybridge plate of men wrestling that had been the basis for almost all of his copulating males, and the photograph of himself that he had used in the left-hand panel of the 1973 triptych (pl. 1).

258 Working document: *The Correspondent Magazine*, c. 1990, front cover

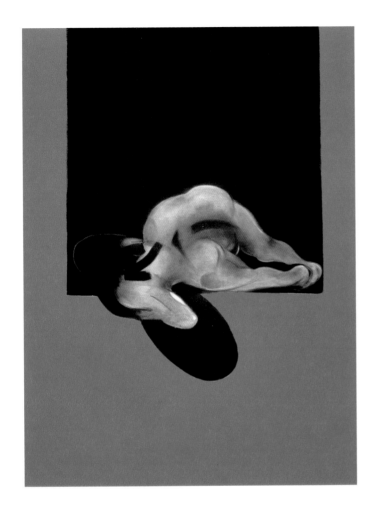

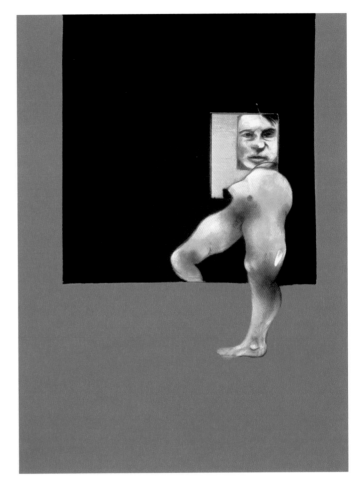

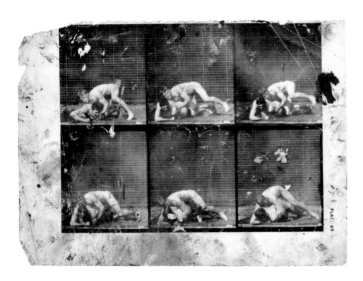

259 Working document: 'Men Wrestling', plate 69 from
Eadweard Muybridge, *The Human Figure in Motion*, 1955 edition

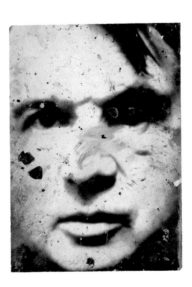

260 Working document: Francis Bacon,
by an unknown photographer, *c.* 1972

What matters it has only
decorative values. Practically
all figurative art is
illustration but from time to
time the great accident appears.
of course the quality of accident
is as variable as the quality
of illustration. the power
to unlock the feelings below
the appearance or unlock them
at all are very rare in
the whole history of art
they have not happened often
there is a long story to
tell.

261 Fragment of text by Bacon, on the inside rear cover of an unidentified book

NOTES

The main sources referred to in the notes are abbreviated as follows:

Russell: John Russell, *Francis Bacon*, London 1989 (first published 1971)

Sylvester: David Sylvester, *Interviews with Francis Bacon*, London 1997 (first published 1975)

Rothenstein/Alley: John Rothenstein (introduction), Ronald Alley (catalogue), *Francis Bacon*, London 1964 (catalogue raisonné)

Archimbaud: *Francis Bacon: In Conversation with Michel Archimbaud*, London 1993.

INTRODUCTION

1 Russell, p. 39.

2 Sir Nicholas Serota, *Sunday Times*, 'Review' section, May 3rd 1992, p. 3.

3 Andrew Sinclair, *Francis Bacon: His Life & Violent Times*, London 1993; Daniel Farson, *The Gilded Gutter Life of Francis Bacon*, London 1993; Michael Peppiatt, *Francis Bacon: Anatomy of an Enigma*, London 1996.

4 See particularly Hugh M. Davies, *Francis Bacon: The Early and Middle Years, 1928—1958*, New York 1978. More recent texts will be found in 'Further Reading', including the valuable revisionist contributions of Ernst van Alphen, Gilles Deleuze, Fabrice Hergott, Michel Leiris, David A. Mellor and Brendan Prendeville.

5 For example, both the concept of the exhibition *Francis Bacon and the Tradition of Art*, Vienna and Basel 2003–04, and several of the accompanying catalogue essays, accept these elevated, high art connections, as though Bacon had headed a revival of Velázquez or Ingres and sought to promote their draughtsmanship or ideals.

6 Andrew Brighton, *Francis Bacon*, London 2001. Brighton devotes sub-chapters to Roy de Maistre and to Bacon's other early mentor, Eric Hall.

7 S. Hunter, 'Francis Bacon: The Anatomy of Horror', *Magazine of Art*, January 1952, pp. 11–15. An article by Minor White, 'The Camera Mind and Eye', is in the same issue.

AFTER PICASSO

1 Sylvester, p. 8.

2 anon. (Georges Bataille), 'Abattoir', *Documents* 6, November 1929, pp. 328–34.

3 Lawrence Gowing, 'Francis Bacon: The Human Presence', *Francis Bacon*, exh. cat. Smithsonian Institution 1989, p. 12.

4 Archimbaud, p. 16.

5 Robert Hopper, *true and pure sculpture: Frank Dobson 1886—1963*, exh. cat. Cambridge 1981, (unpaginated).

6 Russell, p. 18.

7 Two source photographs are reproduced in *Martin Bloch 1883—1954: An Exhibition of Paintings and Drawings*, exh. cat. London 1984, (unpaginated).

8 Heather Johnson, *Roy de Maistre: The English Years, 1930—1968*, Roseville East NSW 1995, p. 119.

9 *ibid.* p. 84.

10 David Sylvester, *Looking Back at Francis Bacon*, London 2000, p. 187.

11 *Hypatia* is in the collection of the Laing Art Gallery and Museum, Newcastle upon Tyne.

12 David Mellor, 'Francis Bacon: Affinities, Contexts and the British Visual Tradition', *Figurabile: Francis Bacon*, Milan 1993, pp. 95–104. The essay is an important contribution to the retrieval of Bacon's British context.

13 *ibid.* p. 100.

14 Hunter, *op cit*, p. 15.

15 Bryan Robertson, 'Francis Bacon at 80', *Review Guardian*, October 26th 1989, p. 21.

16 John Rothenstein, *Time s Thievish Progress*, London 1970, pp. 84–85.

17 'Pablo Picasso 1930–1935', *Cahiers d Art* (special issue, unnumb.), 1936.

18 Rothenstein/Alley, p. 32.

19 Heather Johnson, *op cit*, p. 40 (plate 17).

20 Rothenstein/Alley, p. 33.

21 Sylvester, p. 68.

22 Archimbaud, p. 128. Eduardo Paolozzi's art was no more indebted to Ernst or Dalí than was Bacon's, but he was more relaxed about the Surrealist label, seeing his work as a valid extension of the tradition of Surrealism.

23 Robert Melville, *Picasso: Master of the Phantom*, London 1939, pp. 40–41.

24 Julian Trevelyan, *Indigo Days*, London 1957, p. 80.

25 *Man in a Cap* and *Man Standing* were painted on board, recto and verso, but the two sides have since been separated.

26 Sylvester, p. 70.

27 Rothenstein/Alley, see Appendix A, entries for A1 and A2; also note A4.

28 Robin Ironside, *British Painting since 1939*, London 1948, p. 37; R. Mortimer, 'At the Lefevre', *New Statesman and Nation*, 14 April 1945, p. 239. Bacon's phallicism is a subject that will repay further study. The Furies closely resemble a prehistoric stone pestle from Papua New Guinea, which Bacon is likely to have seen in the British Museum; Henry Moore drew the pestle in a notebook of 1922–24. Bacon was probably familiar, too, with Brancusi's marble *Princesse X* (1916), which was similarly indebted to primitive art.

29 Russell, p. 10.

30 See the essay by Stephen Hackney on the technical aspects of this painting in *Paint and Purpose: A Study of Technique in British Art*, London 1999, pp. 176–81.

31 Baron von Schrenck Notzing, *Phenomena of Materialisation*, 1920, p. 39. Since *La Coiffure* was stored from 1940 until 1945 in a North Wales slate quarry, Bacon's colours in the left-hand panel were probably also based on a printed reproduction. The most authoritative discussion of Degas' photographs is Malcolm R. Daniel, *Edgar Degas, Photographer*, exh. cat. New York Metropolitan Museum of Art 1998.

32 Russell, p. 10

33 The exhibition, which was, strictly speaking, preceded by Bacon's self-promoted one-man exhibition at the Transition Gallery in 1934, opened at the Hanover Gallery, London, in November 1949; Robin Ironside's work was shown in the upper room of the gallery.

34 Sylvester, p. 68.

35 Bacon was involved in preliminary discussions concerning this commission and recommended William Redgrave to complete part of the work de Maistre was unable to fulfil. See Peter Cannon-Brookes, *William Redgrave 1903—1986*, exh. cat. London 1998, p. 17.

36 This phrase is borrowed from Julia Kristeva, *Powers of Horror: An Essay on Abjection*, Columbia, New York 1982, pp. 204–06.

37 *Albrecht Altdorfer und Sein Kreis*, exh. cat. Munich 1938, plate 5.

38 *Francis Bacon: Fragments of a Portrait*, BBC TV documentary, 1966 (dir. Michael Gill; interviewer David Sylvester); edited out of transcribed versions of the interview.

39 *ibid.*

40 Robert Medley, *Drawn from the Life: A Memoir*, London 1983, p.211.

41 Graham Sutherland, 'Welsh Sketch Book', *Horizon*, April 1942, pp.224–236.

42 Grey Gowrie, 'Francis Bacon', *Modern Painters*, Winter 1988/9, p.37.

43 Patrick Heron, *The Changing Forms of Art*, London 1955, p.168. In 1953 Sam Hunter wrote of 'Graham Sutherland's last exhibition in New York, which showed unmistakeable evidence of Bacon's influence': S. Hunter, 'Francis Bacon: "An Acute Sense of Impasse" ', *Art Digest*, 15 October 1953, p.16.

44 Douglas Cooper, *The Work of Graham Sutherland*, London 1961, p.41.

45 See Rothenstein/Alley: Alley's entry, Appendix A, A5, confuses the first and revised states of *Study for Man With Microphones* (1946); the painting in its revised state survives, although with two large central passages slashed from the canvas, in the Dublin City Gallery The Hugh Lane.

MICHELANGELO AND MUYBRIDGE

1 While not disputing the essence of Delaroche's remark, his biographer has called into question its exact authenticity. See Stephen Bann, *Paul Delaroche: History Painted*, London 1997, p.264.

2 A. M. W. Stirling, *The Richmond Papers*, London 1926, p.163.

3 Archimbaud, p.14.

4 *ibid.* p.103.

5 Russell, p.71.

6 Lawrence Gowing, *Turner: Imagination and Reality*, New York 1966, p.13.

7 Sylvester, p.179

8 See Arturo Schwarz, *The Complete Works of Marcel Duchamp* (revised edition, 2 vols.), New York 1997.

9 Sylvester, p.30

10 S. Hunter, 'Francis Bacon: The Anatomy of Horror', *Magazine of Art*, January 1952, p.13.

11 Sylvester, p.134

12 Hannah Arendt (ed.), Walter Benjamin, *Illuminations*, London 1999, pp.211–244.

13 John Deakin, *London Today*, London 1949 (Foreword; unpaginated).

14 Benjamin, *op cit, loc sit.*

15 Thirty-two paintings are listed in the catalogue, but several others were added late to the exhibition – by, for example, Vanessa Bell and Geoffrey Tibble – and were ex-catalogue.

16 R. Melville, 'Francis Bacon', *Horizon* 121, December 1949/January 1950, pp.419–23.

17 *The Observer*, 23 December 1951, p.6.

18 D. Sylvester, 'The Paintings of Francis Bacon', *The Listener*, 3 January 1952, pp.23–24.

19 *The Times*, 13 November 1951, p.10.

20 D. Ades, 'Web of Images', *Francis Bacon*, exh. cat. London 1985, pp.8–23.

21 See Margarita Cappock, 'Finding Order in Chaos: Francis Bacon's Studio Contents', *Francis Bacon's Studio at the Hugh Lane*, Dublin 2001, pp.26–56; also M. Cappock, 'Works on paper by Francis Bacon in the Hugh Lane Gallery, Dublin', *Burlington Magazine*, February 2003, pp.73–81, and Cappock's four essays in *Francis Bacon and the Tradition of Art*, exh. cat. Vienna and Basel 2003–04. Dr Cappock's essays are the main fruits of the research carried out thus far on the 'working documents' and other material that remained in Bacon's Reece Mews studio on his death.

22 Archimbaud, p.12.

23 Sylvester, pp.57–58.

24 *ibid.*

25 *ibid.*

26 Benjamin, *op cit*, p.214; p.217.

27 Irena Fullard to the author, 6 September 2003.

28 The influence of photography on Degas has been a topic of protracted dispute. For the resistance of art historians, see Kirk Varnedoe, 'The Artifice of Candor: Impressionism and Photography Reconsidered', *Art in America*, January 1980, p.67. The most comprehensive study is Malcolm R. Daniel, *Edgar Degas, Photographer*, exh. cat. New York Metropolitan Museum of Art 1998.

29 Anne Baldassari, *Picasso and Photography*, Paris 1997, p.19 and pp.194–97.

30 Rosalind E. Krauss, *The Picasso Papers*, Cambridge Mass. 1999, pp.122–23.

31 Man Ray, 'Picasso, Photographe', *Cahiers d'Art* 6–7, 1937, pp.165–75.

32 Sylvester, p.188.

33 Ianthe Knott to the author, 4 March 2004.

34 Michael Peppiatt, *Francis Bacon: Anatomy of an Enigma*, London 1996, p.321.

35 Diana Watson to Ronald Alley, 4 April 1962, Tate Archive, London.

36 Tom Nichols, *Tintoretto: Tradition and Identity*, London 1999, p.90.

37 Matthew Gale, *Francis Bacon: Working on Paper*, exh. cat. London 1999.

38 David Alan Mellor, *The Barry Joule Archive: Works on paper attributed to Francis Bacon*, exh. cat. Dublin 2000; Mark Sladen, *Bacon's Eye: Works on paper attributed to Francis Bacon from the Barry Joule Archive*, exh. cat. London 2001.

39 Bacon interviewed by Richard Cork, BBC Radio 4, 1991. Printed as a supplement to *Francis Bacon, Pinturas 1981—1991/Paintings 1981–1991*, exh. cat. Galeria Marlborough SA, Madrid 1992 and Marlborough Gallery, New York 1993.

40 *Francis Bacon: Fragments of a Portrait*, BBC TV documentary, 1966 (dir. Michael Gill; interviewer: David Sylvester): edited out of transcribed versions of the interview.

41 Colin Hayes, *Robert Buhler*, London 1986, p.16.

42 *ibid.*

43 David Sylvester, *Looking Back at Francis Bacon*, London 2000, p.114.

44 Bruce Laughton, *The Euston Road School: A Study in Objective Painting*, London 1986, p.110.

45 *ibid.*

46 Malcolm Yorke, *Keith Vaughan*, London 1990, p.37.

47 John Rothenstein, *Time's Thievish Progress*, London 1970, p.27.

48 Roger Berthoud, *The Life of Henry Moore*, London 1987, pp.137–38.

49 Charles Harrison, *English Art and Modernism 1900—1939*, London 1981, p.351.

50 Russell, p.70.

51 D. Mellor, *op cit*, p.104, footnote 32.

52 David Sylvester, *Looking Back at Francis Bacon*, London 2001, p.25. Bacon may also have seen the Sickert exhibition at the National Gallery in 1942. He was definitely aware of Sickert's press photograph sources, for he criticized his method of 'squaring-up' from photographs. For an interesting discussion of Roger Fry's earlier inspiration from a press photograph, see Frances Spalding, *Roger Fry: Art and Life*, Norwich 1999, pp.186–87.

53 R. Daniels, 'Press Art: The late oeuvre of Walter Richard Sickert', *Apollo*, October 2002, pp.30–35.

RAW MATERIAL

1 See plate 200. The lists of ideas recall Derrida's observation in *Of Grammatology*: 'Writing supplements perception before perception even appears to itself.'

2 Sylvester, p.38.

3 Hugh M. Davies, *The Papal Portraits of 1953*, San Diego 2002, p.65.

4 A draft of this letter, in Bacon's hand and dated 1978, is in a private collection; it is, of course, possible it was never sent.

5 D. Farr, 'Francis Bacon in Context', *Francis Bacon: A Retrospective*, New York 1999, p.225, footnote 2.

6 M. Peppiatt, 'Francis Bacon at Work', *Francis Bacon: A Retrospective*, New York 1999, p.226, footnote 8.

7 S. Hunter, *op cit*, p.12.

8 S. Hunter, *op cit*, p.11.

9 Russell, p. 68

10 More than one hundred of these were gathered by Lorant into an anthology, *Chamberlain and the Beautiful Llama*, London 1940.

11 John F. Moffitt, 'Velázquez in the Alcazar Palace in 1656: the meaning of the *mise-en-scène of Las Meninas*', *Art History*, September 1983, pp. 271–300.

12 David Sylvester, *Looking Back at Francis Bacon*, London 2000, p.134.

13 Leon Battista Alberti, *On Painting* [1565], New Haven 1966, p.64.

14 R. Manvell (who apparently adopted the pseudonymous surname 'Marvell' when writing for this publication), 'New Pictures', *New Statesman and Nation*, 16 February 1946, p.119.

15 'Snapshots From Hell, *Time*, 19 October 1953, p.62.

16 See Dawn Ades, 'Web of Images', *Francis Bacon*, exh. cat. London 1985, pp.14–16.

17 H. Lessore, 'A Note on the Development of Francis Bacon's Painting', *A Quarterly Review*, March 1961, pp.23–26.

18 Archimbaud, p.41.

19 David Sylvester, *Looking Back at Francis Bacon*, London 2000, p.56.

20 Many other photographers working in the Terme Museum have employed this pleated backdrop.

21 Bacon wrote down the dream on 22 December 1984 (holograph note; private collection).

22 David Sylvester, *Looking Back at Francis Bacon*, 2001, p.246.

23 James E. B. Breslin, *Mark Rothko: A Biography*, Chicago 1993, p.400.

24 Quoted in Malcolm Yorke, *Matthew Smith*, London 1997, p.214.

25 W. Lewis, 'Round the London Art Galleries', *The Listener*, 12 May 1949, pp.811–12.

26 W. Lewis, 'Round the London Art Galleries', *The Listener*, 17 November 1949, p.860.

27 S. Hunter, *op cit*, p.12.

28 'Survivors', *Time*, 21 November 1949, p.44.

29 Sylvester, p.192.

30 *ibid*.

31 M. Peppiatt, 'Reality Conveyed by a Lie', *Art International*, Autumn 1987, pp.30–33.

32 D. Sylvester, 'A Life with thugs', *Independent on Sunday*, 11 February 1996.

33 The man was also said to have been based on Peter Lacy.

34 C. Colvin (ed.), *Maria Edgeworth: Letters From England 1813—1844*, Oxford 1971: reprinted in *From Today Painting is Dead: The Beginnings of Photography*, exh. cat. London 1972, p.24. Edgworth's letter is dated 23 May 1841.

35 'Snapshots From Hell', *Time*, 19 October 1953, p.62.

36 L. Alloway, 'Francis Bacon', *Art International*, 1960 [vol. iv, nos. 2–3], pp.62–63.

37 See Val Williams and David Mellor, *Too Short a Summer: The Photographs of Peter Rose Pulham 1910—1956*, exh. cat. York 1979.

38 'Surrealist Artists', *Lilliput*, October 1943, pp.319–330.

39 Holograph letter, Bacon to Graham Sutherland, October 1946, National Museums and Galleries of Wales.

40 Pulham's 'The Camera and the Artist' was published in *The Listener*, 24 January 1952, pp.142–146; Bacon's tribute was related to the present author by Francis Wyndham, 8 February 1982.

41 From an unpublished section of manuscript by Pulham, dated August 1951 (private collection).

42 'Little History of Photography', *Walter Benjamin Selected Writings Volume 2: 1927—1934*, Cambridge Mass. and London 1999, pp.507–530.

43 J. Berger, 'The Worst is Not Yet', *New Statesman*, 6 January 1972, pp.22–23.

44 The ICA debate took place on 11 March 1952: the quotation is from a transcript made by Richard Lannoy, who kindly made this available to me.

IN CAMERA

1 Sylvester, p.189.

2 'Remarks from an Interview with Peter Beard', *Francis Bacon: Recent Paintings 1968—1974*, New York Metropolitan Museum of Art 1975, p.15.

3 Gaston Bachelard, *The Poetics of Space*, Boston 1994 (first pub. 1958), p.45.

4 Bacon repeated this story to friends on more than one occasion.

5 See G. Claeys and L. T. Sargent (eds), *The Utopia Reader*, New York 1999, pp.123–25.

6 N. Wallis, 'Nightmare', *Observer*, 20 November 1949, p.6.

7 See Barbara Steffen, 'The Cage Motif', *Francis Bacon and the Tradition of Art*, exh. cat. Vienna and Basel 2003–04, pp.175–78, and James Hyman, *The Battle for Realism*, London 2001, pp.13, 16.

8 There are many alternative sources for this shape, including the gymnastics wheel (featured, for example, in Man Ray's film *Les Mystères du Château du Dé*) and the barriers of greyhound tracks, which Bacon occasionally frequented. Perhaps the most feasible source, although none was found in Bacon's archive, was photographs of operating theatres.

9 Bacon's sister's family, who farmed in Southern Rhodesia, owned the book: Bacon used to sit on their porch reading farming books (the farm was irrigated).

10 B. Colomina, 'Le Corbusier and Photography', *assemblage 4*, Cambridge Mass. and London, October 1987, pp.6–23

11 Russell, p.17.

12 *ibid*.

13 Rothenstein/Alley, p.28.

14 Sylvester, p.136. The photograph of Bacon in hospital is believed to be lost.

15 See pp. 199–214.

16 The vulnerability and isolation of the man in *Lying Figure* (1961), in particular, appears to be thematically connected to the central panel of *Three Studies for a Crucifixion* (1962).

17 Rothenstein/Alley, p.146.

18 After 1962, Bacon clearly regarded the triptychs as his most important paintings.

19 Gordon Anthony vacated the studio in 1940.

20 Sylvester, p.189.

21 *Figure Getting Out of Car* was revised as *Landscape With Car* (*c*.1946): see Rothenstein/Alley, Appendix A, A4.

22 Bacon frequently expressed an unequivocal distaste for mountainous country.

23 T. S. Eliot refers to Webster in the first verse of 'Whispers of Immortality' (1920).

24 Rothenstein/Alley, Appendix B, D9. The number 47 is visible in the photograph of the camera crew filming *The Sheik*, 1921 (plate 48).

25 Michael Peppiatt, *Francis Bacon: The Anatomy of an Enigma*, London 1996, p.151.

26 John Edwards to the author, 27 February 2002.

27 Peppiatt, *op cit*, p.145.

28 Peppiatt, *op cit*, p.146.

29 Bigman's recollection is published on his website. See also Mark Sladen, 'The Bacon Myth', *Bacon's Eye: Works on Paper attributed to Francis Bacon from the Barry Joule Archive*, exh. cat. Barbican Art Gallery, London, 2001, p.99

30 Sylvester, p.189.

31 *ibid*.

32 D. Sylvester, 'A Life with thugs', *Independent on Sunday*, 11 February 1996.

33 For example, Tony Matthews's opinion that Redgrave was 'aggressively anti-abstract' is quoted in Margaret Garlake, *Peter Lanyon*, London 2001, p.44, footnote 29.

34 Written by Bacon on the fly-leaves of an unidentified book; in the collection of Dublin City Gallery The Hugh Lane.

35 John Edwards to the author, 27 February 2002; Bacon recommended 'Belcher's Green' for the

decoration scheme of Edwards's house in (*ex inf.* Brian Clarke).

36 Quoted in William Redgrave's (unpublished) journals 15 November 1959, hereafter referred to as 'Redgrave Journals'; private collection.

37 Redgrave Journals, September 1959.

38 The accuracy of this anecdote (in Daniel Farson, *The Gilded Gutter Life of Francis Bacon*, London 1993, p.117), was confirmed to the author by Louis le Brocquy, who emphasized the long-running antipathy between Heron and Bacon.

39 Sylvester, p.72.

40 For the only discussion of Bacon and Rodin to date, see Matthew Gale, *Francis Bacon: Working on Paper*, exh. cat. London 1999, pp.30–31.

41 Redgrave Journals, September 1959.

42 Gale, *op cit*, p.78. Dates ascribed to various Rodin castings, including *Iris, Messenger of the Gods*, are discrepant and confusing.

43 Bacon and Rodin will be the subject of an extended study by the present author.

44 H. Pinet, 'Rodin and Photography', in Catherine Lampert, *Rodin: Sculpture and Drawings*, exh. cat. London 1986, pp.241–42.

45 George Besson, 'Pictorial Photography: A Series of Interviews', *Camerawork no. 24*, October 1908, p.14.

46 'Remarks from an Interview with Peter Beard', *Francis Bacon: Recent Paintings 1968—1974*, New York Metropolitan Museum of Art 1975, p.15.

47 Beaton, *op cit*, p.101.

48 Beaton, *op cit*, p.102.

49 Holograph letter, Bacon to Graham Sutherland, August 1946, National Museums and Galleries of Wales.

50 Beaton, *op cit*, p.101.

51 B. Robertson, 'Francis Bacon: Out of Decay, Immortality', *Spectator*, 2 May 1992.

52 David Sylvester, *Looking Back at Francis Bacon*, London 2000, p.87.

53 Beaton, *op cit*, p.105.

54 David Sylvester, *Looking Back at Francis Bacon*, London 2000, p.87.

55 Redgrave subsequently became more admired for his sculpture than his paintings.

56 Peter Cannon-Brookes, *William Redgrave 1903—1986*, exh. cat. London 1998, p.35.

57 Sylvester, p.189.

58 Sylvester, p.107. In describing *Three Studies for a Crucifixion* (1962) as Bacon's first triptych since 1944, the 'exception', *Three Studies for the Human Head* (1953), is omitted solely on the grounds that it was not originally conceived as a triptych.

59 M. Gross, 'Bringing Home Bacon', *Observer*, 30 November 1980, p.29.

60 See Michael Peppiatt, *Francis Bacon: The Anatomy of an Enigma*, London 1996, p.190, and further comments on Peppiatt's interpretation in Andrew Brighton, *Francis Bacon*, London 2001, pp.59–61.

61 Victoria Worsley, archivist of the Henry Moore Institute, Leeds, kindly gave me details of the history of *Mother and Child* prior to its accession by the Institute.

62 Bacon's comments on his 'sculpture' were excised from the published versions of an interview conducted by David Sylvester in 1962: the details here are from an unpublished page proof, The Estate of Francis Bacon.

63 David Sylvester in conversation with the author, 30 June 1999.

64 Sylvester, p.41.

65 Sylvester, p.43.

66 Francis Bacon in *John Deakin: Salvage of a Photographer*, exh. cat. Victoria & Albert Museum, London, 1984, p.8.

67 *Vogue*, February 1952, p.73.

68 Daniel Farson in *John Deakin: Salvage of a Photographer*, exh. cat. Victoria & Albert Museum, London, 1984, p.12.

69 'Remarks from an Interview with Peter Beard', *Francis Bacon: Recent Paintings 1968—1974*, New York Metropolitan Museum of Art 1975, p.15.

70 C. MacInnes, 'The Photographer as Artist', *The Times*, 13 July 1956.

71 Henrietta Moraes, *Henrietta*, London 1994, p.72.

72 Sylvester, p.78.

73 Michael Peppiatt, *Francis Bacon: The Anatomy of an Enigma*, London 1996, p.38.

74 Sylvester, p.86.

75 John Edwards to the author, 27 February 2002.

76 David Sylvester, *Looking Back at Francis Bacon*, London 2000, p.151.

77 Sylvester, *op cit*, p.152.

SKIN/FLICKS

1 Roland Barthes, *Camera Lucida*, London 1984, p.81.

2 Hunter, *op cit*, p.12.

3 Didier Anzieu, *The Skin Ego: A Psychoanalytic Approach to the Self*, New Haven and London 1989, pp.31–32.

4 Sylvester, p.176.

5 *ibid.*

6 David Sylvester, *Looking Back at Francis Bacon*, London 2000, p.243.

7 J. Reichardt, 'Developments in Style – V: Francis Bacon', *The London Magazine*, June 1962, pp.38–44.

8 Eric J. Hosking and Cyril W. Newberry, *Birds of the Night*, London 1945, plate 71.

9 J. Arthur Thompson, *The Outline of Science*, London 1922 (2 vols.), plates unnumbered.

10 'Remarks from an Interview with Peter Beard', *Francis Bacon: Recent Paintings 1968—1974*, New York Metropolitan Museum of Art 1975, p.16.

11 Sylvester, p.140.

12 David Sylvester, *Looking Back at Francis Bacon*, 2000, p.98.

13 Sylvester, p.82.

14 Bacon knew of, for example, Harry Edwards, *The Mediumship of Jack Webber*, London 1940 [*ex inf.* Brian Clarke]. Schrenck Notzing's currency in London in the 1940s was sufficient to earn him the popular epithet 'Shrink at nothing' [*ex inf.* Richard Lannoy].

15 Michael Peppiatt, *Francis Bacon: The Anatomy of an Enigma*, London 1996, p.84.

16 J. B. Berkart, *Nervous Asthma: Its Pathology and Treatment*, London 1915, p.29.

17 Archimbaud, p.162; Sylvester, p.189.

18 It may be significant that Bacon had been unfavourably compared to Fuseli. Dore Ashton quoted 'one London wit' who called Bacon 'the poor man's Fuseli': Dore Ashton, 'London: An Insular Psychology', *Art Digest*, 15 September 1954, pp.16–17. Bacon similarly deplored the superficial comparisons made between his paintings and those of Hieronymus Bosch.

19 *Francis Bacon: Fragments of a Portrait*, BBC TV documentary 1966 (dir. Michael Gill; interviewer: David Sylvester): comment edited out of transcribed versions of the interview.

20 David Sylvester, *Trapping Appearance: Portraits by Alberto Giacometti and Francis Bacon from the Robert and Lisa Sainsbury Collection*, exh. cat. Norwich 1996, p.9.

21 Sylvester, p.46.

22 'Remarks from an Interview with Peter Beard', *Francis Bacon: Recent Paintings 1968—1974*, New York Metropolitan Museum of Art 1975, pp.14–15.

23 D. Sylvester, 'At the Tate Gallery', *Encounter*, September 1956, p.67.

24 Sylvester, p.90; and pp.17–18.

25 Sylvester, p.81.

26 Hugh M. Davies, *Francis Bacon: The Early and Middle Years, 1928—1958*, 1978, p.149.

27 *ibid.*

28 *Francis Bacon: Grand Palais*, BBC TV documentary (dir: Gavin Millar), 1971.

29 A later copy of *The Romantic Agony* is visible on a bookshelf in a photograph of Reece Mews in Perry Ogden (Foreword, John Edwards), *7 Reece Mews: Francis Bacon s Studio*, London 2001, pp.110–111.

30 Mario Praz, *The Romantic Agony*, London 1933, p.189.

31 Praz, *op cit*, pp. 226–27. Swinburne's image of the foot on the mouth corresponds with the child in Poussin's *Massacre of the Innocents*.

32 Georges Bataille, 'Mouth', *Visions of Excess: Selected Writings, 1927–1939*, Minneapolis 1985, p. 59.

33 Leonard Shengold, 'More About Rats and Rat People' (ed. Margaret A. F. Hanly), *Essential Papers on Masochism*, New York and London 1995, p. 225.

34 Shengold, *op cit*, pp. 227–28.

35 R. Fliess, *Erogeneity and Libido*, New York 1956, pp. 177–181.

36 Rothenstein/Alley, p. 33.

37 See, for example, Picasso's *Woman in An Armchair* (1929) and *Seated Bather* (1929). Picasso was also the source of more specific and idiosyncratic Bacon motifs, such as the safety-pin, which had first appeared in Picasso's Boisgeloup Crucifixion drawings in 1932.

38 Archimbaud, p. 156.

39 W. B. Stanford, *Aeschylus in His Style*, Dublin 1942, p. 115.

40 Miranda Carter, *Anthony Blunt: His Lives*, London 2001, pp. 92–93.

41 *In the Name of the Father*, BBC TV documentary 1996 (presented by psychoanalyst Darian Leader).

42 Archimbaud, p. 39.

43 Extracts from interviews with David Sylvester recorded May 1966, in *Francis Bacon: Recent Paintings*, exh. cat. London, Marlborough Fine Art Ltd, March–April 1967, p. 36. It was no doubt Bacon who had this self-revelatory remark removed from the published anthologies of Sylvester's interviews.

44 *Journals and Drawings — Keith Vaughan*, London 1966, p. 139. (Vaughan refers to a letter he received from Williams in 1955, containing this recollection). In 1951 Williams told Richard Lannoy that Bacon was 'impossible to work with and used up the creative energy of whoever came his way' (R. Lannoy to the author, July 2002).

45 John Rothenstein, *Time s Thievish Progress*, London 1957, p. 83

46 John Edwards in conversation with the author, 27 February 2002.

47 *ibid*.

48 *Time & Tide*, 6 May 1933.

49 *Harper s Bazaar*, June 1933.

50 James Hyman, *The Battle for Realism*, London 2002, p. 15.

51 D. Ades, 'Web of Images', *Francis Bacon*, exh. cat. London 1985, p. 14.

52 Didier Anzieu, *The Skin Ego: A Psychoanalytic Approach to the Self*, New Haven and London 1989, pp. 99–101.

53 Anzieu, *op cit*, p. 99. See also Didier Anzieu, *Le corps de l 'uvre*, Paris 1981, pp. 333–339.

54 Raymond Mason, *At Work in Paris: Raymond Mason on Art and Artists*, London 2003, p. 169.

55 Ernst van Alphen, *Francis Bacon and the Loss of Self*, London 1992, p. 190.

56 Bacon interviewed by Richard Cork, BBC Radio 4, 1991. Printed as a supplement to *Francis Bacon, Pinturas 1981—1991/Paintings 1981—1991*, exh. cat. Galeria Marlborough SA, Madrid 1992 and Marlborough Gallery, New York 1993.

57 William Michael Rossetti, *Dante Gabriel Rossetti: His Family-Letters, with a Memoir*, London 1895 (2 vols). Rossetti's reading is discussed in Volume I, pp. 100–103.

58 Hugh Kenner, *The Pound Era*, London 1991 (first ed. 1971), pp. 289–90

59 James Hyman, *op cit*, p. 136. Hyman notes that the poem was published in English translation in the first issue of *Arena* magazine (Spring 1949). The most relevant lines are: 'black is the monkey pestering me', 'Black where the arrow-shaft gets home' – 'Black the rage with hair gone white / and with the fallen dribbling mouth'. But *Head I* (1948) was painted before *Arena* was published, and a causal link with the poem (if that is what is implied) would, therefore, depend on Bacon's having read the poem in the French edition, *Po mes Politiques*, 1948. He may have brought *Po mes Politiques* to London from Monte Carlo in 1948; he could also have obtained it through his friend Sonia Orwell, who was working with Cyril Connolly on *Horizon*.

60 T. S. Eliot wrote 'the backward half-look' (*The Four Quartets*, second part, 'The Dry Salvages'). A comprehensive study would no doubt uncover many more literary inspirations for Bacon's paintings. The most extensive essay on the subject to date is R. Lessoe, 'Francis Bacon and T. S. Eliot', *Hafnia (Copenhagen Papers in the History of Art) No. 9*, Copenhagen 1983, pp. 113–130.

61 David Sylvester, *Looking Back at Francis Bacon*, London 2000, p. 248.

62 *Francis Bacon: Grand Palais*, BBC TV documentary (dir: Gavin Millar), 1971.

63 James Thrall Soby, *Modern art and the new past*, Norman, Oklahoma 1957, pp. 126–27.

64 David Sylvester, *Looking Back at Francis Bacon*, London 2000, p. 244.

65 Brendan Prendeville, *Realism in 20th Century Painting*, London 2000, p. 150.

262 Working document: photograph by Michel Pergolani of Francis Bacon, *c.* 1970

FURTHER READING

The most extensive bibliographies to date are those published in Dawn Ades and Andrew Forge, *Francis Bacon*, exh. cat. London 1985 (compiled by Krzysztof Cieszkowski) and in *Francis Bacon*, exh. cat. Paris 1996.

Dawn Ades and Andrew Forge (with a note on technique by Andrew Durham), *Francis Bacon*, exh. cat. London 1985

Ernst van Alphen, *Francis Bacon and the Loss of Self*, London 1992

Michel Archimbaud, *Francis Bacon: In Conversation with Michel Archimbaud*, London 1993

Francis Bacon: The Human Body, exh. cat. London 1998

Francis Bacon, Pinturas 1981—1991/Paintings 1981—1991, exh. cat. Galeria Marlborough SA, Madrid 1992 and Marlborough Gallery, New York 1993

Francis Bacon: Recent Paintings 1968—1974, New York Metropolitan Museum of Art, New York 1975

Francis Bacon: A Retrospective, New York 1999

Francis Bacon and the Tradition of Art, exh. cat. Vienna and Basel 2003–04

The Body on the Cross, exh. cat. Paris 1992

France Borel (introduction by Milan Kundera), *Bacon: Portraits and Self-Portraits*, London 1996

Andrew Brighton, *Francis Bacon*, London 2001

Margarita Cappock (with introduction by Barbara Dawson), *Francis Bacon s Studio at the Hugh Lane*, Dublin 2001

Hugh M. Davies, *Francis Bacon: The Early and Middle Years, 1928—1958*, New York 1978

—, *The Papal Portraits of 1953*, Aldershot and San Diego 2002

Gilles Deleuze, *Francis Bacon: The Logic of Sensation*, London 2003

Christophe Domino, *Francis Bacon: Painter of a Dark Vision*, New York 1997

—, *Francis Bacon: Taking Reality by Surprise* , London 1997

Daniel Farson, *The Gilded Gutter Life of Francis Bacon*, London 1993

Luigi Fiacci, *Francis Bacon: 1909—1992*, Cologne 2003

Matthew Gale, *Francis Bacon: Working on Paper*, exh. cat. London 1999

Lawrence Gowing and Sam Hunter (with foreword by James Demetrion), *Francis Bacon*, exh. cat. Hirshhorn Museum and Sculpture Garden, Washington DC, and London 1989

Martin Harrison, *Francis Bacon: Caged-Uncaged*, exh. cat. Porto 2002

—, 'Points of Reference, Francis Bacon and Photography', in *Francis Bacon: Paintings from the Estate 1980—1991*, London 1999

—, *Transition: The London Art Scene in the Fifties*, London 2002

Fabrice Hergott, 'La chambre de verre', in *Francis Bacon*, exh. cat. Paris 1996

Michel Leiris, *Francis Bacon*, London 1988

—, *Francis Bacon: Full Face and in Profile*, London 1983

Louisiana Museum for moderne kunst, *Francis Bacon*, Louisiana, Denmark, 1998

Raymond Mason, *At Work in Paris: Raymond Mason on Art and Artists*, London 2003

David A. Mellor, 'Francis Bacon: Affinities, Contexts and the British Visual Tradition', in *Figurabile: Francis Bacon*, exh. cat. Milan 1993

Perry Ogden (with foreword by John Edwards), *7 Reece Mews: Francis Bacon s Studio*, London 2001

Michael Peppiatt, *Francis Bacon: Anatomy of an Enigma*, London 1996

Brendan Prendeville, 'Varying the Self: Bacon's versions of Van Gogh', *Oxford Art Journal*, vol. 27, issue 1, 2004, pp. 23–42

John Rothenstein and Ronald Alley, *Francis Bacon*, catalogue raisonné, London 1964

John Russell, *Francis Bacon*, London 1989 (first pub. 1971)

Lo Sagrado y Lo Profano, Valencia 2003-4

Andrew Sinclair, *Francis Bacon: His Life & Violent Times*, London 1993

David Sylvester, *Brutality of Fact: Interviews with Francis Bacon*, London 1987

—, *Francis Bacon: The Human Body*, exh. cat. London c. 1998

—, *Interviews with Francis Bacon*, London 1997 (first pub. 1975)

—, *Looking Back at Francis Bacon*, London 2000

—, *Trapping Appearance: Portraits by Alberto Giacometti and Francis Bacon from the Robert and Lisa Sainsbury Collection*, exh. cat. Norwich 1996

Van Gogh by Bacon, exh. cat. Arles 2002

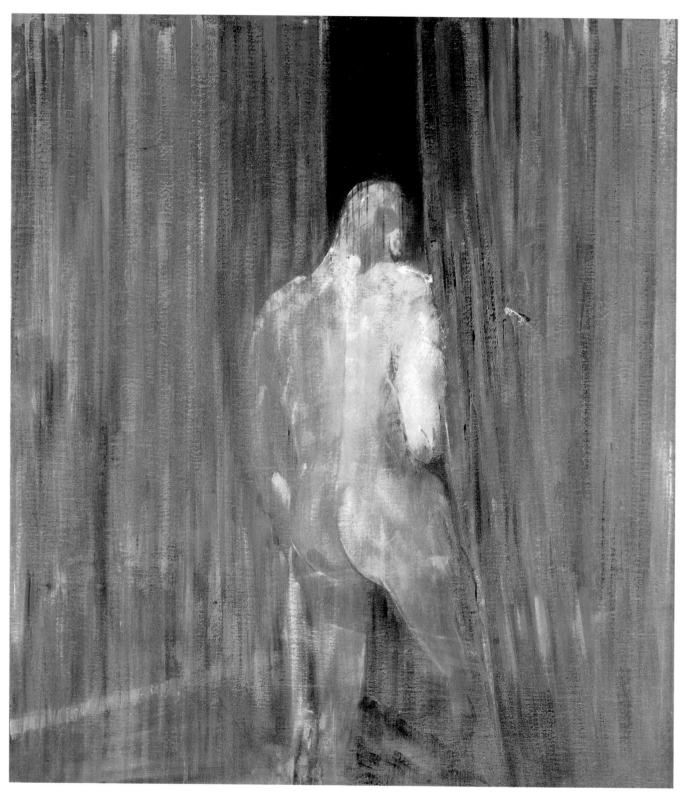

263 *Study from the Human Body* (1949)

LIST OF ILLUSTRATIONS

ACKNOWLEDGMENTS

ILLUSTRATION ACKNOWLEDGMENTS

All oil paintings and works in other media by Francis Bacon (except pls 36, 42 and 43) and all working documents and other studio items held by Dublin City Gallery The Hugh Lane and the Estate of Francis Bacon are ©The Estate of Francis Bacon.

Aberdeen Art Gallery & Museums Collections pl. 238; © ADAGP, Paris and DACS, London 2005 pls 18, 123, 128, 168, 170; Art Institute of Chicago, Harriott A. Fox Fund pl. 177; Arts Council Collection and Hayward Gallery, London pl. 86; Astrup Fearnley Collection, Oslo, Norway pl. 249; © Peter Beard pls 112, 217, 218; by courtesy of Peter Beard pl. 200; Bibliothèque Nationale, Paris pl. 38; Bildarchiv Preussischer Kulturbesitz, Berlin pl. 53; Gilbert de Botton Family Trust pl. 135; Ivor Braka Ltd., London pl. 127; British Museum, London pl. 154; Centre Pompidou-MNAM-CCI, Paris. Photo © CNAC/MNAM Dist. RMN pl. 120; courtesy Curatorial Assistance Inc, Pasadena, and the National Portrait Gallery, London pl. 125; © 1997 by the Des Moines Art Center. Purchased with funds from the Coffin Fine Arts Trust; Nathan Emory Coffin Collection of the Des Moines Art Center, Iowa, 1980. Photo Michael Tropea, Chicago pl. 239; Dublin City Gallery The Hugh Lane and The Estate of Francis Bacon pls 4, 5, 6, 10, 11, 12, 13, 27, 49, 50, 51, 52, 55, 56, 79, 80, 81, 99, 151, 173, 175, 181, 192, 194, 195, 196, 197, 199, 202, 204, 206, 208, 210, 212, 214, 220, 221, 230, 231, 236, 241, 242, 256, 258, 259; Dublin City Gallery The Hugh Lane. Photos Perry Ogden. Copyright © 2005 The Estate of Francis Bacon pls 110, 114; The Estate of Francis Bacon pls 9, 25, 61, 65, 67, 94, 101, 119, 133, 138, 152, 178, 179, 183, 184, 188, 190, 201, 215, 216, 222, 225, 233, 234, 244, 246, 247, 254, 255, 260, 261, 262; © Estate of Patrick Heron 2005. All rights reserved, DACS pl. 147; © Estate of Walter R. Sickert 2005. All rights reserved, DACS pls 70, 71; Galleria d'Arte Moderna, Turin pl. 229; Solomon R. Guggenheim Museum, New York. Photo David Heald © The Solomon R. Guggenheim Foundation, New York (FN 64.1700.a–.c) pl. 167; Samuel and Ronnie Heyman, New York pl. 132; Photo Hirmer FotoArchiv pl. 96; Hirshhorn Museum and Sculpture Garden, Smithsonian Institution, Washington; gift of Joseph H. Hirshhorn Foundation, 1972 pl. 69; Huddersfield Art Gallery (Kirklees Metropolitan Council) pl. 250;

Jan and Marie-Anne Krugier-Poniatowski Collection pl. 237; Kunstsammlung Nordrhein-Westfalen, Düsseldorf. Photo Walter Klein, Düsseldorf pl. 144; Kupferstichkabinett, Staatliche Museen Preussischer Kulturbesitz, Berlin pl. 111; Richard E. Lang and Jane M. Davis Collection, Medina, Washington pl. 182; Leeds Museums and Galleries (City Art Gallery)/ Bridgeman Art Library, London pl. 97; Louvre Museum, Paris pl. 19; © Man Ray Trust/ ADAGP, Paris and DACS, London 2005 pls 92, 93, 151; Marlborough International Fine Art, London pls 14, 34, 83, 87, 211; courtesy Roger Mayne pl. 140; Photo Moderna Museet, Stockholm pl. 198; MUMOK, Museum Moderner Kunst Stiftung Ludwig, Vienna pl. 104; Musée Condé, Chantilly. Photo © RMN-Harry Bréjat pl. 95; Musée Rodin, Paris. © Musée Rodin pl. 153; Museum Bochum, Germany pl. 219; Museum of Contemporary Art, Chicago. Gift of Joseph and Jory Shapiro pl. 235; Museum of Modern Art, New York. Purchase. pls 47, 257; National Gallery of Australia, Canberra pl. 91; National Gallery of Canada, Ottawa. Purchased 1957 pl. 243; National Gallery, London pls 37, 40; National Gallery of Victoria, Melbourne, Australia. Purchased 1953 pl. 263; National Museum of Modern Art, Tokyo pl. 251; National Museums & Galleries of Wales pl. 46; National Portrait Gallery, London pl. 134; Newcastle City Council: Education and Libraries Directorate pl. 30; Philadelphia Museum; The John G. Johnson Collection pl. 98; Pinakothek der Moderne, Munich. Photo Andreas Freytag. Archiv ARTOTHEK pl. 207; private collection, Caracas pl 121; private collection, courtesy J. C. C. Glass pls 2, 73, 74, 75, 156, 264; private collection, Monaco pl. 213; private collection, New York pl. 124; private collection, Switzerland pl. 1; private collections pls 3, 7, 8, 15, 16, 17, 18, 20, 22, 23, 24, 26, 28, 29, 31, 32, 33, 39, 41, 44, 45, 54, 57, 58, 59, 60, 62, 63, 64, 68, 71, 76, 77, 78, 82, 84, 85, 88, 89, 90, 100, 103, 105, 106, 107, 108, 109, 116, 122, 128, 129, 130, 136, 137, 139, 141, 148, 149, 150, 157, 158, 159, 160, 161, 162, 164, 166, 170, 171, 172, 176, 180, 187, 189, 191, 193, 203, 205, 209, 223, 224, 226, 227, 228, 245, 248, 252, 253; Royal College of Art Collection, London pl. 113; Robert and Lisa Sainsbury Collection, University of East Anglia. Photos James Austin pls 163, 165, 174; Scottish National Gallery of Modern Art, Edinburgh; Gabrielle Keiller

Collection pl. 126; SGF/Gaumont/The Kobal Collection pl. 186; courtesy Sotheby's, London pl. 155; Staatliche Museen zu Berlin-Nationalgalerie Bildarchiv Preussischer Kulturbesitz, Berlin, 2004. Photo Jörg P. Anders pl. 18; Stedelijk Museum, Amsterdam pl. 118; Stedelijk van Abbemuseum, Eindhoven pl. 240; © Succession Picasso/DACS 2005 pls 16, 33; Tate, London pls 35, 66, 70, 145, 146, 147, 168, 232; © Tate, London 2005 pls 36, 42, 43; Ulster Museum, Belfast pl. 102.

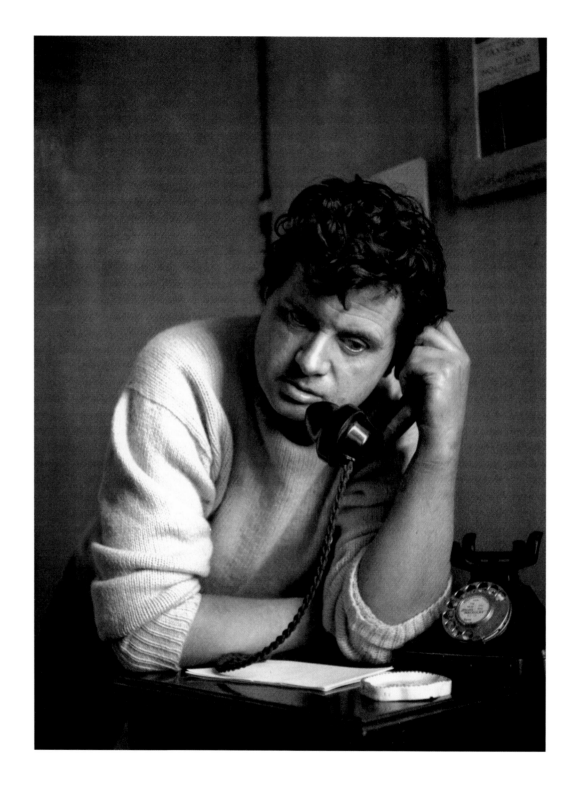

264 Douglas Glass: Bacon at Overstrand Mansions, Battersea, 1960

AUTHOR'S ACKNOWLEDGMENTS

This book is dedicated to the memory of John Edwards, who, even in the painful later stages of his tragic illness, submitted with patience and conscientiousness to all of my questions. At the inception of this project, the advice I received from David Sylvester was also a huge encouragement; he entitled an article he wrote nearly fifty years ago *In Camera*, and not being able to discuss this with him is one of many reasons I have to regret his passing.

The curatorial staff and archivists of many institutions have given me assistance, and I should particularly like to acknowledge: Adrian Glew and Krzysztof Cieszkowski (Tate, London); Victoria Worsley (Henry Moore Institute, Leeds); Barbara Dawson, Margarita Cappock and Alexander Kearney (Dublin City Gallery The Hugh Lane); Alison Cullingford (University of Bradford); Robert Hall (Huddersfield Art Gallery); Pauline Carr and Isobel Siddons (The National Gallery, London); Tim Egan (National Museums and Galleries of Wales, Cardiff); Kynaston McShine (Museum of Modern Art, New York); Hugh M. Davies (Museum of Contemporary Art, San Diego); Amanda Geitner (Sainsbury Centre for Visual Arts, Norwich); Terence Pepper (National Portrait Gallery, London); Mark Haworth-Booth and Charles Newton (Victoria & Albert Museum, London). I wish to warmly thank, too, the staff of the British Library, British Museum (Centre for Anthropology), Westminster Arts Library, and the National Art Library. Bacon was indifferent to the documentation of his visual sources, and were it not for the dedication of Valerie Beston the historical record would be considerably poorer; I am pleased to acknowledge her important contribution in this respect.

My special thanks are due to Elizabeth Beatty, Administrator of the Estate of Francis Bacon, for her enthusiasm, unfailing kindness, and for assiduously keeping me in touch with the myriad developments in Bacon studies. For their help in many ways I am also grateful to Peter Hunt and Norma Johnson, to Gerard Faggionato, Anna Pryer and Bunny Turner of Faggionato Fine Arts, and to Tony Shafrazi, Hiroko Onoda and George Horner of the Tony Shafrazi Gallery. Dr Paul Brass, Bacon's physician from 1963, was a wise and sensitive guide to Bacon's ailments, particularly his asthma. The layout and typography of this book have greatly benefitted from the craftsmanship of Tony Waddingham.

It was a particular pleasure, as well as extremely informative, to be able to discuss Bacon with his sister, Ianthe Knott. Heather Johnson was similarly most generous in sharing her knowledge of Roy de Maistre, as was Caroline de Mestre Walker.

My sincere thanks are also due to Donald and Jo Adie; Robert Adie; Neil Allen; Wendy Baron; Tony Benyon; Peter Blake; Colin Blakemore; Louis le Brocquy; Kevin Brownlow; Campbell and Jacqueline Bruce; Michael Buhler; Peter and Nejma Beard; Sandra Coley; Clare Conville; Peter Cormack; Rebecca Daniels; Jeanette Donovan; John Emanuel; Irena Fullard; Philippe Garner; Chris Glass; Richard Hamilton; Ben, Brett and Francesca Harrison; Tanya Harrod; Janet Henderson; Nick Hughes; Sam Hunter; Lauren Hutton; John Jesse; Doreen Kern; Patti Lambert; Catherine Lampert; Patrick and (the late) Joan Leigh Fermor; David Foxton; Boris Kasolowsky; Wendy Knott; Paul Lomas; Adam Low; Ann Madden; Roger Mayne; Gerry McCarthy; John McDermot; Alison Meek; the late Thérèse Megaw; James Mortimer; Jenny Mortimer; Robin Muir; Myles Murphy; Jeremy Musson; Biddy Noakes; Fr John and Zoe Pelling; Jessica Pennant; Timothy Preuss; Belinda Price; Chris Redgrave; Adam Robb; John Russell; Andrew Saint; Elaine Shepherd; Liz Sheppard; Michel Soskine; and Irene Winsby. Merely to list their names is, I regret, scarcely adequate to convey my indebtedness to all of them.

Richard Lannoy, despite being in the throes of his (eagerly anticipated) autobiography, was always ready with valuable comments, backed up by his intimate knowledge of the London arts scene at the time of Bacon's emergence; he also staunchly withstood the indignity of viewing Bacon's images on a computer screen. Brian Clarke, in addition to constant and sympathetic support and friendship, kindly read, with great care as well as his artist's insight, the first draft of this book; he made innumerable constructive observations, many of which I was able to incorporate, and for which I am most grateful.

In 1910, A. Radclyffe Dugmore dedicated *Camera Adventures in the African Wilds* (one of Bacon's source books) to his wife, who, he said, 'shared the anxieties of the journey and enjoyed none of its pleasures'. Although my wife, Amanda, has had to endure many anxious moments (with which she coped graciously), I hope she found some of the experience pleasurable; I am glad to have the opportunity to acknowledge her much wider contribution to the research for this book, which, during the last two years, she has informed at some crucial points.

January 2005

INDEX